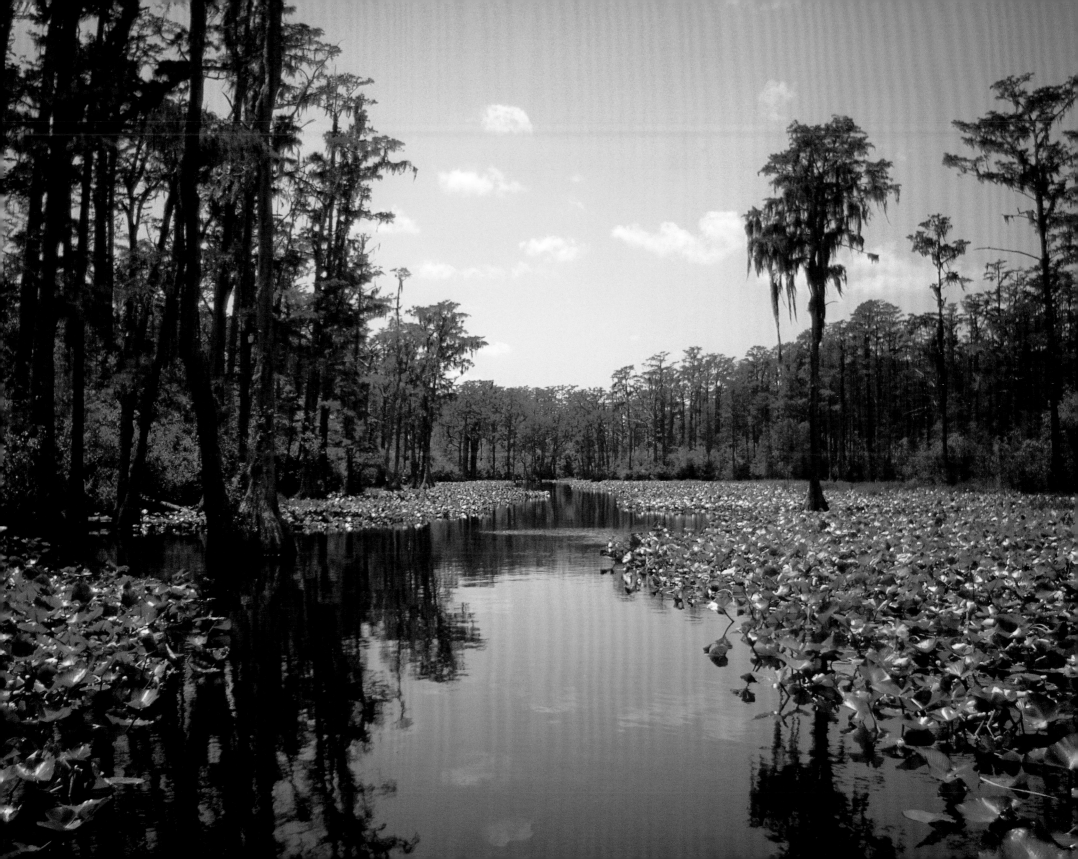

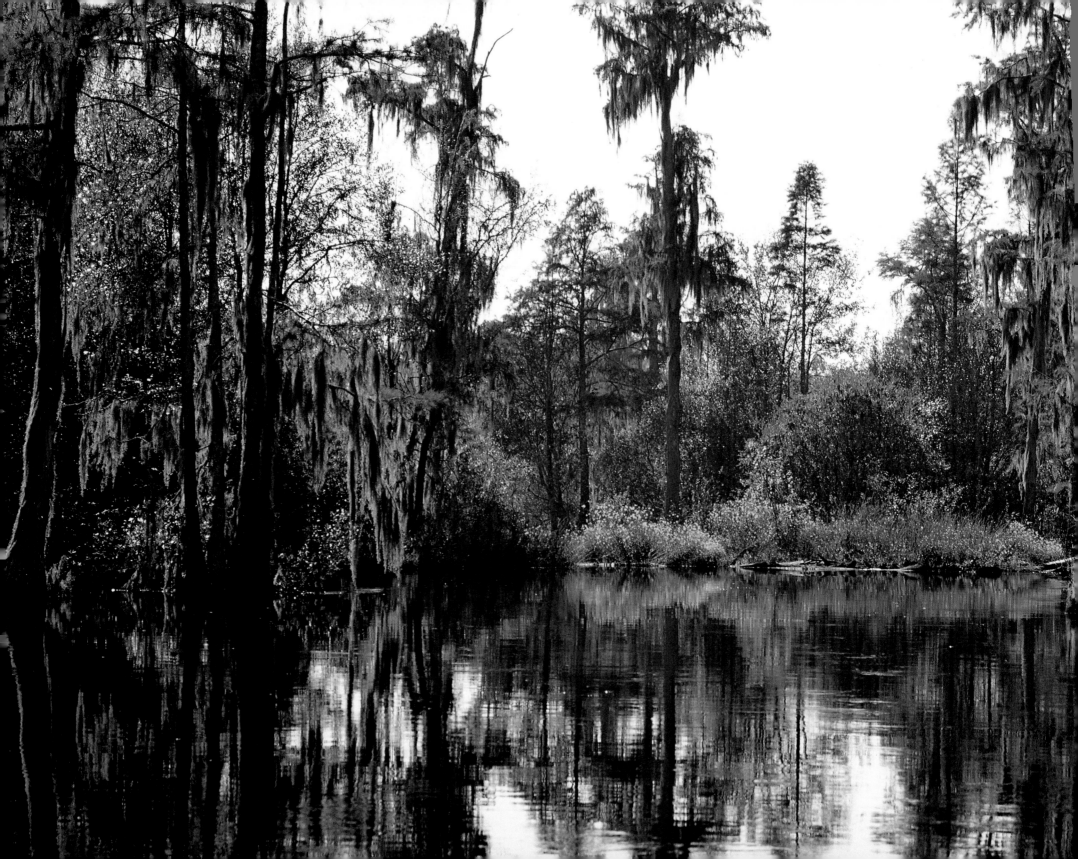

OKEFENOKEE

Photographs by Lucian Niemeyer

Text by George W. Folkerts

University Press of Mississippi *Jackson*

Publication of this book was made possible in part by
the Gertrude C. Ford Foundation.

www.upress.state.ms.us

Photographs copyright © 2002 by Lucian Niemeyer

Text copyright © 2002 by George W. Folkerts

Manufactured in China

Designed by John A. Langston

07 06 05 04 03 02 4 3 2 1

Library of Congress Cataloging-in-Publication Data

Niemeyer, Lucian.
 Okefenokee / photographs by Lucian Niemeyer ; text by George W.
Folkerts.
 p. cm.
 Includes bibliographical references (p.).
 ISBN 1-57806-409-0 (cloth : alk. paper)
 1. Natural history—Okefenokee Swamp (Ga. and Fla.) 2. Wetland
ecology—Okefenokee Swamp (Ga. and Fla.) I. Folkerts, George W. II. Title.

QH105.G4 N54 2001
508.758′752—dc21
2001045485

British Library Cataloging-in-Publication Data available

Page i:
Narrow and long, Minnie's
Lake supports a tenting
platform for campers at its
midpoint. It is a favorite
fishing lake.

Page ii:
Craven's Hammock, named for
a former hunter and trapper,
lies north of the sill, and can
be reached by canoe when the
water table allows (a permit is
required). A campground is
located here.

Facing page:
Billys Lake in the rain. The
lake is 3 1/2 miles long and
250 yards wide.

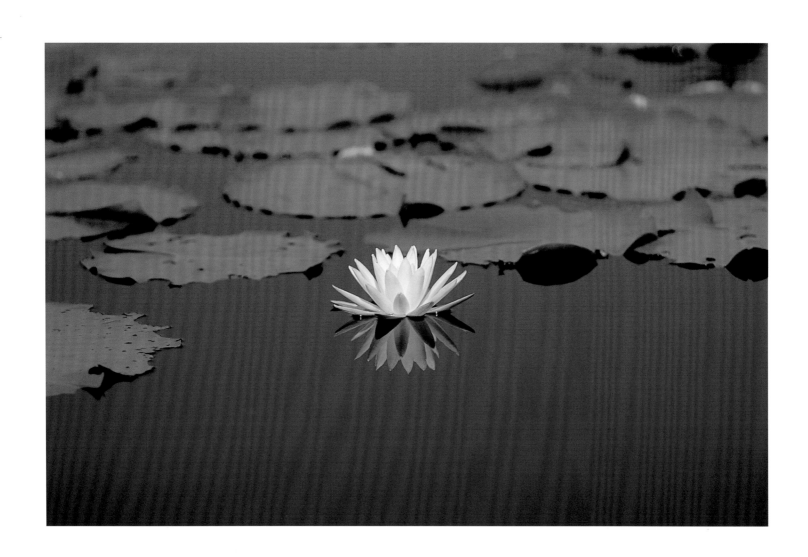

PHOTOGRAPHER'S PREFACE

Of the many natural phenomena in the world, the wetland ecosystems are among the most important, producing a prolific natural order created by sun and water. Representative of world-class wetlands, the Okefenokee Swamp in southern Georgia and northern Florida is a complex environment, with an intricate and diverse food chain ranging from protozoa to alligator, bear, human, and osprey. Here two great rivers are born—the St. Marys, which flows to the Atlantic Ocean, and the Suwannee, which meanders to the Gulf of Mexico. A sand bowl that is fed by rain runoff and by springs spans roughly nine hundred square miles and consists of water prairies, lakes, islands, streams and rivers, floodplains, bogs, batteries, houses, hammocks, pine barrens, canals, cypress groves, and dense underbrush, making this wetland unique in the world. It ebbs and flows based on the amount of rain that falls in the expanded area. As matter grows into thick foliage swimming on a lake and the roots spread into the peat from earlier plants, the water bodies fill in, first creating floating islands and then becoming fixed and surrounded by waterways. Thus, the Native American term *Okefenokee*—"trembling earth"—refers to the moving islands as they float on the basin. Fire, generally from lightning, sweeps through during dry periods, burning deep into the peat, creating new openings for water and reopening lakes and channels. The cycle continues; new growth resumes until one day only minute channels of water exist, and the swamp is no more. Such is the rich short life of the Okefenokee, created some seven thousand years ago. As a child growing up in Georgia, I read in school about the mysterious Okefenokee with its alligators, bears, and snakes. I heard tales of "wild," illiterate, barefooted families who

lived in this trackless water-wilderness, populated by the ivory-billed woodpecker and the fabulous whooping crane. It was a dark and fascinating myth. By then the ivory-billed woodpecker was near extinction, and the whooping crane had not existed there in modern times. Yet as I did research for this study, I came across a wonderful story. Four thousand years ago Native Americans made the lake and swamp area their home, as we know from the many burial mounds on the Okefenokee's islands and at its edges. Early European explorers told of a handsome race, with beautiful women and fierce warriors, living in the land of the trembling earth. Native Americans remained there until late in the nineteenth century. After they left or were driven south, pioneers moved into the swamp and established their own culture. They were for the most part self-sufficient, leading settled and fruitful lives. As the swamp became better known, efforts were made to remove the large stands of cypress and pine. First came an attempt to drain the swamp; although success was close at hand, the company failed. Then a better-financed lumber company created railroads through the swamp, made Billys Island their headquarters, built a company town, and harvested the great virgin cypress forest. Broken and almost clear-cut, the huge swamp began to renew its growth, forgotten by everyone except a few environmentalists. But now the Okefenokee Swamp is preserved for posterity, having been placed under governmental stewardship in the 1930s. The ivory-billed woodpecker and the panther are no longer seen, but the bear, alligator, and osprey hold court in a renewed environment of rich growth and natural order. Now the dangers are larger and more pervasive. Lower water tables, acid rain, disturbed envi-

< Fragrant water lily (*Nymphaea odorata*) in Chase Prairie.

ronmental surroundings, habitats crowded by humans and businesses, and ground water pollution have created new challenges for those who want to preserve this area. A barometer of our stewardship must be the health of the Okefenokee Swamp and its surrounding wetlands. The present study has been undertaken so that readers may learn about the natural history and see portraits of this unique swamp in its current state and thus be moved to participate in the efforts to protect it forever.

No artificial light, darkroom techniques, or filters were used in the taking of these images. I used neutral film, mostly Kodachrome 64 and 200, and Leica R cameras. I did experiment with Kodak Lumiere film for the aerials. I also used long lenses, which allowed me to capture intimate portraits without disturbing nature too much. Our journey into the vast swamp did result in some close calls for my wife, Joan, and me, but that is another story.

Chris Trowell, who has been a student of the Okefenokee for his whole life, was my mentor in this study; he opened the door so that I could understand the vastness of the place and put it into a natural and social perspective. His knowledge of the Okefenokee is unsurpassed and is exceeded only by the generosity he showed in sharing his studies with me. Without Chris this book would not exist. He also introduced me to Dr. George Folkerts of Auburn University, whose riveting and illuminating story is a treasure. The U.S. Fish and Wildlife Service is custodian of most of the Okefenokee, and the people there were very helpful to me; I want particularly to thank Jim Burkhart and Everette Sikes. The personnel at the Stephen Foster State Park, in the heart of the swamp, made a home for me while I stayed there; Bob Boynes, Barbara Pike, Sue Lampert, Pete Griffin, and others on the staff were hospitable and accommodating. The staff of Okefenokee Swamp Park, especially Jimmy Spikes, gave much assistance. The people at Obediah Barber's homestead also helped me greatly, as did Carl Glenn, Jr., of the Suwannee Canal Recreation Area. My wife, Joan, is my partner and was my willing helpmate throughout this journey. Leo Lamer, my friend, keeps me

energized about new studies. And I owe so much to that wild and stunningly beautiful swamp; I value the times I have spent exploring its byways and coming to appreciate its secrets.

I also want to thank Craig Gill of the University Press of Mississippi for his careful shepherding of this book. He has taken the ideas George and I had and made them available for all in a wonderful presentation. Finally I wish to thank my maker for allowing me to do the study and for creating the exquisite Okefenokee Swamp.

This book is dedicated to my wife, Joan, who shared in this wonderful study, and to Dr. Chris Trowel, to whom the secrets of the Okefenokee Swamp are entrusted more than to anyone else alive.

Lucian Niemeyer

PREFACE

In 1958, when I first came to the Okefenokee, I had little idea that I would return so many times. But a combination of circumstances made repeated visits not only possible, but necessary, after the lure of the Swamp captured me. I will continue to return as long as I am able. Even though I have visited the Swamp many times, I still feel ill-equipped to write about it, for it seems that I have not gained the knowledge or feelings that I could have had I constantly lived with the Swamp. I say this in order to partly explain the shortcomings in what I have written but also to acknowledge that there are a great many who are more expert in the lore of the Swamp, more familiar with its history and stories, and probably more attuned to its rhythms and mystique than I.

There are many to whom I am indebted for help of some kind that eventually came out in what I have written here, although some may not realize it. Perhaps most of all, I owe a lot of my original feelings about the Swamp to experiences undertaken with some of my lifelong friends, especially Stuart Fliege, the late Al Skorepa, and the late James Ozment. But I also want to thank other friends who have accompanied me on journeys in the Okefenokee region over the past forty-three years, notably Bob Faber, James Dale Smith, Bob Stout, Delbert Wolfe, Bill Hubble, and Lucian Niemeyer. Students in many classes over the years have not only been my companions, but have furnished many extra eyes and hands, allowing me to notice and experience things in the Swamp that I never could have on my own.

I have received an immense amount of help, in the way of inspiration and information, from many who have written about the Swamp, some of whom I have never met. I feel a need to thank them for all that their work has meant to me. Although I have undoubtedly forgotten several, I owe much to Francis Harper, Roland Harper, A. S. McQueen, Hamp Mizell, Delma Presley, Eugene Velie, Albert Hazen Wright, and Anna Allen Wright.

Chris Trowell, the acknowledged authority on the history of the Okefenokee Swamp, deserves special thanks. He has been kind enough to go out of his way to help me personally on a number of occasions. His work and his words have inspired me more than he can know.

I would like to thank Mr. James Burkhart of Okefenokee National Wildlife Refuge, who kindly helped with information. Scientists who have provided information over the years include Winston Baker, Anne Causey, Don Davis, Wayne Faircloth, Debbie Folkerts, Cyndy Loftin, Sharon Hermann, Bob Mount, Frankie Snow, and Albert Hazen Wright. Cyndy Loftin was also kind enough to review the manuscript, enabling me to improve its accuracy and readability.

One nice November day, Jim Cottingham and his family pulled me for several miles out of the Swamp when my motor had malfunctioned. If not for them, I might have become a permanent denizen of the Okefenokee.

At the University Press of Mississippi, Craig Gill and Anne Stascavage have been helpful, encouraging, and patient. Their willingness to look at this work and their belief in its value are greatly appreciated. The efforts of the skilled copyeditor have also been of great value.

Credit for the idea for this book and for pursuing the idea to completion goes to Lucian Niemeyer, who has my warmest thanks for inviting me to be involved in this effort.

My wife, Debbie, also a biologist, has encouraged me in this work, has accompanied me to the Swamp, and has somehow put up with all of my foibles. She deserves as much credit as I. My children, Merrill, Evan, and Molly, must also be mentioned, because the joy that their lives give me influences everything that I do.

To the many who have helped and have not been thanked here, I apologize. It is not that your assistance was not appreciated, merely that memory serves me poorly.

George W. Folkerts

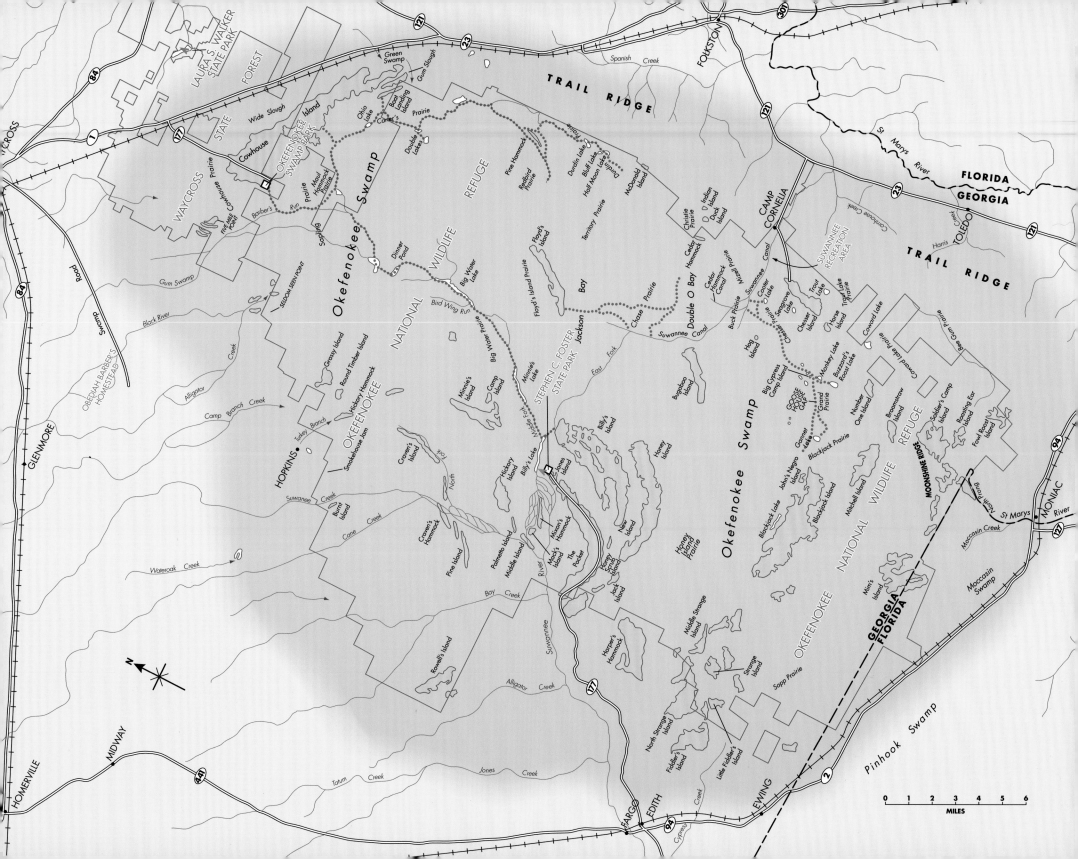

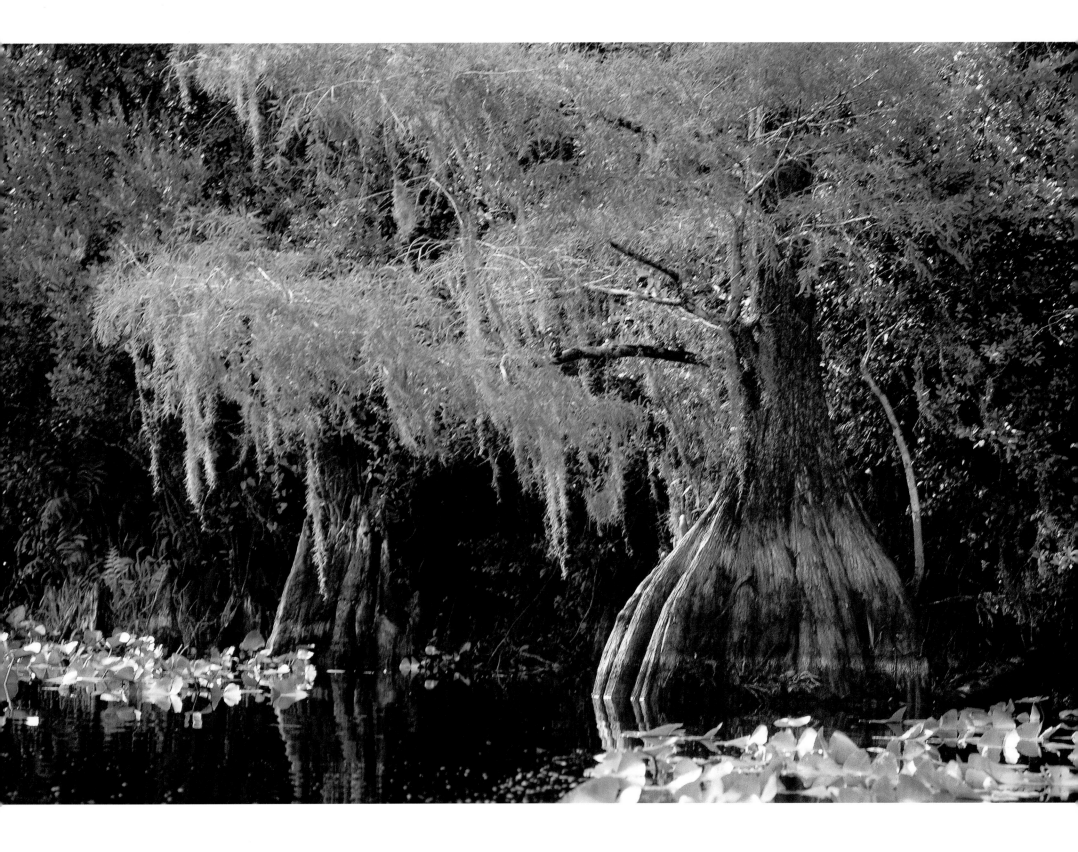

1 THE NATURAL SETTING

THE OKEFENOKEE. The name alone engenders visions of a place mysterious, of a region never completely knowable. Okefenokee, as a human utterance, belongs with Xanadu, Camelot, Atlantis, Avalon, and Hyperborea. These are legendary places of the world, places we all wish to know and experience, sites which it sometimes pains us to realize are largely imaginary. In older speech the Swamp was the Ecunfinocaw, Eckenfinooka, or Ouaqua-phenogaw. These ancient words slip from the tongue with a guttural softness that makes the place they name even more compelling and enigmatic. They are said to mean "trembling earth," supposedly alluding to the floating quaking masses of vegetation which occur in some areas of the Swamp.

Unlike the fabled places of legend, the Okefenokee is real. It is real to the extent that it can be seen and experienced, real enough to allow one to feel the underlying throbbing and humming of life, real to the degree that devotees can enumerate the birds and plants in Adamic pursuits, but, one hopes, never so real that its magic and mystery fade into harsh twenty-first-century reality. The Okefenokee, like the Camargue, Okavango, Pantanal, Sunderbans, and other mystical watery places, is one of the planet's major wetlands.

Lying in a region of southeastern Georgia and adjacent Florida that was little known until recently, the Okefenokee Swamp and its surroundings are rich in natural heritage and in the history of the study of nature. At the edge of the Atlantic lie the many islands of the "golden coast," a few still retaining vestiges of their primeval state. At the mouth of the Altamaha River are the fabled "Marshes of Glynn," made famous by Sidney Lanier's poem. Above them, somewhere along the upper course of this river, William Bartram found plants of the lost Franklinia, the only North American tree extinct in the wild state. In the stream of the Altamaha, the spiny elliptio, one of the strangest and rarest of North American clams, still survives, as do other unique mollusks. The Suwannee, which originates in the Swamp, is as rich in natural history as it is in the celebrated cultural history of song and story.

The Okefenokee Swamp, with its various appendages, sprawls over nearly half a million acres. There is little point in trying to delimit its boundaries precisely. In many parts it more or less fades into the surrounding uplands, smaller satellite wetlands stringing off in many directions. To the south, across the Florida line, it is hard to tell where the Okefenokee ends and Pinhook Swamp or Moccasin Swamp begins. As with most swamps, there are parts that are wet at one time but barely moist or totally dry at other times.

The depression in which the Okefenokee lies is itself enigmatic. Some believe that it was once a lagoon at the edge of the Atlantic. Others consider it to be the largest of the Carolina Bay depressions, mysterious elliptical shallow basins oriented in a southeast-northwest direction, which dot the Coastal Plain from North Carolina to southern Georgia. The method by which Carolina Bays formed is uncertain, with ideas ranging from a meteor shower to scouring by schools of fish at a time when the Coastal Plain was an ocean bottom. Research by J. D. Davis seems to indicate that certain of the islands in the Swamp are remnants of the sand ridges typical of the

< Billys Lake, in the heart of the Okefenokee Swamp, is most easily reached from the west entrance through Stephen Foster State Park. It is a narrow northeast-to-southwest lake, extending from Billys Island to the Suwannee River Narrows that lead to the sill. Stephen Foster State Park.

3

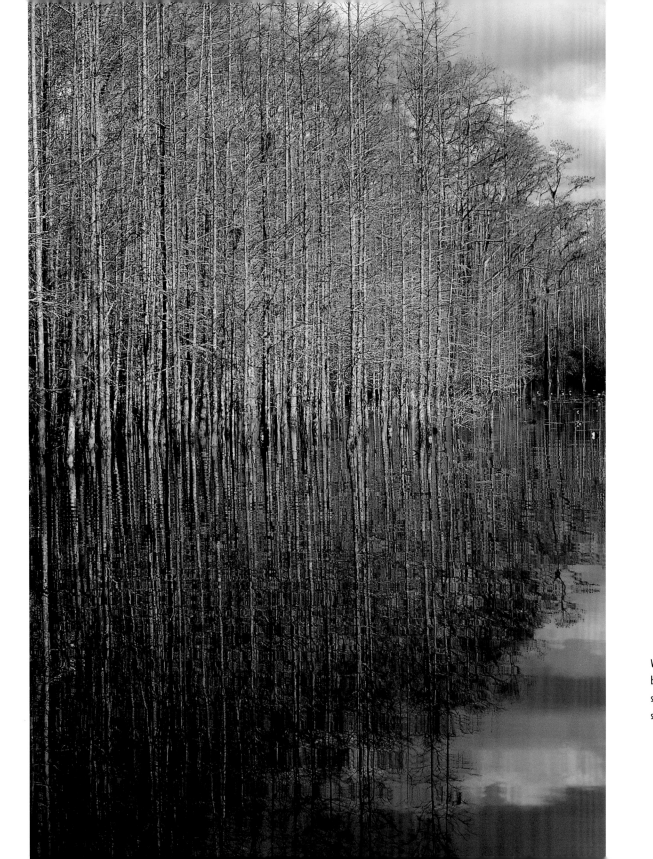

Winter in Big Water presents a beautiful gray symmetry in a stand of pondcypress. It rarely snows in the swamp.

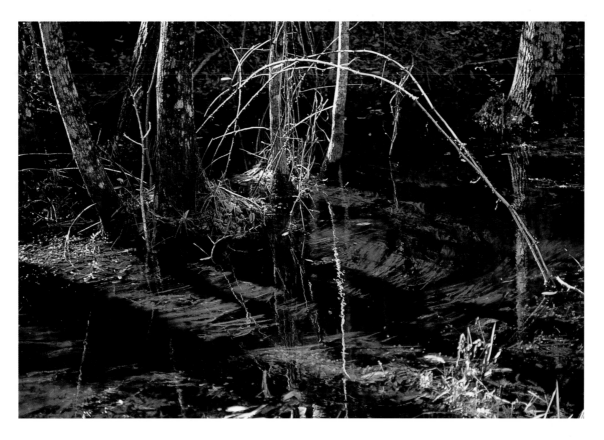

Trail Ridge is a long sand bank that contains the swamp on the east side; some of the swamp's water flow through it has created the St. Marys River. Camp Cornelia.

southeastern edges of Carolina Bays. Conspicuously curved raised areas such as Billys Island, The Pocket, and Honey Island do look a bit like sand ridges, some with their open faces to the northwest, and so could be components of these paradoxical depressions.

Recently, a number of geologists have claimed that dissolution of underlying limestone has been the major reason for the development of the Okefenokee depression. If this is the case, one might think of the Swamp as comparable to a giant sinkhole pond, like those which dot the southeastern Coastal Plain in many regions.

Presently, the Swamp is isolated from the Atlantic by Trail Ridge, a linear crest of sandy soil that extends south into Florida. This ridge is too large and of the wrong shape to be associated with a Carolina Bay. It is probably a remnant of a former coastal dune system or sandbar. As such, it could have formed at the edge of the Atlantic more than two hundred thousand years ago, meaning that the contours of land that eventually formed the Okefenokee were already then beginning to take place.

Trail Ridge, although traditionally thought of as being the barrier that created the Swamp by isolating it from the Atlantic, may not actually block the flow of water from the Swamp to the ocean. Rather, rainwater that accumulates in the sandhills of Trail Ridge may eventually contribute to the water in the Swamp. This concept is an important one because, if correct, it means that alterations of Trail Ridge could result in significant changes in the Swamp.

How was the Okefenokee formed? We may never know with certitude. As with the origin of Carolina Bays, as with the extinction of

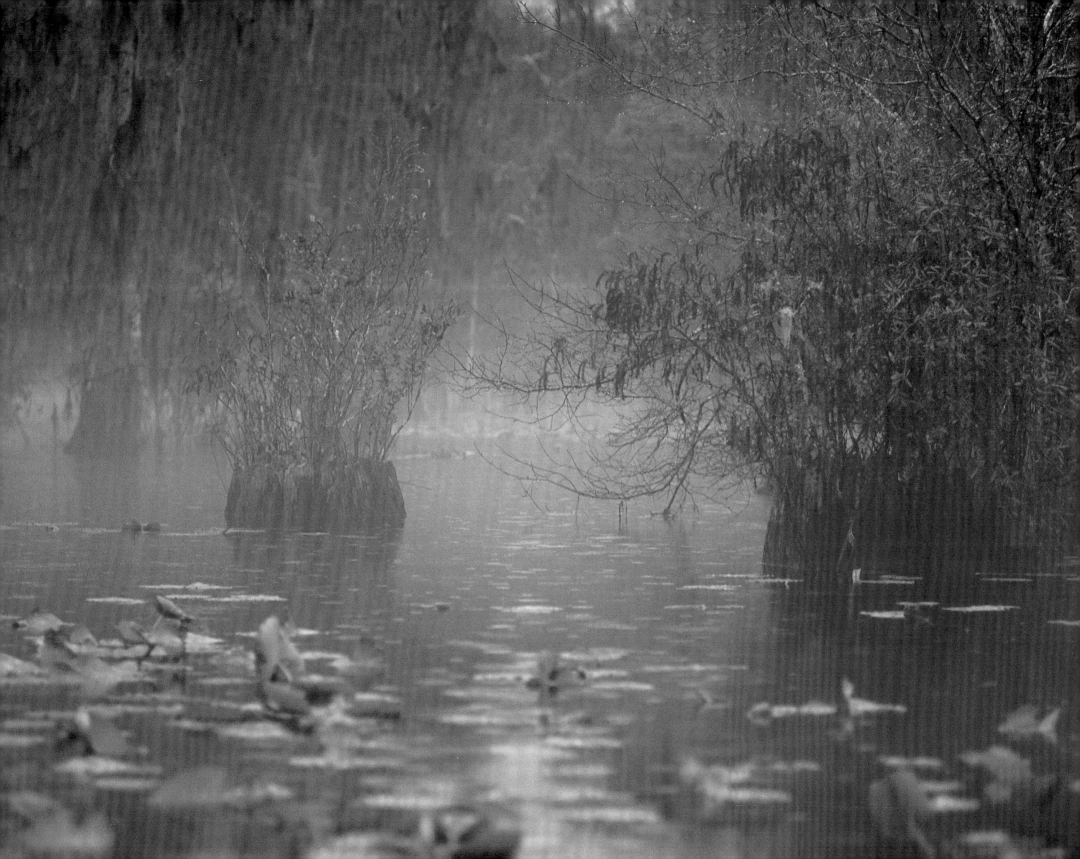

the dinosaurs, as with the origins of Appalachian balds, pick your hypothesis and you will be among a group of adherents.

No matter what the method of formation was, many may view the Okefenokee as an "eternal swamp," and think of it as a habitat of exceptional age. Among the general public, few would quibble if it were claimed that here dinosaurs once tread. This impression, though obviously attractive, is wrong. In the oldest peats at the bottom of the mucky lining of the Okefenokee basin lie pollen grains, preserved for centuries by the acidity. The most ancient of these minute remnants is no more than seven thousand years old. This means that the early Native Americans of the region may have witnessed the birth of the Okefenokee, human beings having arrived in southeastern North America sometime between eighteen thousand and eight thousand years before the present. The earliest direct evidence of human presence in the Swamp dates from only about forty-five hundred years ago.

It is likely that the Okefenokee depression was originally one huge complex of interconnected marshes, with few trees or shrubs. Four and one half millennia ago, cypress trees arrived at the swamp, dispersing to this area from warmer habitats near the coasts. Many other woody plants seem to have become abundant at this time. As a result of the melting of polar ice caps, sea level continued to rise during most of the Swamp's history. This implies that water levels in the swamp have also continued to rise gradually, keeping pace with the rate at which peat was accumulating and thereby maintaining swampy conditions. For the past several thousand years the Swamp probably resembled its state when the first Europeans arrived.

The Okefenokee lies in an area dominated by warm temperate conditions. The average temperature is about seventy degrees Fahrenheit, warm enough for large reptiles, such as the alligator, to thrive. Between early March and mid November, temperatures seldom drop low enough to cause frost damage to plants. Even in the winter, the temperature averages above fifty degrees. Snowfall is very rare in the Okefenokee. In a century, one might expect measurable amounts of snow in fewer than one year of five. During the long hot

summers, the average daily maximum temperature is around ninety degrees. Rainfall in a typical year is between fifty and sixty inches. The delivery of water to the Swamp by rain is not evenly distributed throughout the year. The period from October to December is the driest part of the year. Summers often experience over thirty inches of rain. Several severe droughts have occurred in recorded history, the most recent in 1954. Every few years, in late summer or autumn, the Okefenokee feels the effects of hurricanes that have moved up the Atlantic Coast or in from the Gulf. Although damage to native life forms is seldom noticeable, heavy rains associated with the tropical depressions often occur for several days. A hurricane in the 1800s is said to have destroyed live oak stands on some Okefenokee islands.

The water in the Swamp usually has the color of a weak tea. The stain comes from humic acids dissolved out of decaying vegetation.

< A rainy day in the Suwannee River Narrows leading to the sill.

The tannin-laden water is tea colored and acidic, resulting in a low population of mosquitoes and water-borne bacteria. Merchant ships in the 1800s used water from the St. Marys River because it was fresh and would not spoil during the long voyage home. Middle Fork, Suwannee River.

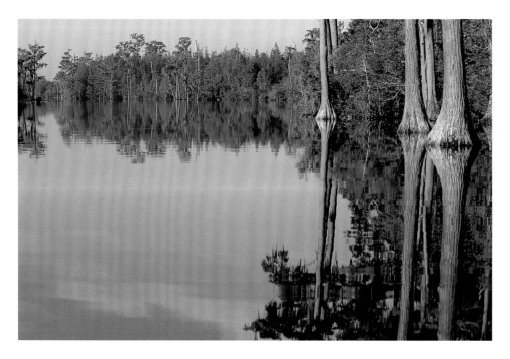

Billys Lake is the center course of the Suwannee River. The characteristics of the Okefenokee are determined by the level of water in the swamp.

Presently, the swamp varies in elevation from 128 feet at the northern end to about 100 feet or a little more at the southern end. The water flows slowly at most places, at some sites imperceptibly or not at all. Flow tends to be most rapid in the early spring, with another lesser peak in late summer. The most rapid water movement occurs in the watercourses that give rise to the rivers. The bulk of the water moves in a southward direction, although here and there one can find channels or passages flowing in almost any direction. Most of the water entering the swamp through rain and runoff from adjacent lands is lost to the air by evaporation from the surface, or returns to the air through the leaves of plants.

The major areas of flow by which water leaves the Swamp form two rivers of respectable size. Originating near the southeast corner of the Swamp, the St. Marys River, the Thlathlathlakupkha of earlier Americans, carries to the Atlantic a little less than 10 percent of the water output. From the southwestern portion, the flow divide being just west of Chase Prairie, the Suwannee and its tributary, Cypress Creek, convey nearly a fourth of the water flow over a 250-mile course to the Gulf of Mexico. Surface water may move through the swamp in less than half a year. However, water among the peat fragments at the Swamp's bottom may be very old, perhaps residing for hundreds of years among the same particles.

The portions of the Swamp that flow noticeably are the watercourses that eventually lead to the St. Marys and the Suwannee, and the capillary network of "runs" that converge and sometimes divide again among the various swamp habitats. Many of the small streams that bring water into the swamp originate in the northwest portion. Although these contribute a small portion of the water in the basin, much of the water in the Swamp is derived from rain that falls on the Swamp itself.

Broadening among the watercourses are lakes having gentler or nearly imperceptible flow. Most are long and narrow, their length sometimes reaching five miles but their width seldom exceeding a hundred yards. The familiar large lakes include Billys Lake, Minnies Lake and Big Water Lake. Many of the smaller lakes and ponds

Many streams and rivers of the Coastal Plain of the southeastern United States have similar darkly stained waters. The term "blackwater" is often used. Because they do not run for appreciable lengths over mineral soils or rock, they carry mainly substances found in peaty waters and therefore tend to be low in nutrients. Only small amounts of suspended particles are found in blackwater streams, causing them to have low scouring power during floods. This also means that blackwater streams have little material to deposit on floodplains during times of flood. All these features affect and are affected by the Swamp. Their influence extends down the Suwannee and St. Marys, eventually having consequences in the marshes at their mouths. The acid waters of the Swamp were known to sea captains as early as the 1600s. They traveled upstream on the St. Marys to take on fresh water, which kept for long periods because of the low bacterial count and acid conditions.

among the trees and marshes have enchanting names like Sometime Hole, Beegum Lake, Buzzard's Roost Lake, and Fishing Pole Lake. Some are named after people, such as Christie Lake, Dan Durkins Lake, and Coward Lake.

We call the Okefenokee a "swamp." From some viewpoints it could just as easily be called a marsh or a bog. In the southeastern United States, "swamp" usually means an area of wet soil or water, flowing or still, in which trees are conspicuous components of the vegetation. Charles Wharton, the authority on Georgia's natural environments, refers to the Okefenokee as a "bog swamp," and considers it a unique mosaic of habitats. The complexity of the meshwork of natural environments in the Okefenokee is actually beyond description, but by attempting to simplify our viewpoint we may succeed in grasping some of the variety. Many of the habitat types bear names that originated in the vernacular of the early European settlers of the area. Confusion often results unless one is provided with rough synonyms based on a more familiar terminology.

The large open marshy expanses without trees, known as prairies, are the most unique and in some ways the strangest portions of the Swamp. Prairies lie mainly in the eastern reaches of the Swamp in areas with thick peat deposits. Water in prairie areas ranges from a foot to a yard deep during years with normal rainfall. The only areas with deeper water are the watercourses themselves and the scattered lakes. The bottom consists of a layer of soggy peat that may go down an additional ten feet. Only in rare periods of extreme drought do the prairies become dry, although the peat surface may be exposed during periods of low rainfall.

Some prairies are dominated by plants with floating or broadly expanded leaves, such as fragrant water lily, floating hearts, golden club, watershield, and spatterdock. Other prairies, often shallower, are typified by dense stands of emergent herbs, including a variety of sedges and grasses. Most prairies are intermediate between these types, and they tend to run together. Also common are yellow-eyed grasses, pipeworts, and arrow arum. Fringing areas may be dominated by taller grasslike plants, such as maidencane and beakrushes.

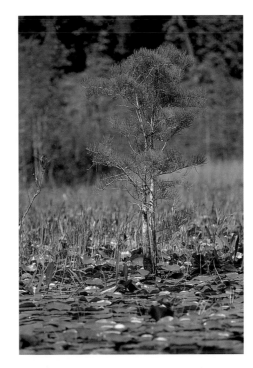

A young pondcypress (*Nutans taxodium distichum*) growing on a floating house in Grand Prairie.

The trunk of an old pondcypress in Billys Lake. Boaters must be wary so as to avoid the submerged tree trunks.

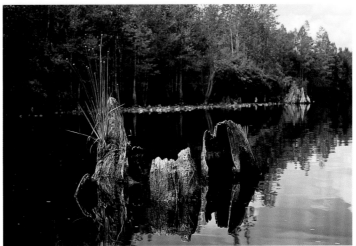

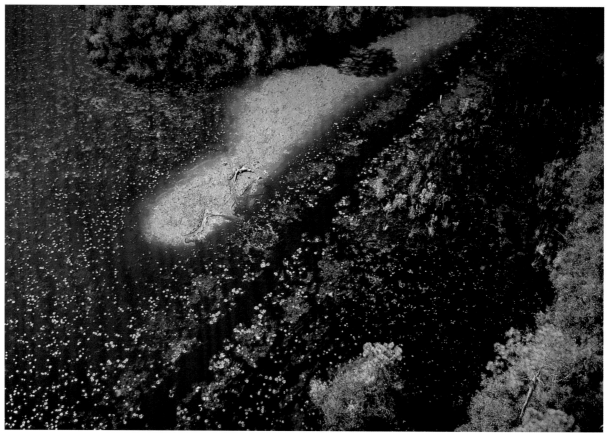

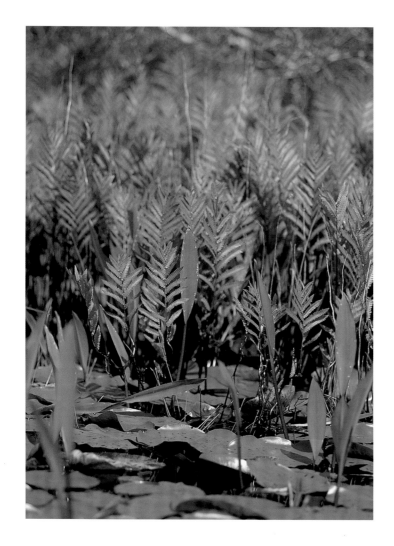

Virginia chain fern (*Woodwardia virginica*) in the Grand Prairie.

Three distinctive kinds of carnivorous plants also occur in prairie habitats. Virginia chain fern often forms dense stands, especially where masses of sphagnum moss have accumulated. These habitats have been called fern bogs.

The larger prairies, such as Chase Prairie, Chesser Prairie, Grand Prairie, and Floyds Prairie, may be over five miles in their longest dimension. Chase Prairie occupies over six thousand acres, an area larger than many metropolitan airports. The aspects of the prairies are constantly changing as plants flower, produce seed, die, and are

An aerial view of a battery. Methane gases created from dead plant life cause masses of organic material to rise to the surface, sometimes with a great roar. Territory Prairie.

replaced by later bloomers. Flocks of birds come and leave again. As the prairies age they are invaded by woody plants. With the help of fire they may fight back the invaders and expand again. They are almost organisms. Frequent visits to the prairies reveal that each has a unique personality. In the words of J. G. Needham, famous student of dragonflies, the Okefenokee prairies are among the most "wonderful waterscapes" of the continent.

At times, the layer of peat on the bottom floats to the surface and creates island-like masses that the native swampers call "batteries." Battery formation seems to be related to the production of methane, or "swamp gas," in the peat layer on the bottom. When enough gas has formed and when the attachment of the peat to the bottom is weak, a layer breaks free and floats. These events, called "blow-ups" by some natives, are often sudden and unexpected. New batteries often look pink and naked before oxidation and colonization by vegetation have faded them. At times the edges of a battery remain attached to the bottom, and a central area of peat bulges to the surface. Floating masses may move around with wind and water level changes and sometimes fuse to form larger masses. In the prairies of the eastern portion, floating mats are numerous. Chase Prairie has several thousand batteries ranging in size from clumps a few feet across to masses of several acres.

There are some interesting variants among the ideas about the formation of batteries. Two botanists who worked extensively in the Swamp, Eugene Cypert and Jane Glasser, have found evidence that alligators and their activities may be associated with their formation.

The batteries are the famous "trembling earth" for which the Okefenokee was supposedly named. These areas are thought to be the Swamp's main feature by many who have never visited. I have heard people say that the Okefenokee is the only place in the world where trembling earth occurs. This is folklore or stems from lack of familiarity with wetlands. Orange Lake, in central peninsular Florida, is well known for its mobile clumps of floating life. Huge floating islands of papyrus sedge occur in the marshes of the Sudd area of the central Nile River. In the innumerable bogs in northern North

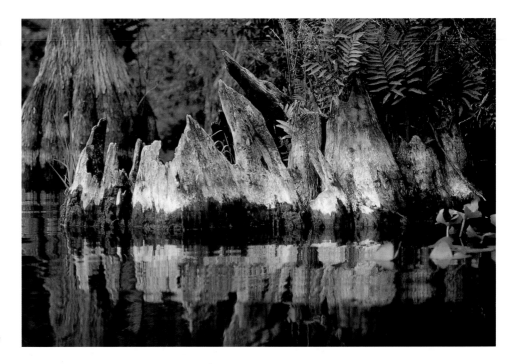

America and Eurasia, sedge and sphagnum floating mats form huge quaking expanses. Places where the earth trembles tend to form in wetlands in most parts of the world.

Batteries support a greater variety of plant life than the more open watery marsh, probably because their surface lies above the water level and provides a somewhat drier foothold. Grasses and sedges are the first plants to colonize a newly formed battery. Plant diversity increases as the battery ages. In these unique habitats sundews, pitcher plants, red root, three way sedge, and Virginia chain fern flourish.

Scattered among the prairies are "houses," clumps of taller vegetation consisting of sometimes only a few shrubs or a cluster of cypress trees. Some of these islands of trees and shrubs cover several acres. Aside from cypress, other abundant plants include bays and hurrah bushes. The vegetation is usually very dense. A common

The trunks of old pondcypress trees reflect the extremely low water table. These are usually well below the surface of the lake. Billys Lake.

Billys Island.

Ultimately the trembling nature of the mass is reduced as anchorage becomes firm and a mature house is formed. If the age of the oldest cypress trees is a reliable indication, some houses are over five hundred years old.

Much of the Swamp consists of prairies and other open habitats. Perhaps around half could really be classified as "swamp," in the sense of being covered with a fairly dense stand of trees. The wooded areas consist largely of cypress and loblolly bay stands with other trees intermingled. These habitats lie mainly in the northern and western portions of the swamp.

Pondcypress, the common large conspicuous tree of the Swamp, is typical of acid conditions where fire is frequent and is therefore well adapted to conditions in the Okefenokee. Scattered among the cypress or sometimes forming small stands without cypress are swamp tupelo, Ogeechee tupelo, red maple, sweetbay, red bay, and loblolly bay.

The only portions of the Swamp that nearly always remain dry are the islands. Around seventy masses of protruding land in the Swamp are large enough to be thought of as islands. These areas of highest elevation may be remnants of hills created by erosion in an area underlain by limestone. On the other hand, some may be remnants of the sand ridges on the edges of drowned Carolina Bay depressions. Still others may have resulted from rippling of the earth's surface as crustal movements occurred. In any case, slightly over a tenth of the Swamp's area consists of islands, the great majority lying in the southern half.

The vegetation of the larger islands consists mainly of forests of slash pine with some longleaf and loblolly pine also present. Sandy ridges on the islands may have stands of scrub oaks or live oak. The trees tended to be widely spaced under the primeval conditions of frequent fire, although now they are usually more crowded. Saw palmetto is an abundant shrubby plant on some islands but is absent from others. Wiregrass often dominates the forest floor. Dozens of species of flowering herbs are typically sprinkled among the wiregrass, some being in flower at almost all seasons of the year.

obstruction when one attempts to travel through the houses is the blaspheme vine. Its heavy thorns and cable-like snaking stems cause it to easily merit the name.

Houses seem to form on portions of batteries that have become stable enough to support woody plants, or perhaps on any shallow prairie site. Gradual ecological changes eventually create conditions suitable for shrubs and trees. Sometimes a house may begin as a single small buttonbush. The woody plants send roots down to the swamp bottom, and the battery becomes anchored, more stable, and suitable for even more types of woody plants. Eventually the area occupied by the trees and shrubs enlarges as they gradually create more favorable conditions by their advance on the battery surface.

Some islands have historically been called "hammocks" by the local inhabitants. The name hammock may be derived from the Native American word "hamaca." Some say it has its origin in "hummock." There are other etymological guesses. In any case, hammock generally refers to a mass of trees easily distinguished from the surrounding vegetation. It nearly always refers to broad-leaved evergreen trees of some sort. Thus, some islands, which may have had stands of southern magnolia and other broad-leaved trees in the past, appeared distinct from the surrounding cypress and tupelo masses, and the name hammock was applied to them.

To understand the Swamp's ecology, one has to be aware of the important role of fire in shaping the swamp and governing the condition of its habitats. To understand the significance of fire, it is often necessary for us to give up some of our cherished folklore.

Fire, in the eyes of most, is a destroyer. We hear of fires in California that destroy thousands of acres and hundreds of homes. Smokey the Bear has told us for years that fire destroys woods and wildlife. We are made to feel ashamed when we allow the forests to burn. We think of fire as evil and unnatural.

These viewpoints are largely wrong. Often they are so wrong that they are damaging to conservation efforts and to the health of natural systems. In the southeastern United States, many natural communities burned frequently, sometimes as often as every two or three years. Nearly all natural fires were started by lightning and were most common at times of year when thunderstorms were frequent. Under primeval conditions, barriers to the spread of fire were large watercourses, areas with sparse vegetation, and habitats in which the litter on the ground was not very flammable. Fires could therefore burn for miles from a single starting point. Natural fires tended to burn in a spotty fashion, leaving many small areas untouched.

The Native Americans and the early settlers burned the woodlands fires for a variety of purposes. Fires were used to drive game, to increase visibility by keeping down undergrowth, and to produce the higher-quality fodder that results from regrowth. Fires were also

Fire is an important aspect of swamp health. Burning some of the peat substrate creates open areas that fill with water, allowing an extension of swamp life. Chesser Island.

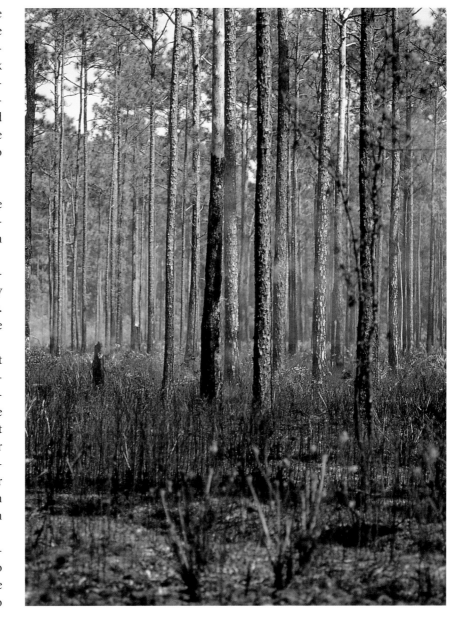

used in attempts to kill snakes, although probably without effect, the snakes of the burned habitats having lived with fires for millennia. Dr. Baldwin, a colonist who lived at St. Marys in the early 1800s, decried the burning of the forests and claimed that "stupid people" in the area set fires "for the fun of looking at it." In retrospect, we see that it was Baldwin who lacked insight into the natural system, rather than the residents. But biologists themselves have found it difficult to accept fire as a beneficial natural process. It is only within the last three or four decades that the place of fire in natural systems has been recognized. Even so, those with some familiarity with Swamp habitats soon realized that fires did no permanent harm. Writing in the 1920s, Albert and Anna Wright stated that, after having burned, the pine barrens of the Okefenokee "revive and come back rapidly."

The plants and animals of most habitats in southeastern North America have adaptations that allow them to survive fire, or allow rapid recolonization of sites where populations have been decimated by fire. Many of the plants have underground parts which are unharmed by passing fires, although the stems and leaves may be consumed. Some plants survive as fire-resistant seeds. Small animals take refuge in the soil or in holes and burrows. Birds and many insects fly away and soon return. Larger animals may flee temporarily, take refuge in water or wet places, or be able to leap through the flames of a cool fire and reach the other side with no more damage than a minor singeing. Under natural conditions, most fires never reached the roaring inferno stage.

Today, conditions for fires are very much different. Roads, railroads, canals, agricultural areas, cities, and other artificial habitats block the spread of natural fires. In most areas, fires are detected and aggressively put out, even if they are not likely to result in economic damage. Reducing the frequency of fires causes the buildup of large amounts of flammable litter, the accumulated dead components of vegetation. This means that when a fire does start, it may be much hotter, more difficult to control, and much more damaging than under the more natural conditions of frequent fire. Plants and ani-

mals that can tolerate, evade, or escape from natural fires may be killed by these abnormal infernos.

Like most adjacent habitats, the Okefenokee was prone to natural fires. In the underlying peat, bits of charcoal document the fires that occurred throughout the Swamp's history. Without fire the history of the Swamp would have been brief. The basin would have filled and disappeared long ago as a result of the accumulation of centuries of dead plant parts. Without fire, by now, the Swamp would have become a mosaic of woodlands of moist to dry types.

Fires in the Okefenokee have their major affect during periods of drought. As the water dries down, fires can start at the base of lightning-struck trees and spread, burning not only the vegetation, but burning down into the peat, in effect re-excavating previous depressions that can subsequently fill with water. Then the process of filling begins anew, only to again be set back by fires.

Many of the fires that have altered the Swamp vegetation most significantly seem to have been associated with major droughts. In historic times, severe droughts are known to have occurred in 1860, 1884, 1908, 1932, and 1954. Major fires in 1909, 1933, 1955, and 1990 apparently followed these times of little rain. At the time of this writing, the year 2000 appears to be a drought year. This may predict major fires in the coming months.

With the realization of the importance of fire in maintaining natural systems, changes in how the Swamp is managed have occurred. Prescribed fires, those purposefully set to achieve certain management goals, are going to become more common, especially on the uplands and islands. As a more natural fire regime (more accurately a periodicity that attempts to mimic what the natural regime is thought to have been) is achieved, some habitats in the Swamp will change. Those who grasp the significance of the changes will not be disturbed, but there will be some who will still lament the "burning of the Swamp."

The Okefenokee is truly a "wild" place, where natural processes occur without significant interference by humans. But it is not a

trackless area, nor is it untrammeled. Few areas of the Swamp lack signs of human presence. Canoe and boat trails penetrate into most portions. Most of the forested areas with large cypresses were logged at least once. Sawmills and railroad engines once puffed and whined in the center of the Swamp. The water level in the western Swamp is partially controlled by the artificial sill on the southwestern edge. Suppression and management of fires affect the vegetation. All these disturbances, however, have not destroyed the Swamp. Most of its natural values remain. The Swamp has shown the resilience that most natural systems have, an ability to which enables them to recover from minor traumas in short periods of time. Natural processes of ecological change can sometimes heal the minor wounds that humans inflict on nature.

If the Swamp survives, the healing will continue, the cypress stands will mature, the cabins and stills decay away, and the Okefenokee may again resemble something like its primeval state. Human disturbance has not permanently despoiled, nor do the signs of humans usually interfere with the joy of visiting the Swamp and getting to know it. When you come to the Okefenokee, view it as a natural place. Although the hand of human beings once lay heavily here, at present it rests more lightly.

Mixon's Hammock is found in the southwest corner of Billys Lake. An earlier entry point into the swamp was via a crossing of the Suwannee River. The area contains old logging roads, Native American mounds, a boating dock, and a camping-by-permit site.

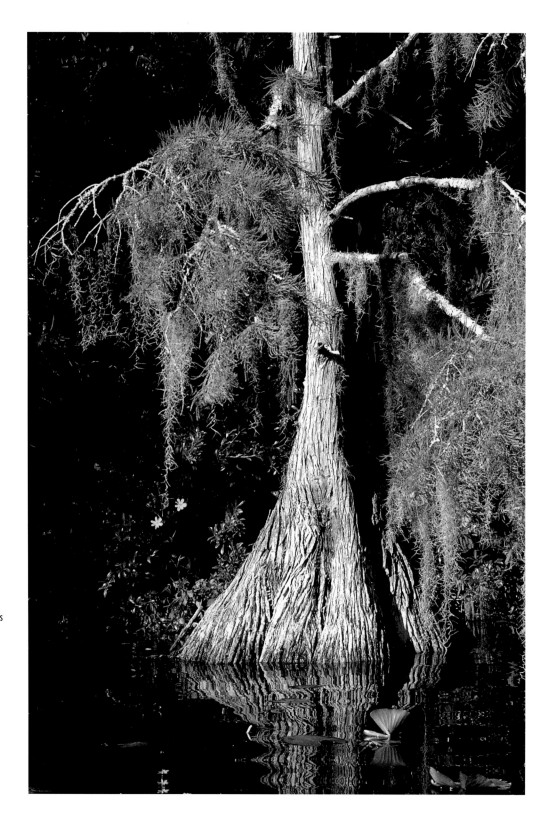

A pondcypress holds court in Billys Lake. In the early 1900s timber was clear-cut from the swamp, leaving rail trestles, an old company town, and a bare landscape filled with debris.

> Fall in the Okefenokee Swamp is a special time of quietness and subtle colors. Big Water.

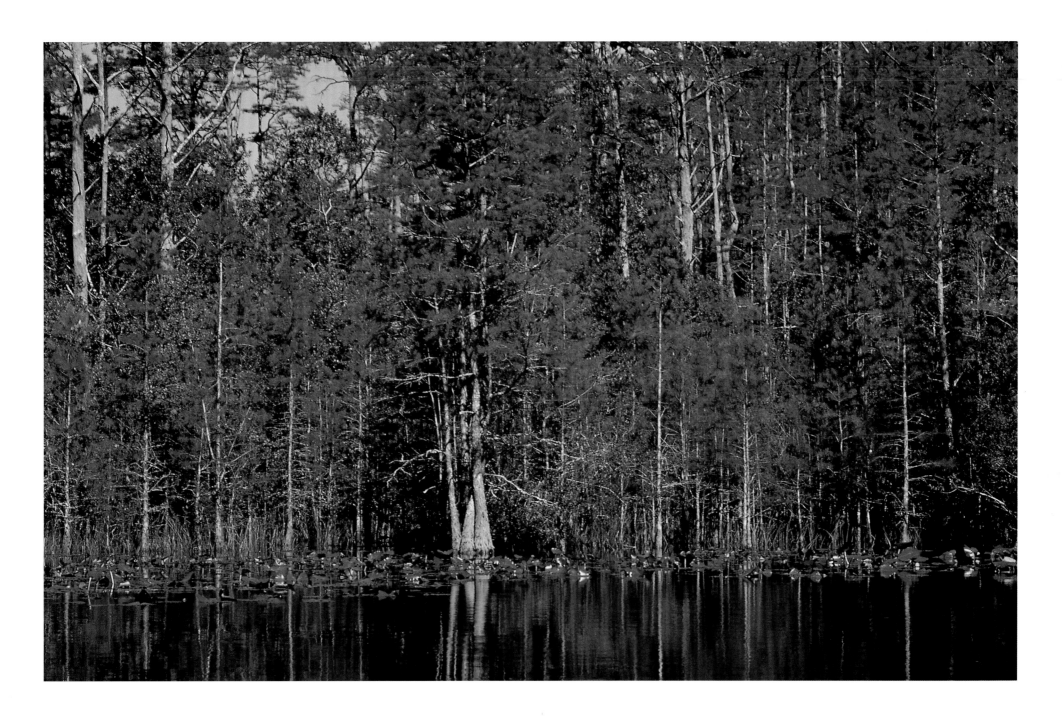

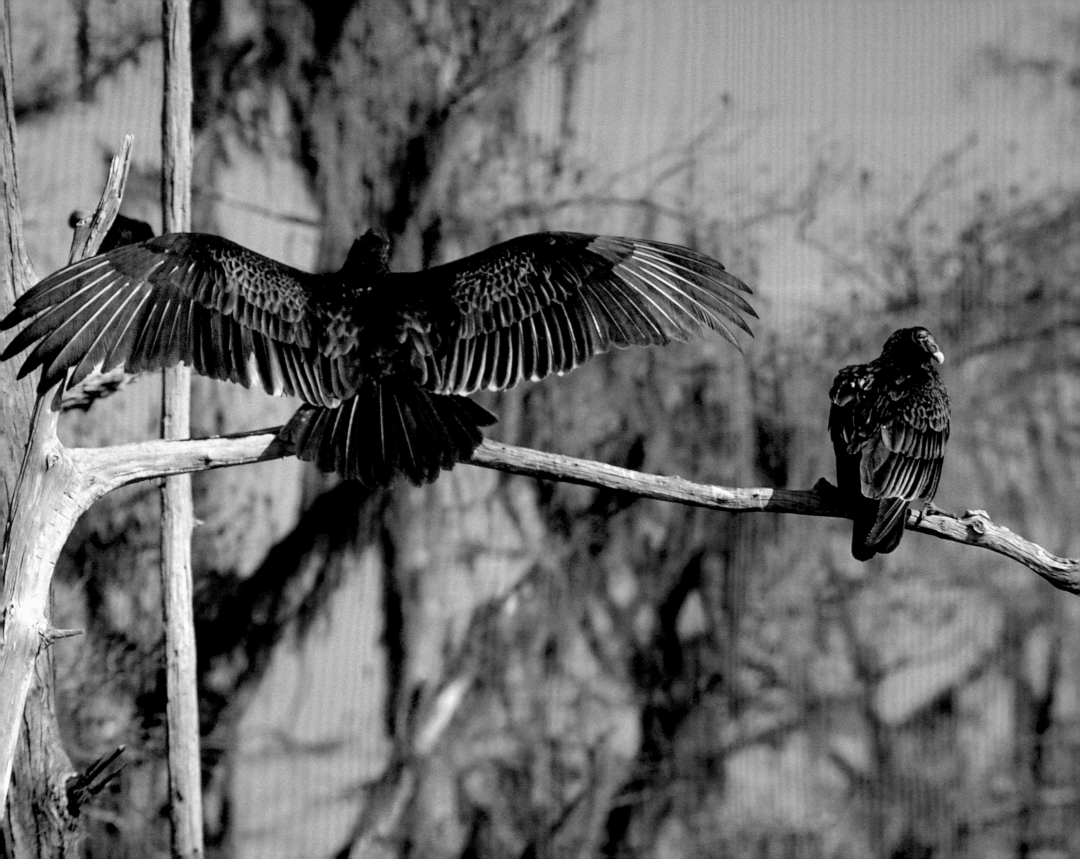

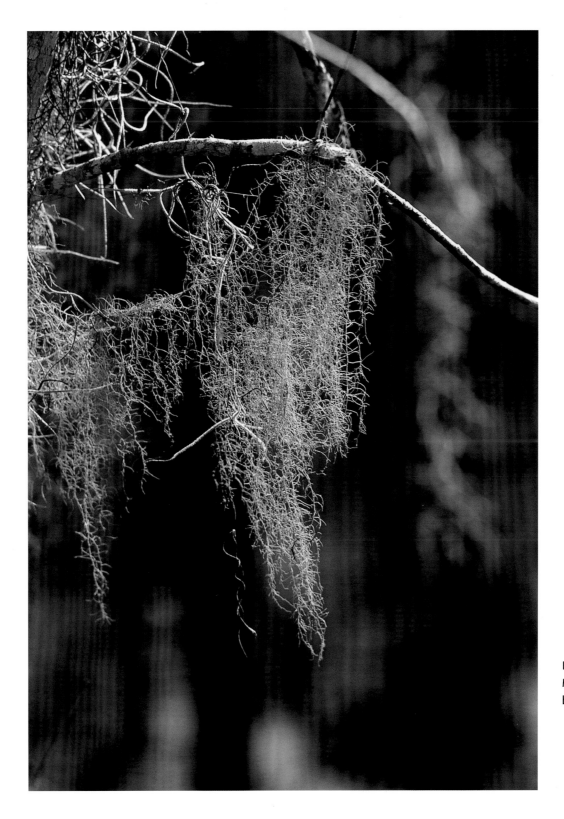

< Turkey vulture (*Cathartes aura*) drying its wings in the morning sun. Billys Lake.

Lichen, also known as Old Man's Beard (*usnea*), in the barrens east of the sill.

A Ramble on the Trembling Earth

Everyone who visits the Swamp is tempted to venture out onto the battery surface. Anyone who has been to the Swamp a number of times has invariably tried. In a way, one is obligated to attempt to walk on the batteries. After all they are the "trembling earth," the very essence of the Swamp. In the minds of many they are the Okefenokee. How could one visit the Swamp without a stroll on the batteries? Traversing the batteries, along with canoeing the trails and encountering an alligator, is "the" Okefenokee experience. If you haven't tried, it almost seems like you really haven't been to the Swamp.

One afternoon I decide to try it, but my first venture onto a battery meets with immediate failure. The battery is small, has little buoyancy, and immediately sinks to the bottom under my weight. I am left standing in about two feet of water, my feet embedded in the battery peat, which has again become, under my weight, a part of the bottom.

I try again, this time at the edge of a large battery whose opposite fringe I cannot discern. I gingerly step out of the boat and place one foot on the mat. It sinks to the point where my ankle is awash, but no farther. Sitting on the gunwale, I place my other foot on the mat and with both hands grasping the edge of the boat begin to push myself to an upright position. The boat wants to float away behind me, but I pull it back. I rise to a semicrouched stance and then more or less quiver to a standing position, having gently pushed the boat away. Establishing my equilibrium more firmly, I take two tentative steps. The mat holds. I have made it.

As I wobble precariously across the surface, the entire mat undulates unpredictably with the syncopated rhythm of my halting steps. The earth is indeed trembling all about me. Leaves of irises wave at me erratically as I pass. I attempt to adjust the rhythm of my steps to the mat undulations and succeed in almost sauntering along. For once, I appreciate my size fifteen shoes, which nearly allow me to negotiate the mat like a gallinule treads a lily pad.

As I career onward, without warning the mat gives way beneath my feet and I fall through. In the fraction of a second during my descent, my mind brings up an image of Tollund Man, those little people found so perfectly preserved in the acid waters of Danish peat bogs. Perhaps I will be trapped under the mat and drown? Maybe my body, undecayed, but tanned and pickled by the sour swamp water, will be discovered by some future archaeologist? Possibly I will be displayed in the visitor center as "Okefenokee Man," and my demise ascribed to primitive rites and ceremonies. I decide it is a distinction I can do without and reach out to grab the battery surface. But the water is shallow and I hit bottom, standing with the peat layer around my thighs. I slither back up onto the mat and progress, eel-like, back to my boat. I drag myself in, wet throughout, particles of peat clinging to every part of me. I comfort myself by remembering that it is rumored that swamp water is good for the skin.

Looking back on the ragged torn path that I have made, I am reminded of a disheartening fact about the Swamp and about many of the other relatively unspoiled places of the world. Natural processes can heal the disturbance resulting from a path trod by a single person. But I am not the only visitor here. Thousands wish for similar experiences. Most of the planet's shrinking wild places are in high demand by those who aspire to savor the real earth before it disappears. As we all clamber for these unique encounters, our sheer numbers threaten the existence of the very places we cherish. I leave the battery and row away from the brassy afternoon sun, sadly knowing that I should probably never do this again.

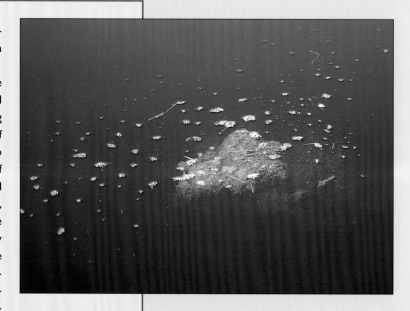

A peat mat of organic material, the forerunner of the batteries that create islands upon which new plants and trees grow. Grand Prairie.

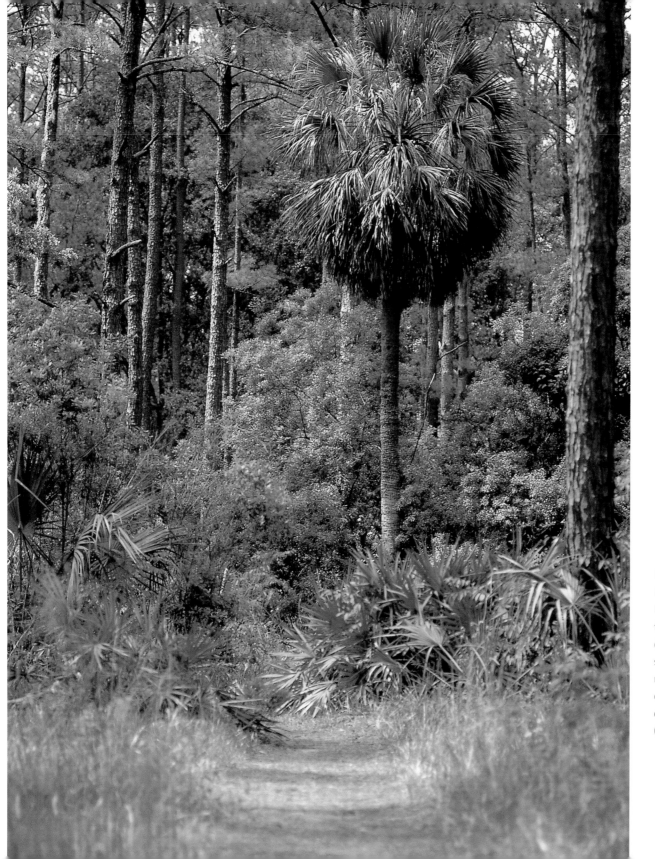

Billys Island is home to the Lee family's graveyard. Residents of the island since the early 1850s, the Lees were displaced in 1932 when the swamp became a government refuge. The island supports a colony of the endangered red-cockaded woodpecker (*Picoides borealis*).

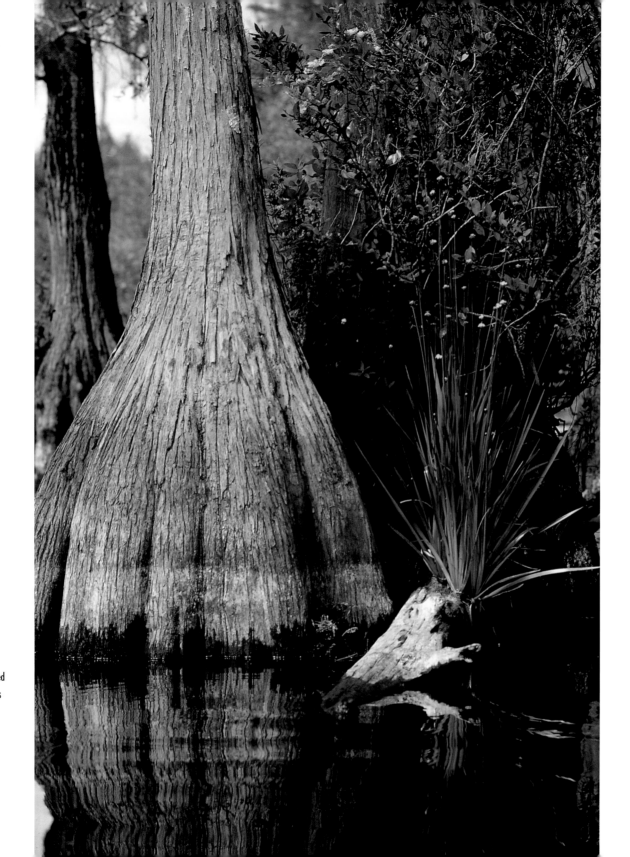

Pondcypress and yellow-eyed grass (*Xyris iridifolia*). Billys Lake.

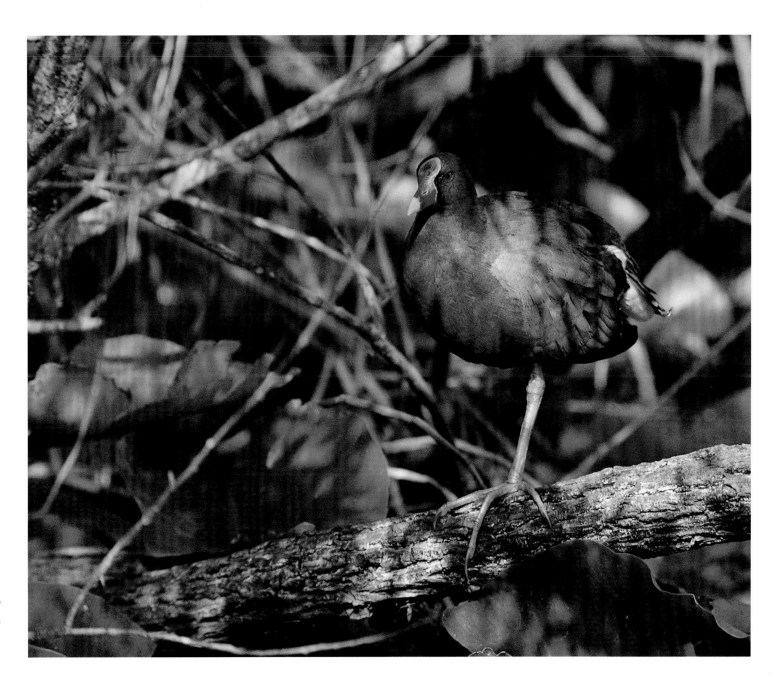

A purple gallinule (*Porphyrula martinica*) is a wary feeder on the shores.

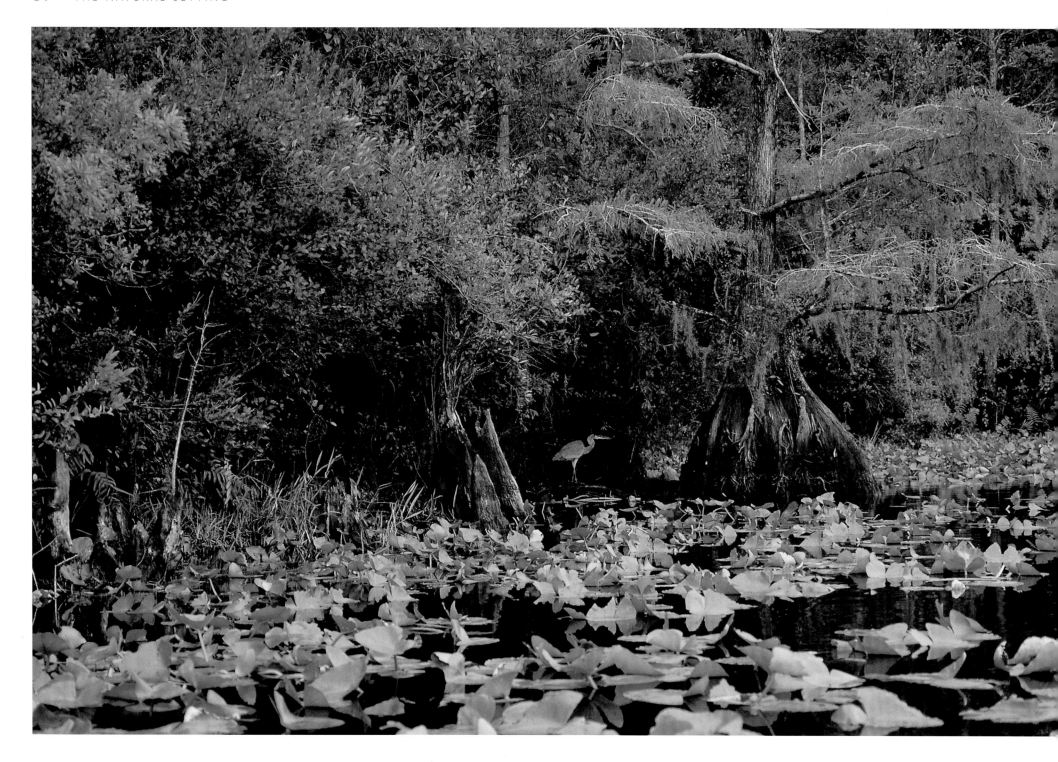

< A great blue heron feeds on the shore of Billys Lake.

Seen at extremely low water, the trail to Billys Lake includes a bridge, used while the sill was being created, near the old corduroy logging road.

The Source of the Suwannee

It is Thanksgiving Day, and I have discovered the source of the Suwannee. Since my early youth I have envied those who were with Henry Rowe Schoolcraft when he discovered Lake Itasca, where the great Mississippi has its modest beginning. There is something about finding an origin, a birth or beginning, a prime force or cause, which seems important and exciting. Why else would John Hanning Speke have given so much of his life's energy to the search for the origin of the Nile? Having been born too late to participate in the grander, more newsworthy searches for sources, I decided to conduct my own search, and perhaps to even invent my own source.

I stand somewhere near the south-central edge of Atkinson County, Georgia, southeast of Pearson and a bit west of a basically nonexistent town called Sandy Bottom. I have found my way here by using maps and by following the flow of Suwannee Creek upstream as it drifted below bridges and eased through culverts. I have crossed Suwannee Creek nearly a dozen times between the area where it merges with the Swamp and the point where I now stand. I have not had the adventures or endured the hardships that Schoolcraft or Speke encountered. But I have been chased by emaciated dogs, stumbled over sunken refrigerators, waved at smiling urchins, and been snared a score of times by the blaspheme vine. Worst of all, I suffered the stultifying monotony of the even-aged pine stands that have robbed southeastern Georgia of much of its natural charm. Finally, I reached the source. I stand at the place where the mystical river starts. This is the source of the Suwannee.

It is true that the beginning point of any stream or river is debatable. Even Lake Itasca has streams feeding into it, any of which might be considered the source of the Mississippi. Who says the Nile originates in Lake Victoria? Why couldn't it be half a dozen other lakes, puddles, or wide spots in streams? In this case, the early settlers in the Okefenokee area called this Suwannee Creek, perhaps because this was the name given by the native tribes. The earlier Americans, both European and Indian, may have somehow felt that this was a flow continuous with that which issues from the Swamp as the Suwannee River, that if the river began anywhere, this stream was an early part of it. Why else would the two streams have the same name? Some maps, even some recent ones, show Suwannee Creek continuing through the Swamp and becoming the Suwannee River. Other maps call the area of flow in the Swamp that leads north to Suwannee Creek, the North Fork presumably meaning that it is part of the Suwannee.

I stand at a soggy border. At my feet water seeps very slowly from the soil and heads downstream. During my search, when I finally came to the last road that crosses Suwannee Creek, the road farthest to the northwest, I began to walk. I knew that the next road in this direction crossed no trickle or trough that could be a continuation of the creek, but I had to follow to the very uppermost soggy reach to really verify that I had located the source. At the point where the last road crossed, a well-defined channel was apparent downstream. Above the road was a pool, the result of partial damming by the road fill. I tried to think of it as my Lake Itasca or Victoria. Although it was an attractive and even entrancing pool, I failed, my concentration being jarred by the whine of automobiles on a road less than a mile away. I peered at this pool for a long time before I detected the nearly nonexistent flow through the culvert. Then I walked around the pool and followed the soggy trough above it in the direction that slope and seepage seemed to dictate . . . upstream. Vines and branches seized my clothing and snatched at my sleeve, shrewdly attempting to keep me from my goal. Finally, after crashing through several hundred yards of titi, maple, fetterbush, and bay, I came to a point where the seeping soil ended, gradually rising to become drier ground. As I walked beyond this point I emerged into a clearcut. Ahead I could see the road that I had driven earlier this morn-

ing, the road which no creek crossed. I had found the source. I walked back to the very edge of the seep and stood savoring it. For me it was a significant triumph.

From this place of its origin, the Suwannee flows to the southeast, winding a bit but not meandering greatly. After nearly thirty miles, after being joined by Little Creek and other minor tributaries, it begins to broaden. After the main stream, flowing now in a wide trough, passes through Woods Lake, Suwannee Lake, and Lower Lake, between Smokehouse Jam and Burnt Island, it merges with the Swamp and nearly completely, but temporarily, loses its identity. To the south, channels again become distinct and coalesce to form the North Fork, which runs along the sill to join with other waters and become the Suwannee proper. The rest of the story of this river is more familiar. Downstream to the southwest, after winding for about 120 or so more miles and making a big loop to the north, it pours its waters into the Gulf of Mexico, downstream from Old Town, near the small village of Suwannee.

A drop of rain that falls at my feet would eventually reach the Gulf. But to the northwest, just across the road, I can see a line of trees that marks a small drainage that leads into Red Bluff Creek, which in turn feeds into the Satilla River, which flows mainly to the east and enters the Atlantic via St. Andrew Sound, just north of Cumberland Island. So here I also stand at a major divide. Just about at the road in front of me, an imperceptible elevation marks a segment of the line between the Atlantic and Gulf drainages. Even this I have discovered.

When Captain Cook came upon an unknown island in the Pacific, he named it after the day on which it was discovered. From then on it

has been called Christmas Island. In like manner I christen the seep that marks the birth of the Suwannee. From now on it shall be perhaps the only seep in the world with an appellation, named after this day, which reminds us of what we have received. I take one of the reddest of the tupelo leaves and thread through it a small stiff twig. I plant it firmly in the moist soil. This banner marks Thanksgiving Seep, source of the Suwannee.

Seagrove Lake from the Chesser Island observation tower.

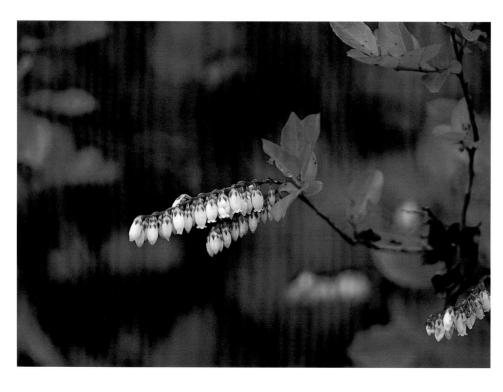

Fetterbush (*Leucothoe race-mosa*) on the shore of Billys Lake.

Virginia chain fern (*Woodwar-dia virginiana*) in Billys Lake.

> Wood stork, also known as wood ibis, feeding near Billys Lake. Eastern Fork, Suwannee River.

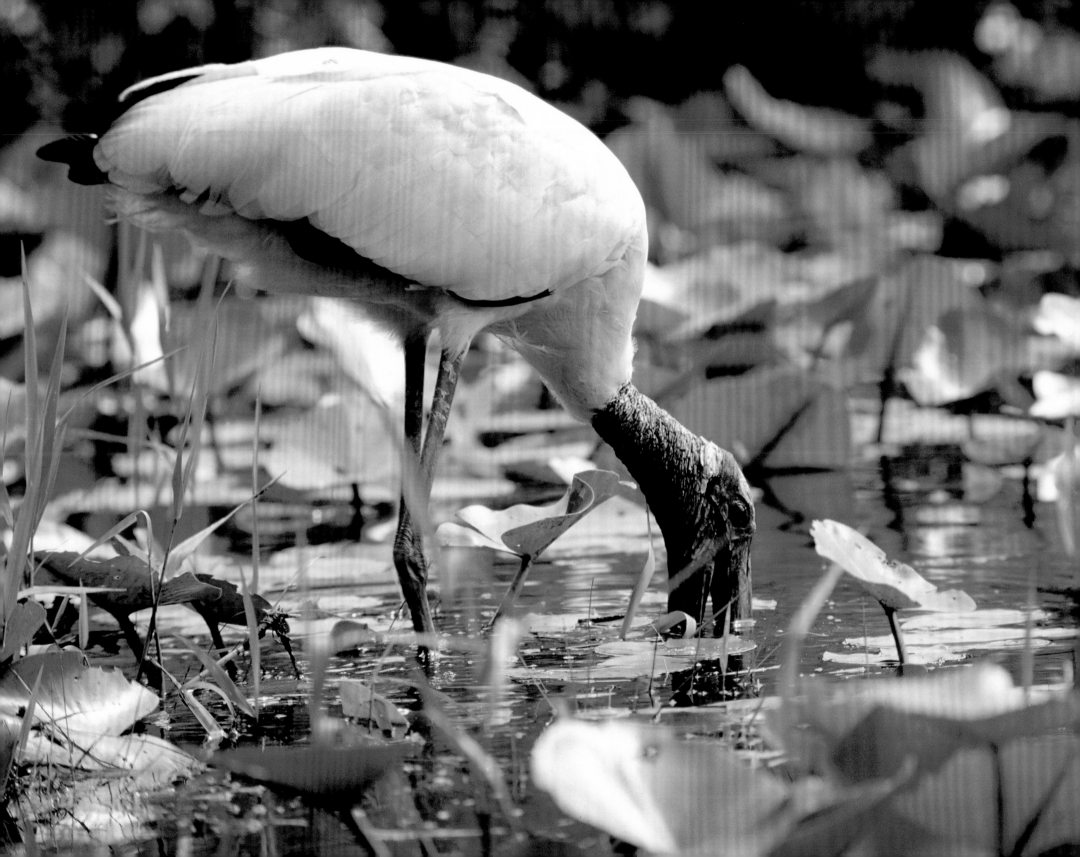

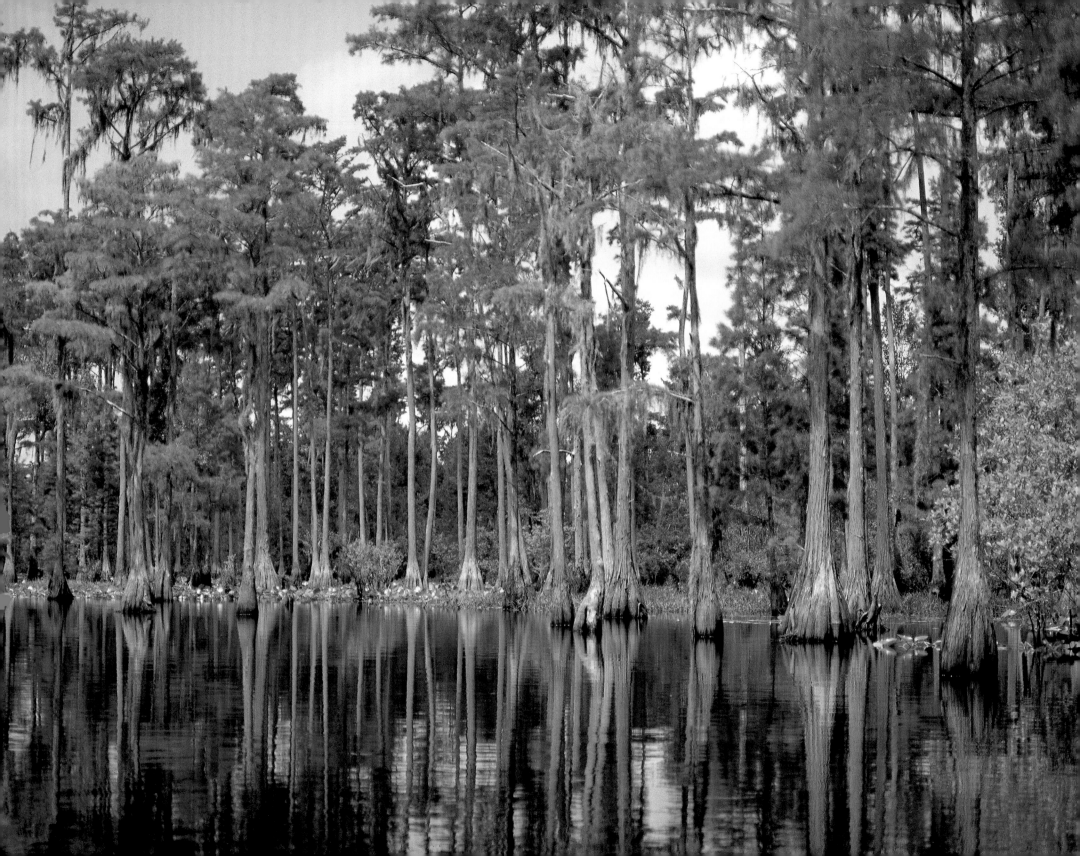

2　A WORLD OF GREEN

The greens of the Okefenokee are rich beyond description. From the almost imperceptible hints in the swaying grayness of dry Spanish moss, to the verdance of the unfolding water lily pads, to the new greens of the cypresses in spring, there are innumerable greens. Greens are renewing colors, hues of hope and life, shades of vigor and growth. One of the reasons that we go to the Swamp is to sample the lushness of its colors, to experience a world dominated by the many greens resulting from the presence of so many plants. It is the plants which give the Swamp much of its character, which give it its life.

It has been claimed that the world could exist without animals but that without plants all life would soon disappear. The last part of this idea is more or less correct, but there are many plants, perhaps most, that would not last long in the absence of all animal life, animals being important in pollination, in the dispersal of seeds and fruits, in the recycling processes which keep materials available in natural systems, and in many other activities vital to plants. Even so, there is no doubt that green plants form the basis of the processes that support all life on the planet.

The Okefenokee is rich in plant types. Among the flowering plants, those that we usually think of when the word "plant" is mentioned, nearly 700 species inhabit Okefenokee environs. This compares with about 550 species at Reelfoot Lake, Tennessee, around 850 in the Everglades region, and perhaps 1200 in the quaggy reaches of the Pantanal, that great but disappearing wetland in Brazil and Paraguay.

How can plants survive in an environment where the substrate is unstable, where vital oxygen is in short supply or sometimes absent around the roots, or where leaves may be shredded by waves or currents? Swamp tupelo, a common tree in the Okefenokee, has roots that loop above the saturated soil and take in oxygen through many tiny openings. A number of the swampland herbs pump oxygen down to the roots and out into the surrounding soil, creating an oxygen-rich environment in which the root tissues may function. Swampland trees often develop swollen bases which lower the center of gravity and increase anchorage, a feature called stooling. Cypresses and some of the oaks form flattened vertical ridges called buttresses around the base of the trunk. These broaden the base of support for the tree and may also function to trap litter and nutrients that float past.

If we could single out any plant or plant group which is most significant in the plant realms of the Swamp, it would undoubtedly be the cypresses. The cypresses are a group of trees that I have always associated with places of enchantment and wonder. When I was a child, moss-draped cypresses typified the southern swamps and their flourishing life. My first contact with a cypress swamp was also my first contact with cottonmouths, bird-voiced treefrogs, and beavers. I could never tire of cypresses in all of their variety or of cypress habitats and their magic.

Unfortunately, the "cypresses" of the Southeast, not true cypresses, have no group name that is handily applied to them. "Baldcypresses" is confusing because only one of the southeastern species is

< Stand of pondcypress west of the Suwannee River Narrows leading to the sill.

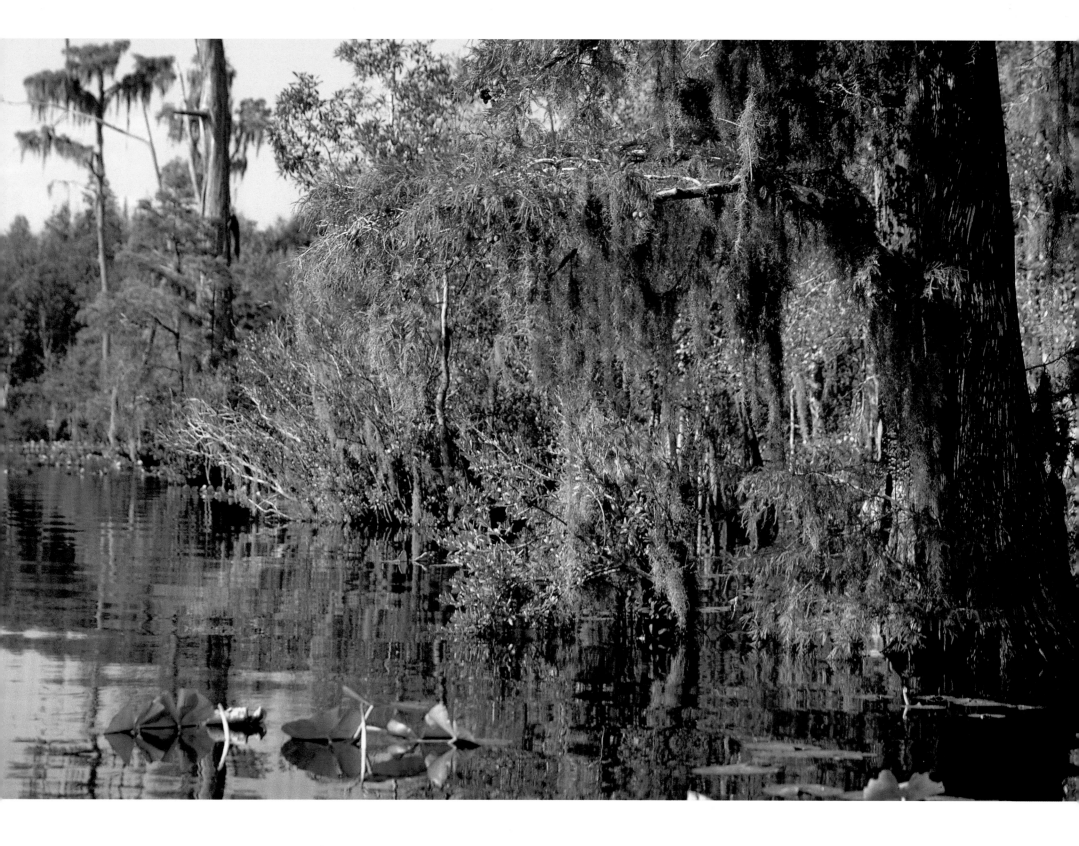

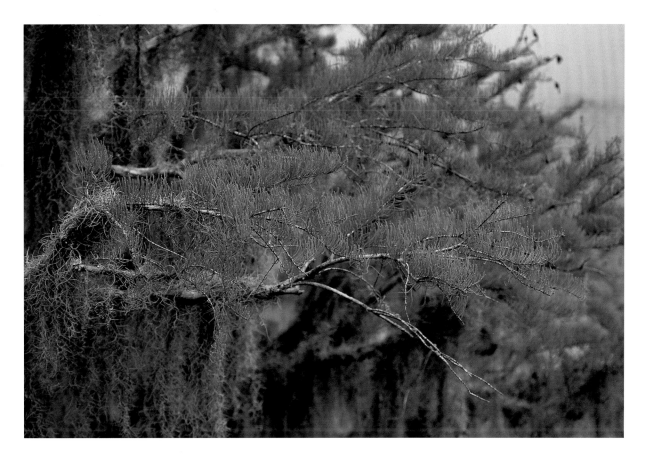

Pondcypress and Spanish moss (*Tillandsia usneoides*). Chesser Island.

< A pondcypress in full foliage in Billys Lake. The swamp's fall color is muted compared to that of a Vermont forest, but it is beautiful and subtle in its own right, featuring a variety of browns and golds.

called baldcypress. In addition, "bald" refers to the habit of dropping the needles in the winter, but the southernmost of the three species in this group is typically evergreen. Perhaps we should adopt a modification of the group's scientific name and call them the taxodii. For most readers, this name would be both cumbersome and unfamiliar. "Southern cypresses" has been suggested. Here, we will just call them cypresses or the baldcypress group and be satisfied.

The cypresses of the Swamp are pondcypresses, smaller than the baldcypress and inhabiting more acid sites, often away from conspicuous flow. The third species of this group is the Montezuma cypress, known by many because of the famous Tule tree which stands next to the cathedral in the village of Santa Maria del Tule in the state of Oaxaca, Mexico. Before it was found to really be a fused clump of trees, the Tule tree was thought to have the largest circum-ference of any tree in the world, being about 170 feet around the trunk. In any event, the Tule tree is notable, Hernán Cortés having remarked on it when he passed by in the 1520s.

Cypresses bear flattened needle-like leaves along the branchlets. They produce vertical growths from roots, and sometimes from the trunk base, which are called knees. In the fall of the year, the branchlets are shed and the trees become bare. Seeds are produced in ball-like female cones which hang from the branches.

And what of the knees? The variety and form of cypress knees is staggering. Some occur singly. Some are fused to form castles and mountain ranges of woody protuberance. Some are short and humped. Others are tall, thin spires. It is generally assumed that the height of cypress knees reflects the changes in water levels in the habitat. In areas of great fluctuation the knees may be eight or nine

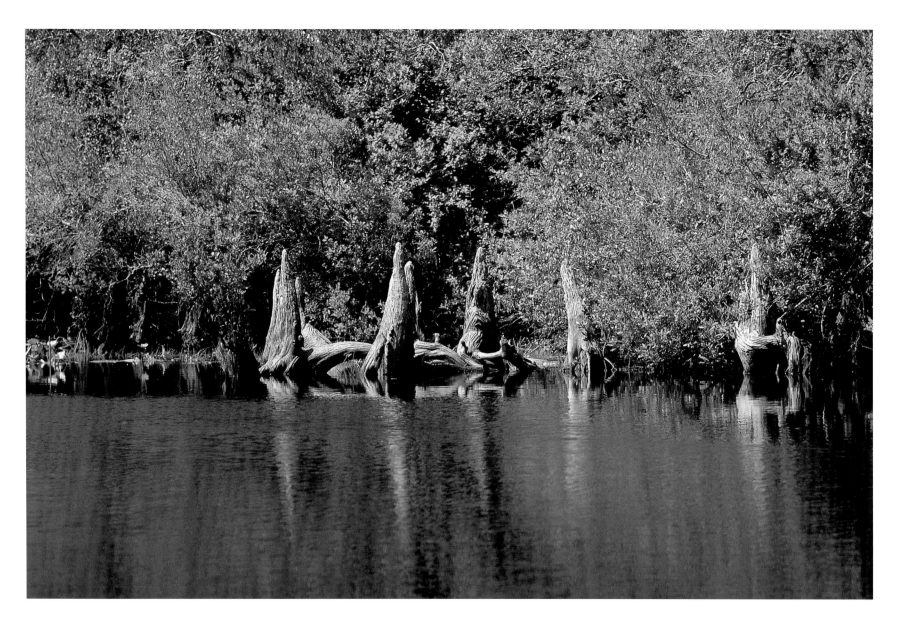

Big Water is a long trip into the swamp from Stephen Foster State Park and is the northern extent for power boats and most fishing. Long, narrow, and quiet, it is a home for otters, many bird species, and other wildlife.

feet tall, although none approaching this size are found in the Oke-fenokee.

Surely cypress knees must have some function other than being made into tasteless lamps, clocks, and other items of tourist bait. Biologists have never come to complete agreement on how cypress knees function. In many books one can find adamant statements about the oxygen-absorbing activities of cypress knees, how they are like breathing structures. Even so, experimental evidence is contra-dictory, and no firm proof exists that cypress knees can absorb oxygen. The idea has been advanced that the knees function as weights to anchor the roots, helping to prevent windthrow, a common cause of mortality in swampland trees with shallow root systems in an unstable soil. It has also been suggested that knees slow water movement around the base of the trunk, benefitting the tree by trapping nutrients associated with floating litter.

Like cypresses, tupelos are typical trees of southeastern wetlands. Water tupelo, the largest of the three species in the Southeast, does not occur in southeastern Georgia for reasons which are obscure. Flow rates may be too slow in the rivers in the area. Nutrient levels may be insufficient. Acidity may be too high. The tree simply may never have colonized the area. Whatever the reasons, only swamp tupelo and Ogeechee tupelo inhabit the Swamp.

Also called black gum or tupelo gum, swamp tupelo is one of the commonest of the Swamp's trees. It tends to inhabit shallow areas like island borders, pond edges and peripheral shallows. It often has swollen stooled bases. Some botanists consider it to be a wetland form of the black gum, its close relative of drier upland habitats.

Although not as large as the cypress or the swamp tupelo, in one sense Ogeechee tupelo is one of the most characteristic of the Swamp's trees. It ranges only in a small area in the southeastern United States, and may have originated somewhere in the vicinity of the Okefenokee. The tree was first made known to western colonists when William Bartram discovered specimens along the Ogeechee River a hundred and fifty or so miles north of the Swamp. It is sometimes called Ogeechee lime because the acid juice of the fruit was

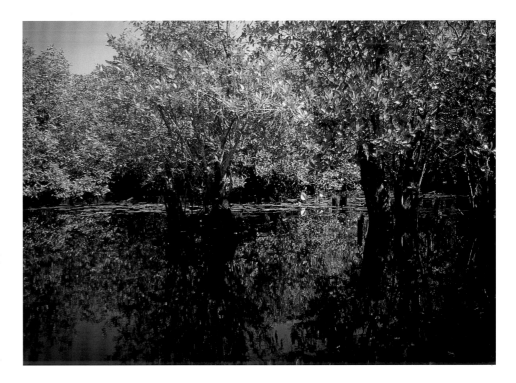

Ogeechee-lime, or ogeechee tupelo (*Nyssa ogeche*), in the river's barrens east of the sill.

used by early settlers as a substitute for lime juice. Ogeechee tupelo is easily recognized by its many swollen trunks coming from a common base. It seldom reaches heights of more than forty feet. Here the trunks are often gnarled and crooked, giving the tree a macabre appearance. A beautiful and somewhat eerie stand of this plant lies along the Narrows portion of the Suwannee, west of Stephen Foster State Park.

The fruits of both tupelos are much sought by animals. Bears may climb trees to eat them. Deer, who also browse the leaves, stretch to obtain fruits from the lowest branches. Rabbits search the litter to find those that have fallen. Tupelo fruits have been recorded in the diets of several dozen bird species. The animals benefit, but so do the trees. Some seeds find rich new sites in which to germinate. Tupelos are also famous as sources of nectar, which honeybees use to make a

delectable honey. In the fall, the scarlet hues of the tupelo leaves are some of the most brilliant in the Swamp.

There are at least four trees in the swamp that are called "bay" of one kind or another. The bays are trees of somber greens, with evergreen oval leaves. Two of the bays are really magnolias, if we want to think of them from a botanical perspective. Sweetbay is easily seen to be a magnolia if one examines the flowers. This plant is easily recognized by the whitish bottom surfaces of the leaves, especially when light winds turn them over and make the tree shimmer with whiteness. Sweetbay is common in wet areas where water stands for only short periods of time.

Bullbay is another magnolia, often called southern magnolia. Its masses of large thick leaves create patches of green in the winter on islands, hammocks and other high areas. It tolerates slight soil moisture but is not really a wetland plant. Large white flowers may be present throughout the summer and are often very abundant on unshaded plants. In the late summer and fall, bright red seeds dangle from the cones on slender threads and entice birds.

Loblolly bay is a member of the tea family and a close relative of Bartram's lost Franklinia, the latter originally discovered along the Altamaha. Loblolly bay has showy white flowers about the size of those of sweetbay, but the brush of stamens easily shows it not to be a magnolia. It begins flowering in the summer and continues to produce some flowers until frost occurs. The bark was used by early settlers in the tanning of leather. Loblolly is a term found in the common names of a number of southern plants. The term alone refers to an area of low wet ground where trees occur.

Red bay, a member of the laurel group and related to the plant that produces bay leaf, is sometimes divided into several species. The wetland type is called swamp red bay and is the common form in the Okefenokee. Inconspicuous greenish-white flowers are borne in the spring. Purplish fruits form in summer. Crushing the leaves of this species yields the familiar scent of the bay leaf used as a spice. Nearly every swamp red bay has at least a few leaves that bear tumors produced by a gall-forming aphid. The presence of these insect domiciles is sometimes the easiest way to identify the plant.

Three pines occur in the Swamp. We often think of pines as trees of drier sites, but these easily tolerate wet soils, and two may grow in water. Most large specimens were logged out by the early 1900s. Slash pine is the common pine in most areas. Its tolerances are broad, especially in the absence of fire. It is now the common pine on most of the islands. At the edges of islands it may grow in shallow water. Scattered plants occur throughout the Swamp in shallow sites away from any islands and are sometimes found on floating mats. I have the feeling that there was more slash pine out in the Swamp several decades ago than is now present. Maybe this idea comes from impressions gained in the region of the sill, where the species may be less abundant because it can tolerate fluctuating waters but usually cannot stand constant inundation.

Pond pine is truly a wetland pine. In the Swamp it occurs in ponds, peaty strands, shallow bays, and wet flatwoods on islands. It may grow among bays or swamp tupelos. The egg-shaped cones remain on the tree for one or two years before shedding their seeds. Pond pine is adapted to fire and quickly sprouts from the base after hot fires.

The sandier higher parts of islands and sandhill habitats around the Swamp are the major habitats where longleaf pine occurs. It also inhabits some lower, moister sites. Under primeval conditions it was the most abundant pine in the Southeast. The decline in longleaf pine resulted from lack of natural fires and from the timber industry's desire to use pines with rapid growth rates to maximize pulpwood yields.

Longleaf pine is one of the most fascinating North American trees. It is amazingly resistant to fire, the thick bark of larger specimens having thermal insulatory qualities almost like that of asbestos. Seeds germinate only on relatively bare soil, so fire is often necessary to provide a seed bed. During the first few years, the seedling exists in the grass stage, in which only a terminal clump of needles protrudes from the ground. Fires may burn off the needles, but seldom damage the growing tip. In a few years, after nutrients have been amassed in the underground parts, the stem rapidly grows to a height of twenty feet or so in a few seasons. This allows the tree to

Collecting pine sap is a labor-intensive and sticky business. The pine forests of the swamp provided cash crops for residents in and near the swamp. Cowhouse Island.

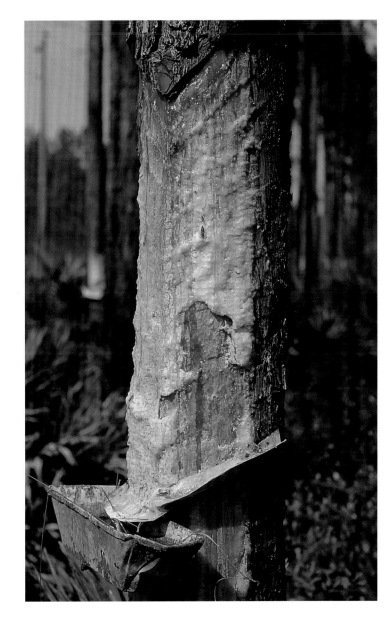

A catface is cut on a longleaf pine (*Pinus palustris*) to allow the flow of pine sap into a bucket. The sap is turned into pitch and turpentine. The making of naval stores was an important industry in the swamp. Cowhouse Island.

pass rapidly through the only stage which is easily damaged by fires. The loose crown retards the spread of fire through the crown. The lowest branches of trees more than a few years old are above the level at which normal ground fires can ignite them. To these remarkable features one may add resin characteristics which make longleaf pine more resistant to insect attack than any other North American conifer.

The open longleaf stands which dominated the uplands of southeastern North America when European settlers arrived are gone. This pine was the dominant tree of islands in the Swamp before human disturbance occurred. If we are to have any grasp of what this land was like before we traumatized it, public lands are places that can and should be used to preserve and restore some of the components of our heritage. With proper management, longleaf pine stands resembling primeval habitats can once again exist on the Okefenokee islands.

Cabbage palms occur naturally along the Georgia coast and at several sites along the Satilla and St. Marys. Specimens on islands in the Swamp may have been planted, but it is claimed by some that the Billys Island palms are natives. Blue or swamp palms inhabit some of the nearby bottomlands. However, the only palm found naturally

Saw palmetto (*Serenoa repens*) is found throughout the islands and surrounding land areas of the swamp. Chesser Island.

within the Swamp is the saw palmetto, a denizen of the bordering flatwoods and the drier parts of islands. This palm usually has a prostrate stem. Its name comes from the sharp teeth along the stalk of the leaf. Saw palmetto sprouts vigorously from the stem after fire has swept through an area. The fruits are favorites of raccoons, opossums, foxes, and bears. How the vegetation in the Swamp looks to us is the result of the presence of a number of species of small evergreen trees or shrubs, most of which are very tolerant of flooding. We cannot mention here any but the most common types. Even these types are sometimes hard to separate, the leaves of most being of similar sizes and shapes.

In the Okefenokee region, the wax myrtle grows everywhere. It occurs at the edges of marshes at the mouth of the St. Marys. It is found on the highest, driest parts of the islands. It abounds on the bases of cypresses, and small specimens are occasionally seen atop floating logs. Biologists say that the wax myrtle has a wide ecological

amplitude. They mean that it can grow in many different habitats. Part of the reason for its success really lies in the success of another plant, an intimate partner to the wax myrtle. In swellings on the roots of wax myrtle live fungus-like slime bacteria, primitive plant-like organisms which are able to take nitrogen from the air surrounding the roots and convert it to a form that the wax myrtle can use in its growth and life processes. The nodules on the roots of legumes contain bacteria which provide a similar service. The nitrogen compounds produced by the bacteria enable the wax myrtle to live in habitats in which nitrogen is low in the soil.

But the mutually advantageous relationship it has with a very different type of living thing is not the only key to the success of wax myrtle. It also has managed to escape many of the chewers, gnawers, biters, and browsers that consume, skeletonize and generally devastate the leaf tissues of plants. If you look closely at a wax myrtle leaf, top or bottom, you will see many tiny golden dots. Each dot is an

area of concentration of volatile aromatic compounds which deter feeding by animals. Crush a leaf and the aroma of the substances is obvious. Most animals find the compounds distasteful or sickening and thus learn to avoid chewing on wax myrtle.

Hollies of a number of species are among the anonymous small trees and shrubs. One of the most common is dahoon holly, also called white holly because of the bark color. This small tree has beautiful red berries which, at about Christmas time, provide a vivid display. Gray squirrels harvest many of the berries, distributing seeds in their droppings.

White titi is the most common shrub in many areas. Clusters of long sprays of white flowers form in the late spring. Black titi, with similar leaves but not closely related, produces compact single white spikes as early as March. Buttonbush, poorgrub, hurrah bushes, fetterbushes and a variety of huckleberries and blueberries add to the variety of shrubs and small trees. Many of the species produce berries favored by wildlife, and the huckleberries and blueberries are also gathered by the local citizens.

The flora of the Okefenokee contains a number of woody plants which are rarely seen or noticed. One of the oddest of these is the vine wicky, sometimes called low andromeda. This plant may grow as a small shrub with more or less erect stems. But usually it grows on, or, more accurately, *in* the bark of trees. Pondcypress is the common host. One can detect the plant by noticing an oblong, somewhat pointed, evergreen leaf seemingly growing from the trunk of a cypress. Close inspection may reveal the stem of the vine, closely fused to the bark. Often the stem develops entirely under the outer layers of bark and is nearly invisible. To find the vine wicky easily, one must come to the Swamp in late February or early March when the protruding branches produce clumps of a few to several dozen white globe-like flowers.

Another jewel of the Okefenokee flora is the pond spice, a plant which seems to be rare throughout its range. Although it occurs from lowlands of the Carolinas across the Gulf Coast and at scattered sites inland, I have seen the plant only a few times. This small

Dahoon holly (*Ilex cassine*) on the shore of Billys Lake.

Titi shrub (*Cyrilla racemiflora*) is a common plant at Billys Lake in the fall.

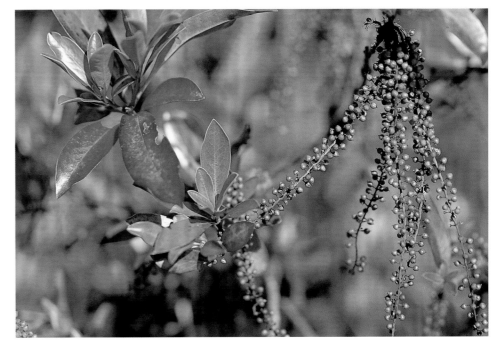

shrub, which seldom reaches heights of over ten feet, is most easily spotted by the conspicuous zigzag form of the smaller branches. In the late winter it produces clumps of yellowish-white flowers, followed later in the year by small round red fruits. Pond spice is a plant of shallow fluctuating waters, but I have never developed a feel for its exact habitat. In the Swamp it is a plant mainly of ponds and shallow marginal areas near the edges. Other than the fact that it is related to red bay and spice bush, I do not know the origin of its name.

Were we to attempt to do justice to the diversity of herbs in the Swamp, we would need several volumes. But there are a number that we must mention. Which of the many herbs most typifies the Okefenokee? There is no species that occurs only here. But to me, there is one that comes to mind first when I think of the Swamp. It is the neverwet, or golden club. This species seems to occur in some numbers in nearly all of the Swamp's habitats. It cannot grow in deep shade, but may be found in sites with scattered trees. In the early spring, often as early as late February, the blunt golden spikes of tiny flowers thrust up from beneath the water. Later, round green fruits develop. Many who know the golden club do not realize that it is a relative of another favorite herb, the jack-in-the-pulpit. In the golden club, "jack" is yellow and has misplaced his pulpit.

Typical of the swamps and wet places of the world are the water lilies. In the Swamp, two types of water lilies occur, and often dominate the wetter prairies. Both have large round or oval leaves, which may float on the water. Beyond that their similarities end, although both are referred to as "bonnets" by people in the region of the Swamp.

The fragrant water lily, with white flowers like floating roses, is the plant that usually comes to mind when water lilies are mentioned. It has floating round leaves with a slit. The stalks of the leaves are flexuous, preventing the leaf from ever standing erect or protruding from the surface. The flowers and leaves of the fragrant water lily seem to vary in size with water depth, smaller types occurring in the shallows.

Spatterdock, or splatterdock, also called cow lily, has heart-shaped leaves and yellow cup-shaped flowers about an inch and a half across. It comes in several forms in the Swamp. One type has robust stiff leaves whose heavy stalks allow them to stand erect and protrude from the water surface. Other plants have weaker leaves which float on the surface or are submerged. Occasionally, plants with long floating arrow-shaped leaves may be encountered.

One of the herbs which shows that Okefenokee boggy habitats have some affinities with the bogs of northern North America is cotton grass. Cotton grass is really a sedge. The main stem is beneath the surface, but the stalk, leaves, and flowering parts stand erect to several feet in height. The fruits possess tawny cottony bristles which make the fruiting head resemble a cotton boll. Cotton grass grows only in the Okefenokee in southeastern Georgia. To the north, the closest sites are in northwestern Georgia and the Carolinas. In the northern bogs, this same species and other cotton grasses occur.

If there is a single group of plants that all with an interest in natural places love, it must be the orchids. For some reason, when "orchid" is mentioned, the response is different than when one points out a "legume" or "milkweed." The reason for this may lie in the strange beauty of the flowers, in the rarity of some species, or in the fact that cultivated orchids used in corsages and bouquets are known to all.

There are bogs in northern North America where twenty orchid species flower in one small area. Although this number cannot be approached at any single site in the Swamp, at least this many can be found in the area. Most orchids have a specific flowering season. In the Swamp, the flowering peak of the white rein orchid, the whitest

Two types of water lilies are indigenous to the Okefenokee Swamp. One is the yellow pond lily, also known as bullhead or spatterdock (*Nuphar luteum*). Suwannee River Narrows.

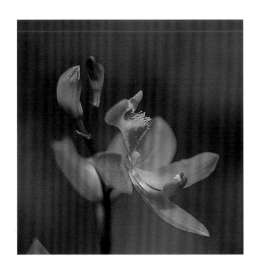

Grass pink (*Calopogon tuberosus*), common on the edges of the swamp, is in the orchid family. Chesser Island.

of all of the Swamp's flowers, is about mid-July. The rose pogonia, with its snake-like mouth, produces flowers from early May to mid-August. Several species of ladies tress orchids exhibit their twisted stalks of delicate flowers from April to early fall. In late summer the brilliant flower clumps of the yellow fringeless orchid dot the moist pinelands.

A relatively large number of Okefenokee plants are carnivores. Many are surprised when told that the southeastern United States is one of the world centers of carnivorous plant diversity. They think of carnivorous plants as tropical oddities, or believe that, like the "man-eating tree of Madagascar," they exist only in folklore. Five types of carnivorous plants occur in the Southeast. The only general type not represented in the flora of the Okefenokee is the Venus flytrap. Its native range is restricted to the coastal areas of the Carolinas, even though plants have been introduced to many other areas.

Three carnivorous pitcher plant species live in the Okefenokee area. Pitcher plants have tubular leaves which trap and digest insects and other animals. Out in the Swamp, especially in the prairies and on the batteries, the hooded pitcher plant is the most conspicuous type. It has erect pitchers with hoods that curve down conspicuously over the opening. Around the edges of the swamp, it may occur in habitats that are relatively dry. Clumps may often be found on roadsides.

The parrot pitcher plant has pitchers that recline on the soil. The hood is swollen and rolled over the opening, creating a vague resemblance to a parrot's beak. This species is also found on the floating batteries and is abundant in boggy areas around the edges of the Swamp.

The third and largest pitcher plant species, the yellow pitcher

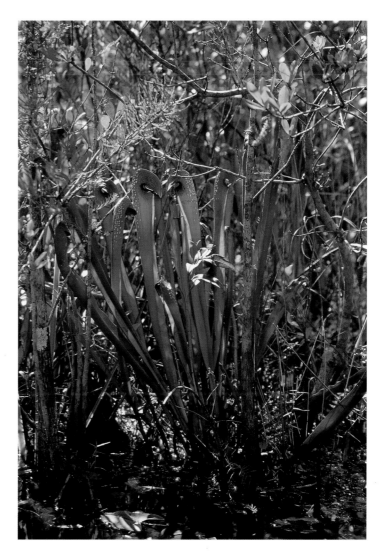

Giant hooded pitcher plants (*Sarracenia minor*) in Sapling Prairie.

plant, frequently called "trumpets," does not occur in the interior of the Swamp. However, in the moist pinelands and boggy depressions around the edges, it is often conspicuous. Its yellowish-green pitchers may be nearly a yard tall. The tube is wide enough so that butterflies and other large insects may be trapped. A red spot is often present in the throat of the pitcher, beneath the large flat hood.

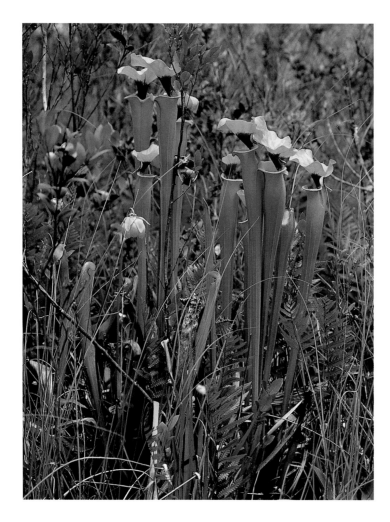

Trumpet-leaf pitcher plants (*Sarracenia flava*) on Cowhouse Island.

The sundews are a group of plant carnivores that trap prey on sticky hairs borne on the leaf surfaces. In the Okefenokee area, the common species is the pink sundew, which consists of small pinkish clumps of spoon-shaped leaves, about an inch or two across. The water sundew, with longer spoon-like leaves coming from an upright stem, also occurs. The dew threads or thread-leaved sundew pro-

duces what appear to be cylindrical leaves up to a foot long. Shimmering clumps of this species are often easily noticed. Dew threads trap large numbers of gnats, more than a thousand of these tiny insects once being found stuck to a single leaf. In somewhat drier areas, often in the pinelands, the dwarf sundew may be found. It is tiny, like the pink sundew, but has spatula-like leaves.

Butterworts are less known than other carnivorous plants, perhaps because their appearance yields little evidence of their carnivorous habits. They have circular clumps of flat leaves, sometimes inrolled at the edges, which trap insects on nearly microscopic sticky hairs on the surfaces. Three species occur in moist habitats and pine barrens in the Swamp area. Two are larger. One of these has blue flowers with conspicuous blue veins. The other has flowers of a vivid yellow. The third species is so small that it is seldom seen except when in flower. It produces clumps of leaves only about an inch across and has small flowers varying from yellow to white.

The Swamp is prime habitat for the bladderworts, a group of carnivorous plants which trap small animals in tiny bladders borne on stem-like parts beneath the water or in the soil. Bladders have tiny one-way doors surrounded by sensitive trigger hairs which when stimulated cause the bladder to expand rapidly, sucking in insect larvae, water fleas, and other minuscule prey items.

I have seen six species of bladderworts in various habitats in the Okefenokee. Two or three more probably occur. Four of the common species are aquatic, masses of millions of bladders occurring on underwater branches. One, with wheel-like floats at the base of the flower stalk, flowers abundantly in the early spring, turning many ponds a bright yellow. Another species produces purplish flowers throughout the year. Two others, sometimes called "fire grasses," bear yellow flowers, and tend to occur in shallow muddy or peaty areas. Two more are found in moist sites on land. One has tiny flowers on stalks only a few inches tall. The other bears flowers with lower spur-like projections on stalks up to nearly a foot tall.

I shall not bother you with the details of my calculations, but in a year's time, the bladderworts of the Okefenokee capture and digest

at least 400,000,000,000 small aquatic animals. This amounts to a weight of perhaps five hundred tons of prey. Sometimes it is hard for us to appreciate the significance of small events in nature unless we have some feeling for the totality of their effects. This information takes on a more personal meaning if one keeps in mind that many of the animals caught are larval mosquitos.

Swamp habitats support a variety of vines, including at least twenty species. In most areas, every tree bears at least one climbing, dangling, twining, trailing, or clutching vine. Vines are basically small plants, without much body mass. But most need high levels of light and cannot survive or produce flowers and fruits if their leaves are in the shade. Being a vine is the solution to their predicament. They climb to the light.

Catbriers of one kind or another are among the commonest of the Okefenokee vines. I have come across at least seven kinds in the Swamp, and there may be more. Catbriers climb by using tendrils, string-like or thread-like structures that wind around anything they come in contact with. Their stems are often tough, cord- or cable-like, and may be covered with stiff thorns. One of these, called black bamboo by people of the Swamp, is sometimes called blaspheme vine. My most blasphemous encounter with it involved chasing a black racer into a thicket and having to extract a length of spiny blaspheme vine from my cheek skin before I could leave. The racer escaped, and would undoubtedly have grinned, had his anatomy allowed.

Another common vine in the Swamp is poison ivy, a plant that deserves considerable admiration. It can grow as a small herb-like plant, as a shrub or small tree, or as a rather large vine that may climb to great heights. Climbing specimens use suckers, outgrowths with disk-like adhering portions which cling to bark and other surfaces. It is often said that plants that produce a dermatitis are protected from grazing animals who have suffered the irritation and itching and are not willing to go back for more. This makes some sense at first, but there is little evidence that poison ivy is irritating to animals other than humans. Clearly, further investigation is needed.

The Okefenokee Swamp is not rich in species of epiphytes, those plants which grow on other plants, usually on the branches of trees. Epiphytes are small plants which have solved the problem of needing light by growing in high places where the light intensity is higher than it would be on the ground below.

Five species of epiphytic higher plants inhabit the Swamp. By far the most common of these is Spanish moss, that odd bromeliad that is neither Spanish nor moss. Spanish moss is essentially a midget pineapple in which the parts of the stem between the points where leaves are attached have become long and stringy. The gray appearance is the result of a covering of whitish hairs which help to absorb water and reflect excess light. Spanish moss is metabolically inactive most of the time, growing mainly after rains. It is typically a plant of humid sites and tends to be abundant near or over water. Like all members of its group, it produces flowers and fruits. It is rumored that these are uncommon, but I see many every year. Closely examining a hanging mass of Spanish moss will usually reveal them.

Bartram's bromeliad is a Swamp rarity, being confined to a few sites in the eastern portion. It produces clumps of quill-like leaves of around a foot in length. It typically grows on horizontal tree branches over water.

Although there are around thirty species of epiphytic orchids in the Everglades–Big Cypress region, the Okefenokee has only one, the relatively common greenfly orchid. This orchid appears to grow from the trunk or branch of a tree, often a swamp tupelo. The elongate leaves with narrow stalks dangle in many directions from a basal stem which is firmly attached to the bark by fibrous roots. Flowering, which may occur at almost any time in the warm season, produces stalks of rather small, inconspicuous, usually greenish flowers. The tissues of most epiphytic orchids are too delicate to tolerate the low temperatures of the Okefenokee winter. How the greenfly orchid manages is not known.

The last of the epiphyte denizens of the Swamp is the common resurrection fern, a small fern which grows on tree trunks, branches, and at times on rocks or roots on the ground. The resurrection fern

The Miracle of the Neverwet

There is something about plants of the arum family that seems to make them enigmatic or bizarre. The ponderous titan arum, or bunga bangkai, of western Sumatra produces the largest unbranched flowering mass in the plant kingdom, often ten feet or more tall and bearing thousands of flowers. It also produces one of the most disgusting odors emitted by any organism. The skunk cabbage of eastern North America produces enough heat to melt its way up through the snow in the early spring. Jack-in-the-pulpit plants change sex from year to year depending on conditions. The cuckoo pint of Europe traps its pollinators for days before releasing them to carry pollen elsewhere. In the Swamp, the commonest member of this curious group is the neverwet or golden club, although the exquisite whiteness of the spoonflower and the arrow-shaped leaves of the green arum are also common in some areas.

The thick stems of the neverwet lie anchored deep in the bottom mud. I have tried to pull up a stem several times and have invariably been discouraged or had to work for several minutes to dislodge the plant. It is anchored in the mud as if by steel cables. From the hidden subterranean stems grow a number of green, elongate leaves. The leaf stalk is often a foot or more long and is usually white at the base. The upper leaf surface of the neverwet, as the name implies, sheds water and cannot be moistened. But rather than possessing a luster like the waxy surface of water lilies and many other plants whose leaves shed water, the leaf surface of the neverwet is dull, showing only an inconspicuous burnish in some lights. There must be something about the covering of this leaf that causes water to bead and roll off without wetting it, but I had never been able to see it, even by peering closely. So, recently I took a few leaves back to my laboratory and subjected them to close scrutiny under my microscope. When a leaf is magnified sixty

times, the mystery of the surface is revealed. The top of every cell on the upper surface of the leaf is a tiny dome. When I first looked at the magnified leaf, the cells reminded me of the clusters of round huts which are found in villages of the Shilluk tribe in the southern Sudan. I even considered coining a name for the cell shape based on this resemblance—"shillukecoid"—but soon thought better of it. Even those who love the obscure and cryptic would probably find this word cumbersome.

The microscope has revealed the secret of the neverwet. The cells protrude as minuscule nipples, hundreds of thousands to the square inch. Droplets of water have too much cohesion to extend into the depressions between the nipples and hence wander about as flattened silvery globes, supported by the tips of the nipples, lacking any real contact with a significant amount of leaf surface. Eventually they succumb to gravity and roll off the leaf.

The undersurface of the leaf is very different. Near the edge of the upper surface, the cells lose their dome-like shape and become broader and flatter. The edge of the leaf is sharp and blade-like. On the lower surface the cells are typical of plant leaf surfaces, flat and quadrangular. They have neither wax nor a group microstructure which prevents wetability. In fact water adheres to the lower surface remarkably well. If one considered the lower leaf surface alone, the golden club could be called the "alwayswet."

I have looked closely at thousands of neverwet leaves in nature and now have examined a dozen or so under the microscope. Seldom do any items clutter the upper surface. Few insects, spiders, or snails attempt to traverse the roughly pebbled veneer. They seem to have as much difficulty with footing as do the droplets. But the lower surface, much of which is submersed most of the time, has a varied and abundant fauna. In fact, the lower surface presents a world of life different from any other. An insect that I have not seen, probably the larva of a beetle, eats out the lower layers of leaf cells, leaving only the top layer of nipple-like cells. Whitish patches appear on the leaf wherever this has happened, for the upper layer is mainly protective and lacks the

greenness imparted by chlorophyll. Other animals colonize these chewed-out depressions. Small mites with stiff hairs protruding behind wander about, feeding on the invisible. Water fleas, tiny seed shrimp, and scuds jerkily wander here and there. It is the only place that I have seen that strange, slowly revolving, green protist, *Climacostomum*, its one cell nearly as large as the many-celled bodies of some water fleas. At times, a velvet water bug stalks slowly along. The humped shells of freshwater limpets cling tightly to the undersurface. Many leaves bear waving tentacled forms of the green hydra. The undersurface is churning with life.

We marvel at the machinations and feats of humans but seldom realize that nature has already devised solutions to problems that we have yet to conceive of. The neverwet has solved one problem of its amphibious life by making its upper leaf surface intricately different from the lower, allowing the leaf to float and preventing the upper surface from drowning so the minute openings in it can imbibe oxygen. It is to some of the smallest parts that we must look to understand the miracle.

No matter what the scale, when we look at nature it is always miraculous. The view of the earth from the moon, the Swamp from a lingering helicopter, the fragile waving of the ladies tresses in the prairie, the flash of a cardinal in the hammock, all evoke an awed response. And the leaf of the neverwet is a world of natural history in itself. If we could wander through the innards of a cell, stroll among the folds of the endoplasmic reticulum, jump from ribosome to ribosome, or climb the spiral ladder of DNA, the experience would be one of wonder. At all levels nature is ineffable.

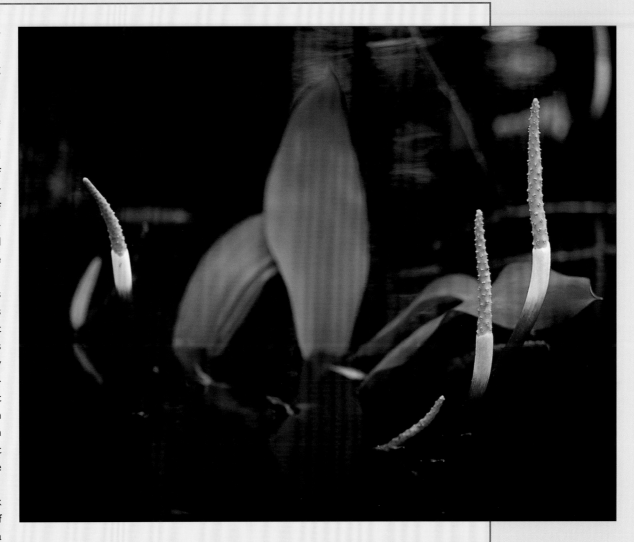

Golden club spike in the Middle Fork of the Suwannee River north of Billys Lake.

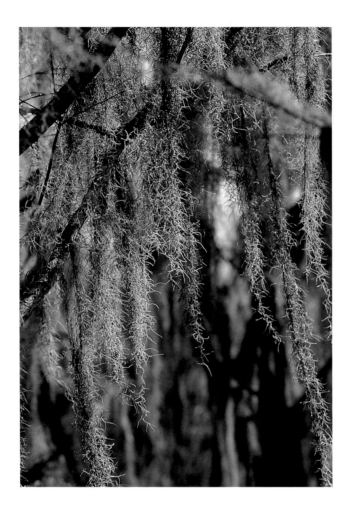

Spanish moss is an air plant that gathers its food from airborne moisture and nutrients. Chesser Island.

Named for the famed naturalist William Bartram, Bartram's bromeliad can be found in few areas; two are in the Okefenokee Swamp. Camp Cornelia.

sustenance from the trees that it parasitizes. However, it is green and can make some of its own food by photosynthesis. Mistletoe parasitizes mainly hardwoods, especially oaks. However, it is known to grow on over forty species of southern trees and occasionally may pop up on almost any tree. Mistletoe flowers in the spring and produces its glistening white fruits in the fall. Birds disperse the seeds by eating the fruits and leaving droppings on branches or by getting the glutinous fruits stuck on their beaks and rubbing them off on branches. Mistletoe is a beautiful and interesting plant with a rich cultural history. Like all parasites, when viewed in the proper context it is a wonderful organism. Near my home is a water oak with over fifty clumps of mistletoe on the branches. The water oak is healthy. The mistletoe is healthy. In the winter this tree still shows a lot of green, a welcome sight among the browns and greys in that season of short days and long nights.

The Okefenokee is a massive sponge, oozing water in two directions into the seas. Its sponginess largely derives from the masses of sphagnum moss, which in some areas seem to be nearly overflowing the swamp. Sphagnum is only one of the "lowly" plants of the Swamp. There are many species of mosses inhabiting the area, growing in water, on soil, and on the bark of trees. However, the so-called "moss" which grows on the north side of trees is not a moss at all, but is a type of alga. Although there is a tendency for it to inhabit the north side as a result of the sun's drying rays normally coming from the south in the northern hemisphere, wind direction and other factors can influence the side of the tree on which it grows.

In the Okefenokee, the bark of trees sometimes seems to be covered with grey splotches, within which are curious script-like messages. These are the bodies of the graphis lichens, strange combina-

derives its name from the fact that during periods without rain, the leaves coil, crumple, and appear dead. When the rains come, the leaves expand, become green, and seem to have arisen from a dead state.

Although not simply an epiphyte, mistletoe is very common in the swamp. In the winter it is obvious on the leafless trees as dense evergreen clusters. It is more abundant in open forests than in more densely wooded sites. Mistletoe lives by getting a large portion of its

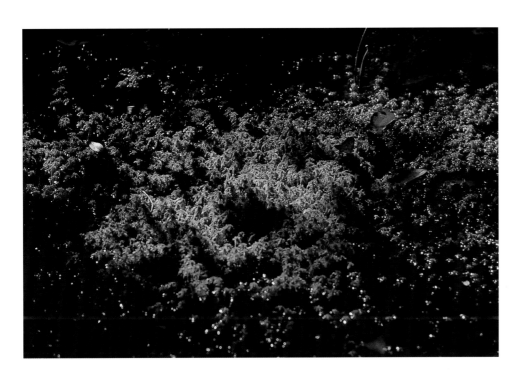

Lichen in Big Water.

Sphagnum moss acts like sponge, absorbing a great deal of water during wet periods and then releasing it slowly in a drier season, providing nourishment for the surrounding area. It is common throughout the swamp. Chesser Island.

tions of alga and fungus that exist as a living paint. On the bark of oaks, one can find the gold-lined lichen whose underside of bright yellow is normally hidden from all but those who know to look. The red blanket lichen makes bright scar-like blotches on the trees it inhabits, normally cypress. Tufts of the common beard lichen sometimes make dead branches of the titis appear to be furred with white.

In the fall, masses of algae produce floating bubbly mats among the trees and shrubs. Under the microscope, the verdant crescents of the desmids, the swarming flagellated euglenas, and the mazes of the waternet make us realize that there are plant worlds which we seldom think of. Strands, threads, cords, and hairlike fuzzes of fungi pervade the places of decay, helping to return materials and compounds back to the living. Beneath the bark on the rotten log, the

giant amoeba-like mass of the slime mold oozes, preparing to thrust up its ornate cups of spores.

How can one describe in words even a single plant, much less the teeming plant life of a swamp? They toil not, neither do they spin. This expresses our sentiments about the inanimate nature of plants. At times we make the mistake of thinking that plants are not alive, that they are mere decorative props which create a matrix, a stage on which the lives of animals take place. To know plants is to know otherwise. In their way, plants are as dynamic, as alive, as busy, as responsive as any animal. It is the life of plants with which we must empathize to have a feeling for the pulsating existence of the Swamp. It is the achievements of the plants that make the Swamp so precious and unique.

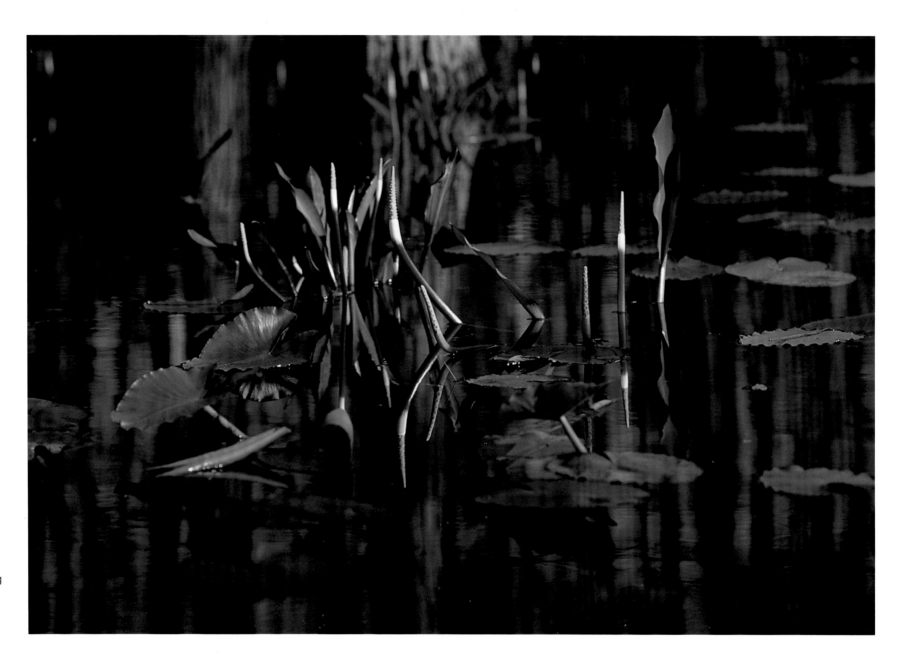

Golden club (*Orontium aquaticum*), also known as neverwet, presages the coming of spring with its blanket of colorful spikes in February. Middle Fork, Suwannee River.

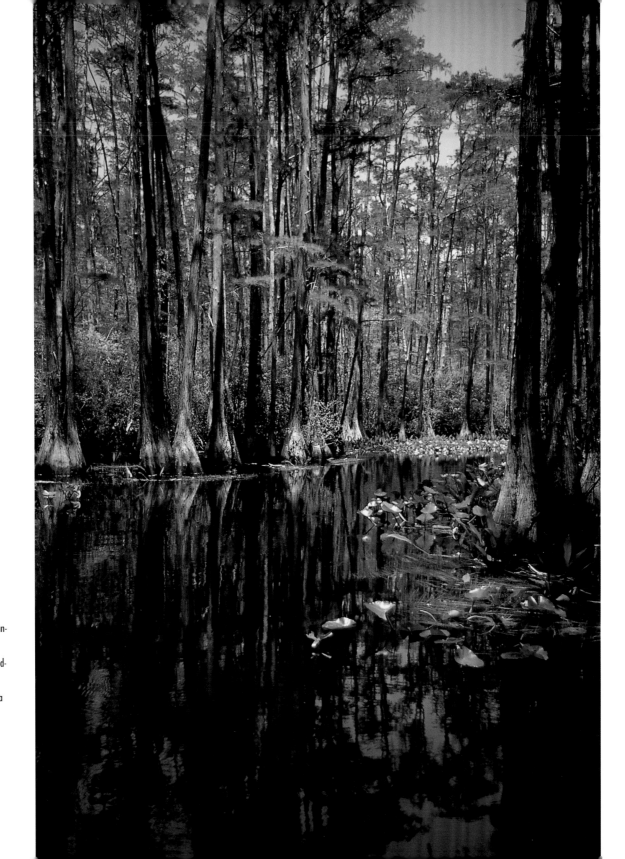

The Middle Fork of the Suwannee River Narrows. The tall trees and water passage winding among large cypress trunks and knees make for a magical panorama.

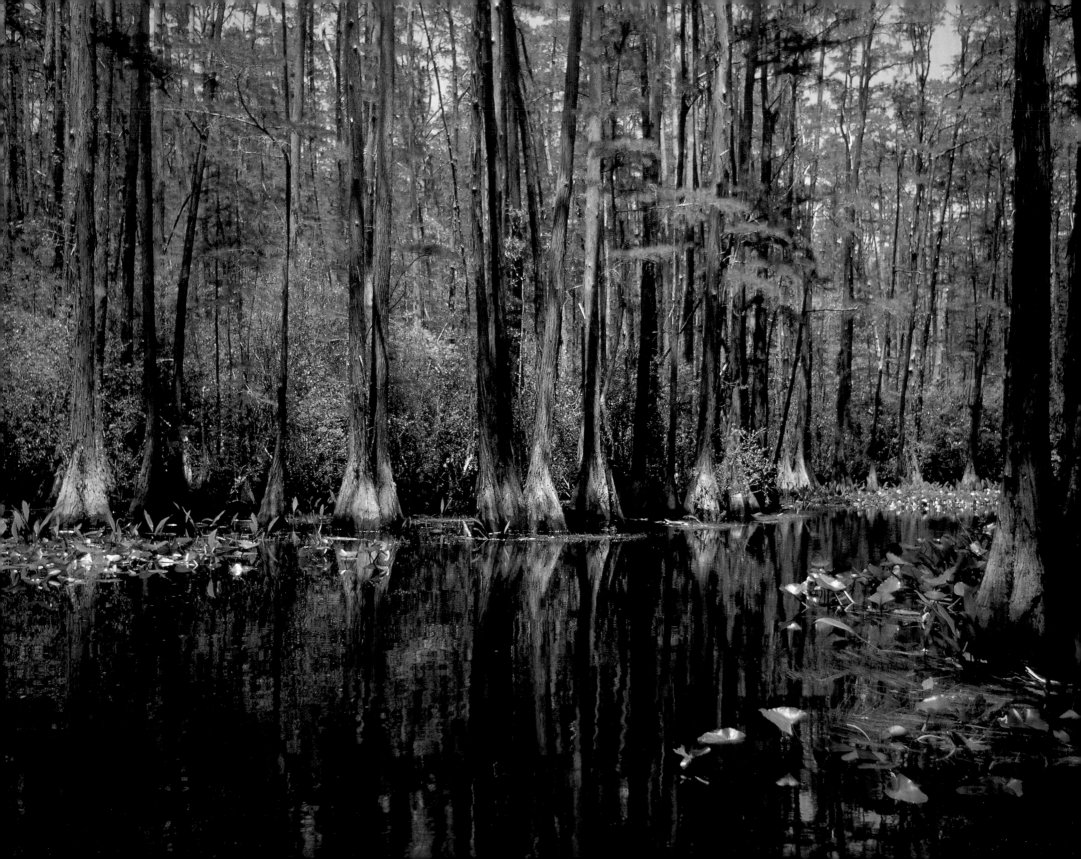

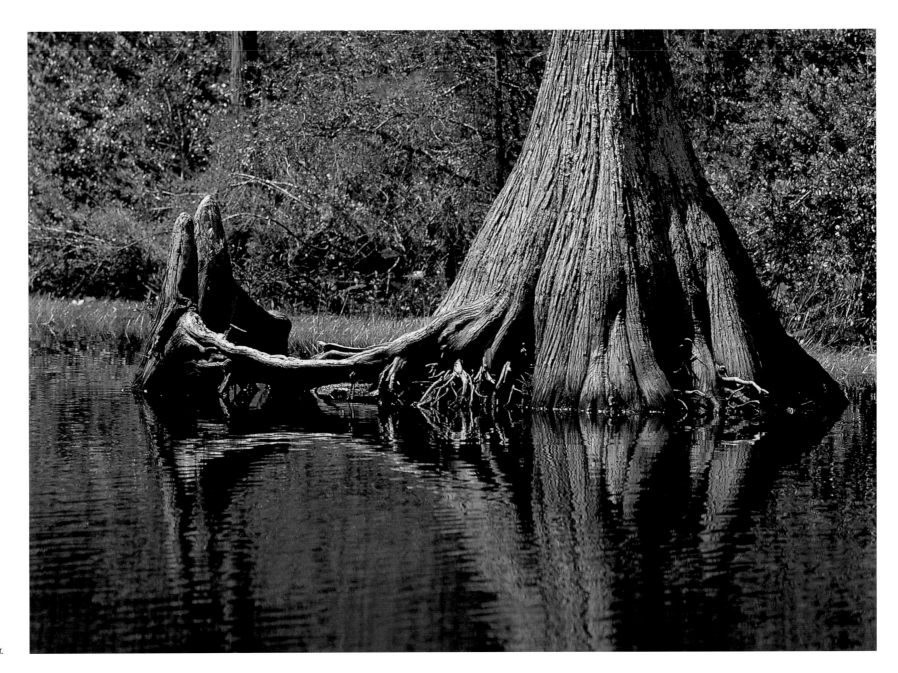

< The Middle Fork of the Suwannee River, going north into the narrows to Minnie's Lake, is a place of haunting beauty.

A pondcypress stump in low water with its knees showing. The knees provide a support system for the tree. Big Water.

The southern blue flag iris (*Iris virginica*) is a lovely sight in the open areas of the Middle Fork of the Suwannee River as well as in the eastern water prairies. Middle Fork, north of Minnie's Lake.

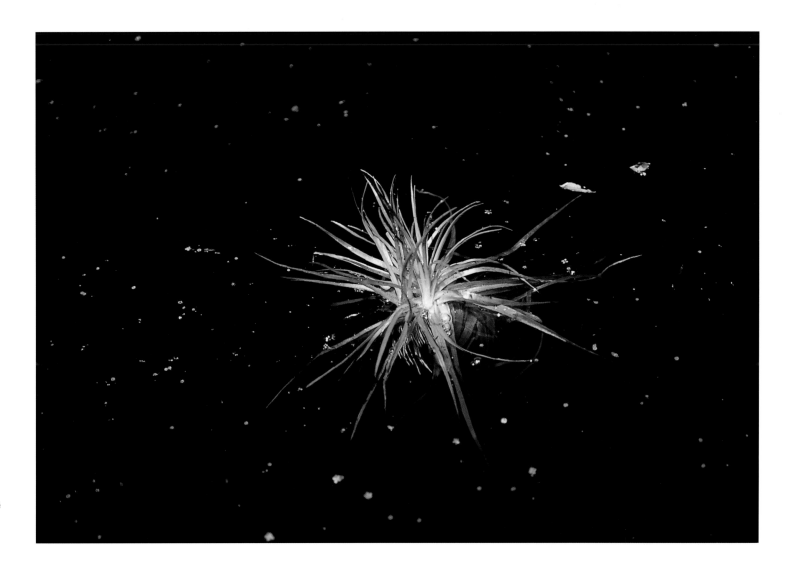

The migration of plants via
the water flow is a valuable
means of colonization.
Suwannee Canal.

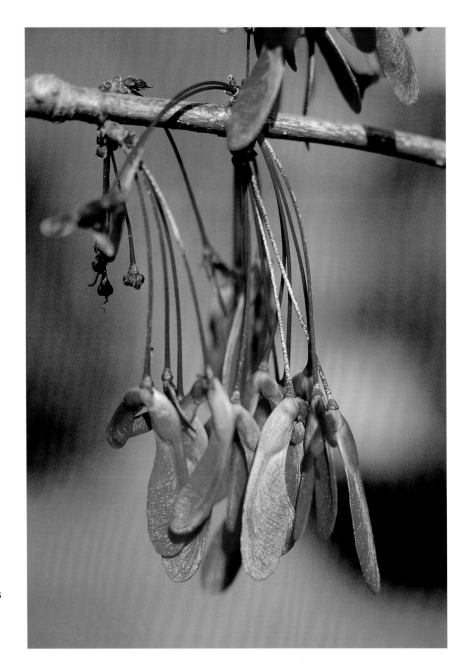

Red maple (*Acer rubrum*)
seeds. In the fall the strong
reds of the maple contrast
with the soft browns and golds
of other swamp foliage.
Obediah's Homestead,
Waycross, Georgia.

Pondcypress needles in late
fall. Cowhouse Island.

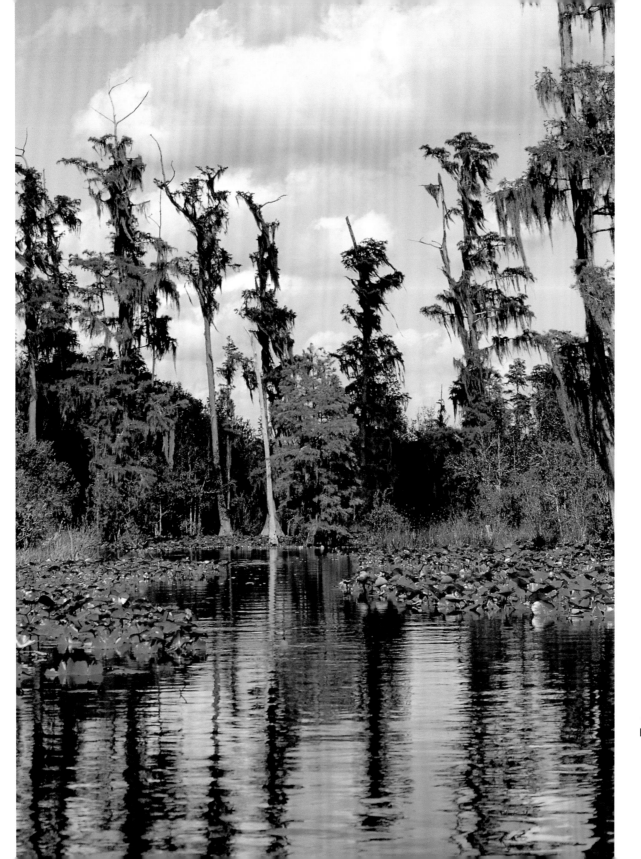

Minnie's Lake on the Middle
Fork of the Suwannee River.

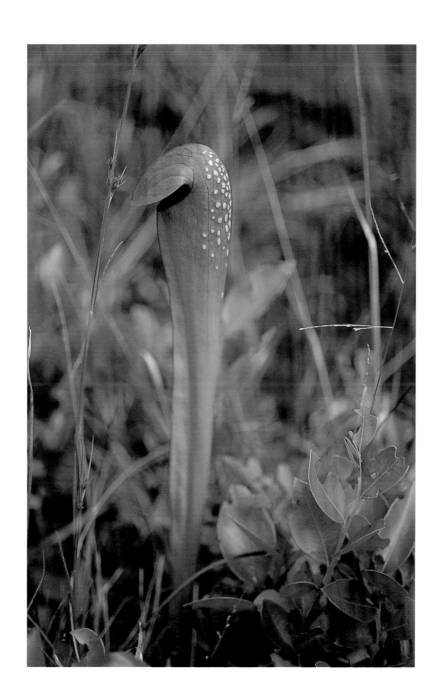

Giant hooded pitcher plant. Plants this large are rarely found outside the swamp. Near Cowhouse Island in Sapling Prairie.

The Swamp's Green Foundation

Sphagnum, or peat moss, is one moss that can be recognized as such by almost anyone. The common name "peat moss" comes from the fact that remnants of sphagnum are often the most common component of the preserved masses of undecayed plant remains that we call peat. Sphagnum is not just one kind of moss. About thirty types occur in North America, and there may be a half dozen or more species in the Swamp. As with nearly every plant that crosses my mind, I am tempted to call sphagnum marvelous, and it is. Sphagnum is beyond my understanding, a plant truly described by superlatives. It is a kind of super-moss. The body of a sphagnum plant is filled with spaces, even down to the level of hollow cells perforated by pores, which can be permeated by fluid, allowing a dry but undecayed sphagnum plant to absorb over a hundred times its dry weight in water. The plants can dry out, revive, then desiccate again, revive, and again dry and come back to life over and over.

The sponge-like nature of sphagnum may be of great importance in certain parts of the Okefenokee. Water delivered to the Swamp by runoff or rain is absorbed by masses of sphagnum which swell to take up more space. The gradual release of water from these mats controls, in part, the rate of downstream water discharge. During droughts, the water stored in the mass of moss becomes very important. When severe droughts strike, fires sweep through the Swamp, consuming the surface masses of sphagnum that have dried enough to be combustible. This not only alters the water-holding capacity of the Swamp, but may leave deep holes and depressions where none existed before. These are gradually colonized by the moss, and the cycle begins again. Although this may be the major way in which sphagnum affects the ecology of the Okefenokee, it is known to exert other influences. The cells of peat moss absorb nutrients, typically more than the plant needs

for its own uses. This reduces the amount of nutrients in the water, giving it a chemical composition more resembling distilled water that that of many lakes and rivers. Sphagnum plants also release into the water ions which intensify the acid conditions present, meaning that peat mosses partially control wetland chemistry. Peat moss clumps in the Okefenokee may grow by as much as two to three inches in a season, but the weight of the newly produced parts tends to collapse the clump down again.

Throughout history, sphagnum has been important to humans. Masses of sphagnum have antiseptic properties which caused them to be used in wound dressings in many conflicts. Peat derived from sphagnum stoked the home fires of many of the peoples of northern Europe for millennia, and still does in many areas. Peat moss has been used to stuff mattresses, has been formed into odor-reducing shoe insoles, and once served Native Americans well as an antiseptic diaper padding. Recently it has become important as a natural organic soil conditioner.

Peat mining has altered the ecology of many of the world's sphagnous areas, especially in the northern portions of Europe. The great flows of northeastern Britain, extensive lands covered with undulating blankets of sphagnum, have been nearly destroyed by peat mining. Closely spaced rows of trees grow where waves of peat moss once ruled. Peat has even been mined in the Okefenokee, the canal at Kingfisher Landing being the result of a peat mining attempt in the early part of the century.

Global temperature is related to the storage of peat in wetlands, because carbon dioxide is liberated into the atmosphere as peat is mined and burned or as peaty lands are cleared and oxidize. The increased carbon dioxide aggravates the greenhouse effect, and global warming increases. It is becoming apparent that to interfere with the natural processes of peat formation and destruction is to tamper with the health of the world.

Compared to what we know about the biology of many plants, sphagnum is relatively unstudied. But it is a plant easy to appreciate with only a little experience. The next time you visit the Swamp, peer

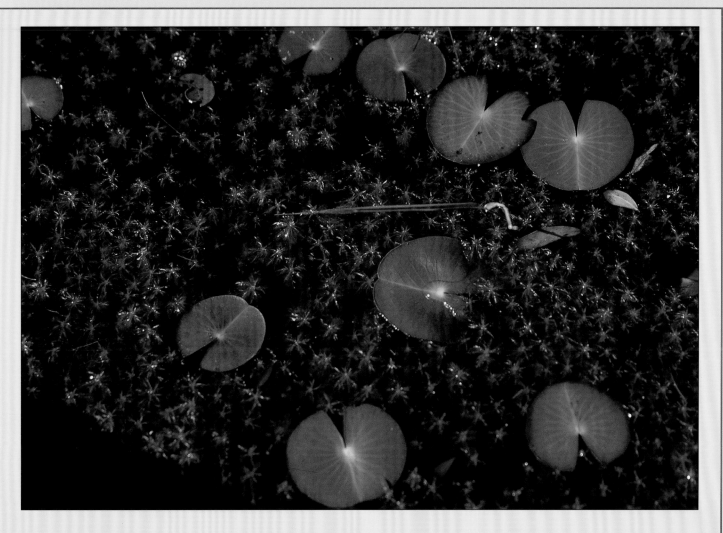

Sphagnum moss and water lilies in the northeast part of the swamp. Cowhouse Island.

closely at the masses of sphagnum to try to decipher the graceful symmetry. It is not easy. The leaf-like structures are arranged on the stem in whorls, in which it takes five leaves to circle the stem twice. Pick up a handful of sphagnum and look at it. You will notice that the bottom portions are dead and browned. Peat moss does not have and does not need roots. All parts of the plant can absorb materials from the habitat. Now squeeze the mass of sphagnum. The plant is more spongy than the sponges themselves. Sphagnum is the crowning achievement of the tribe of mosses. It is a main block in the Swamp's green foundation.

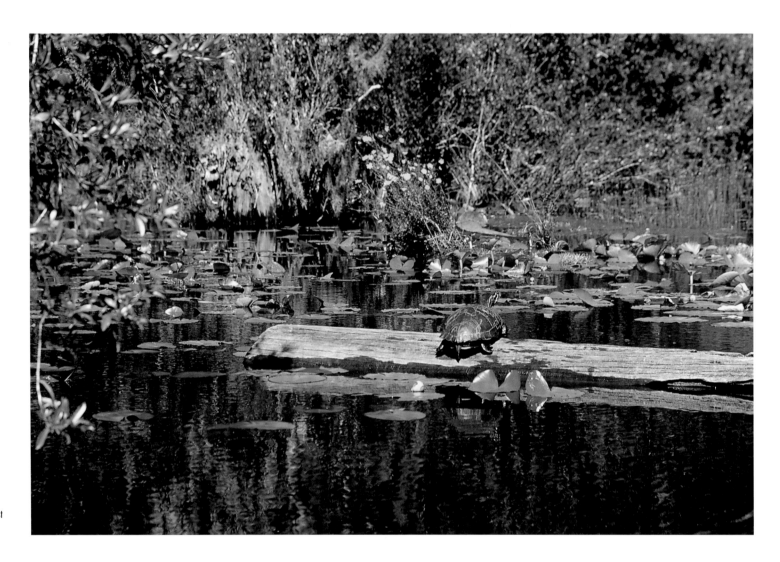

Turtle on a log in the
Suwannee River Narrows east
of the sill.

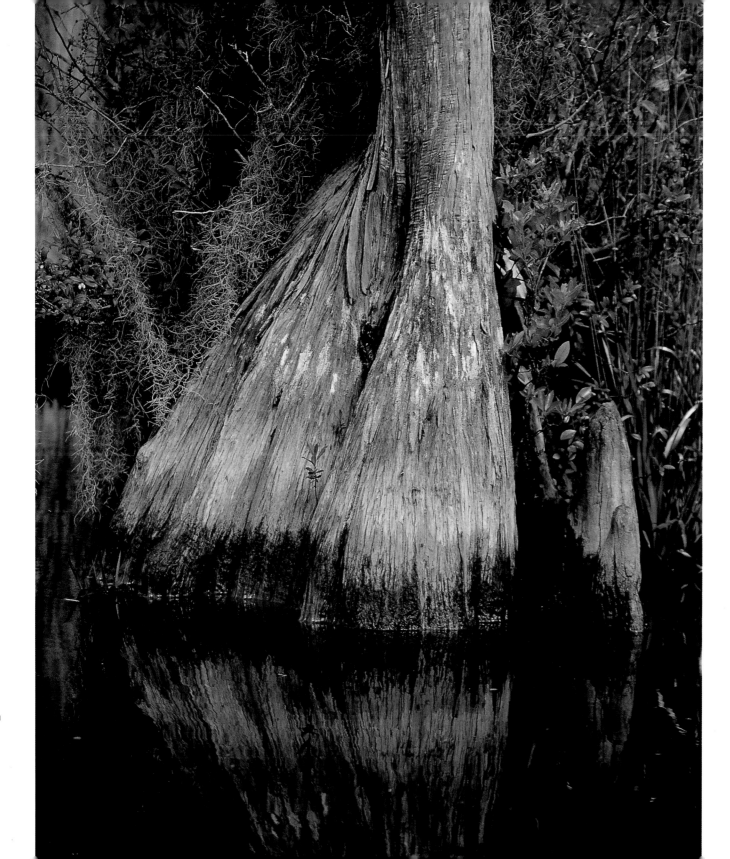

Pondcypress holding court in
Billys Lake.

Coral greenbrier (*Smilax walteri*) in the Suwannee River Narrows.

> Grand Prairie in average water flow. The eastern side of the Okefenokee Swamp is characterized by the vistas of open water prairies, while the western side contains the familiar cypress groves.

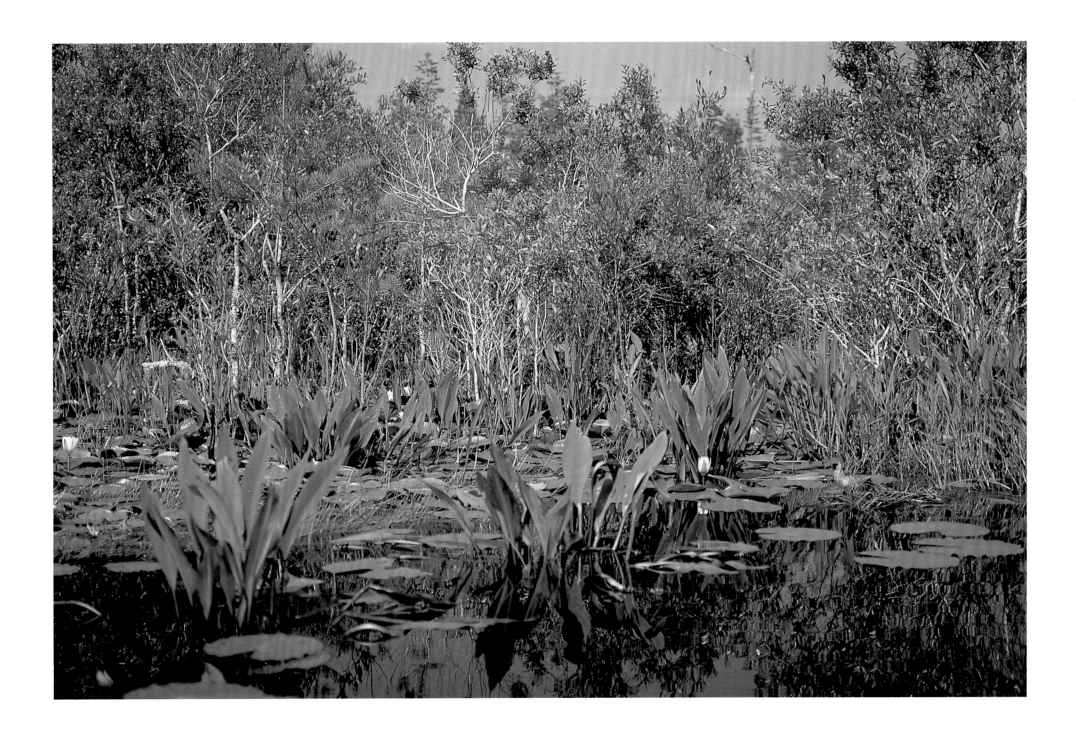

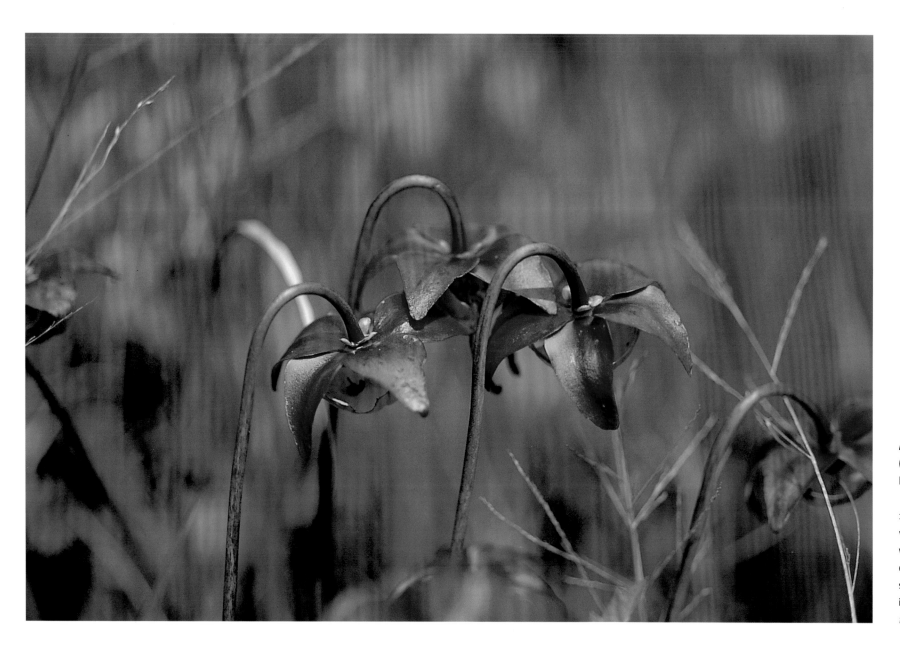

An insect-eating pitcher plant (*Sarracenia* sp.) on Chesser Island.

> At high water all of the vegetation in the swamp is waterlogged. At low water only small passages of streams are visible. Seen here is Walter's sedge (*Carex walteriana*). Chesser Island.

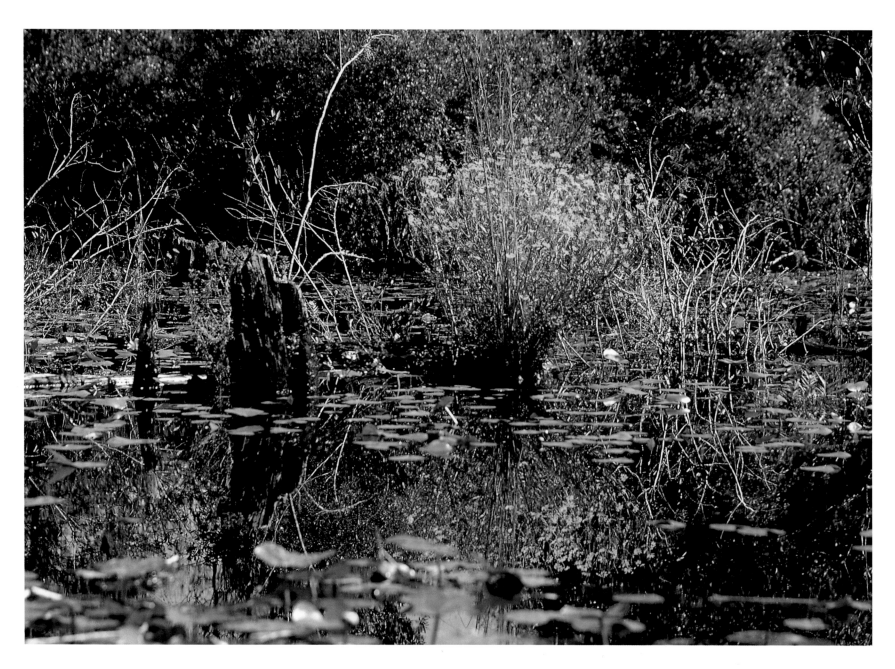

Beggar-ticks. The Suwannee River flow is quite strong at the river narrows, creating a path so that boaters can go to the sill.

> The Suwannee River overflow creates a lake between the narrows and the sill.

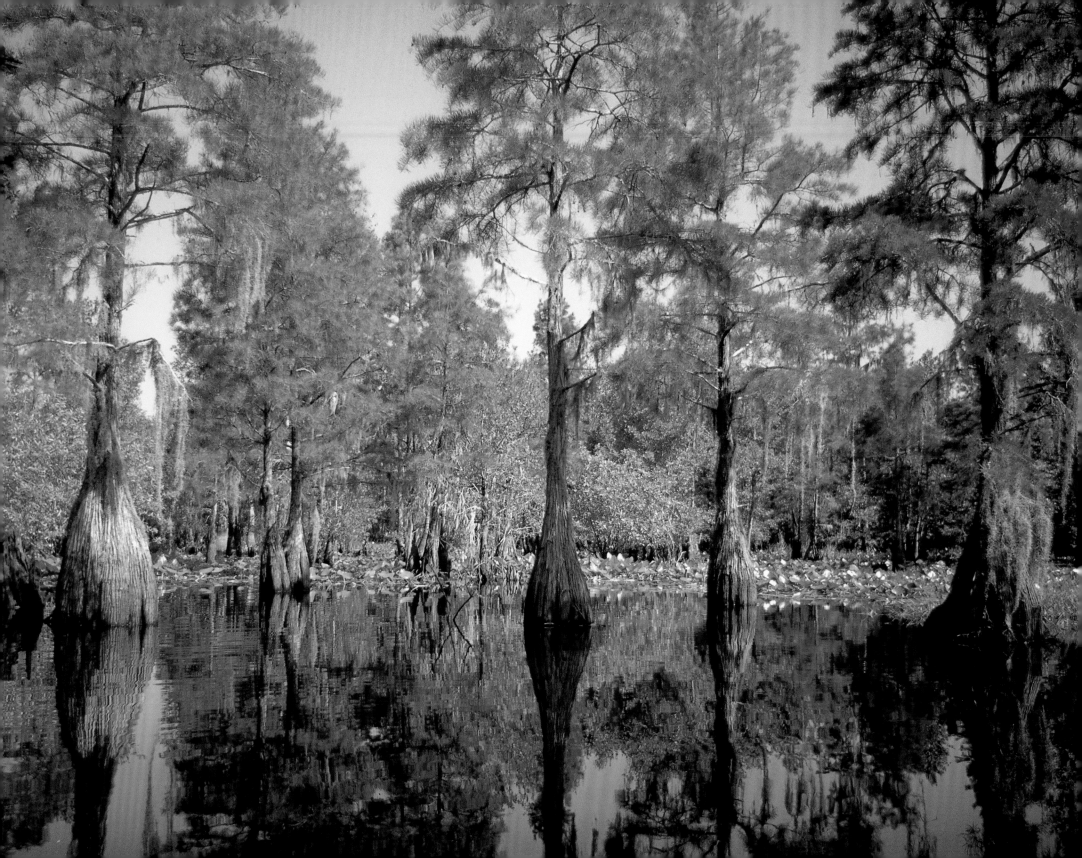

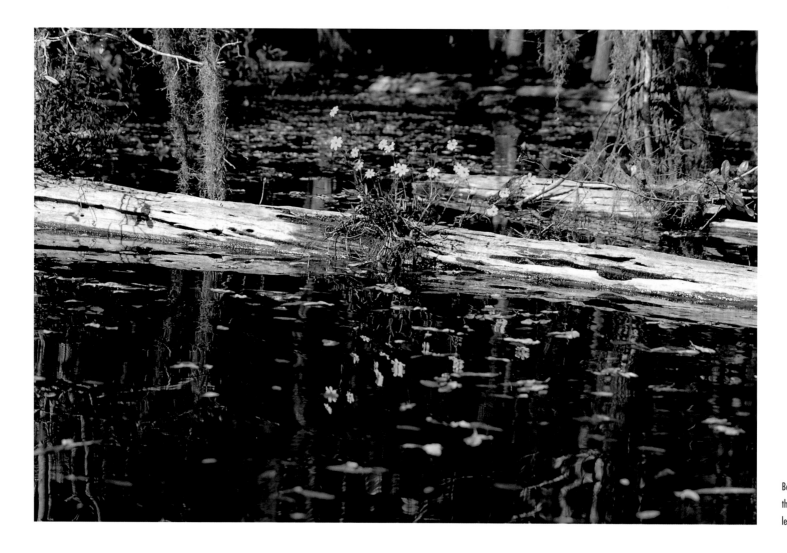

Beggar-ticks (*Bidens mitis*) in the Suwannee River Narrows leading to the sill.

> Fall brings the rich muted browns and golds in the pond-cypress stands. Suwannee River Narrows.

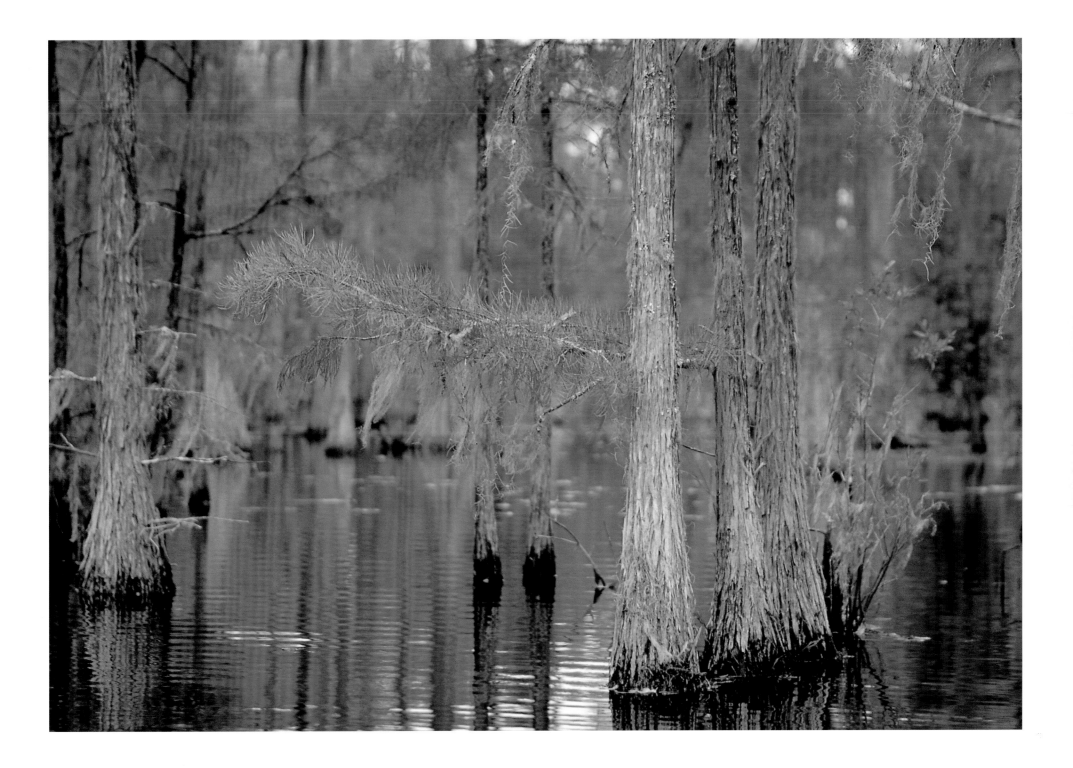

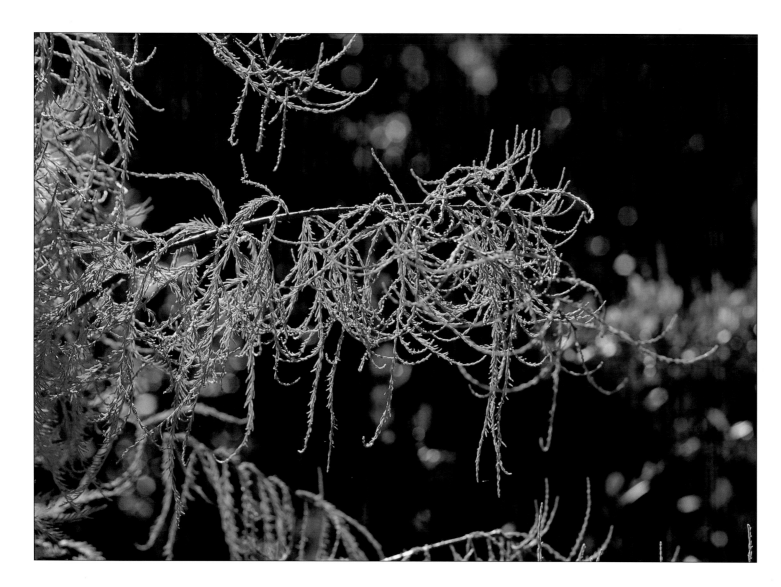

Pondcypress. Cowhouse Island.

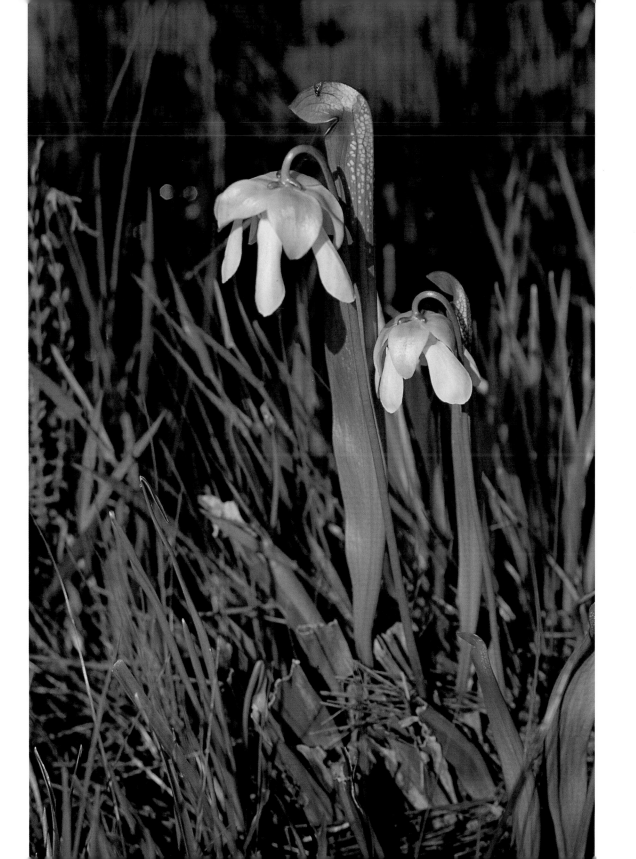

Hooded pitcher plant, one of
several insect-eating plants in
the swamp. Cowhouse Island.

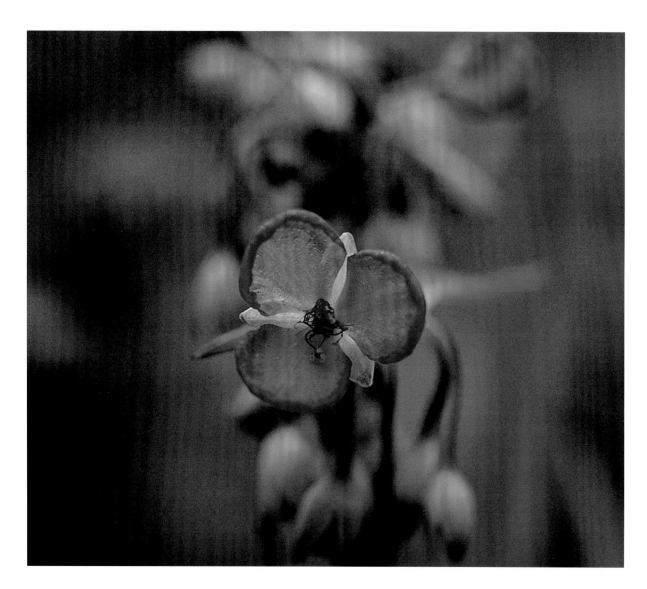

Spiderwort (*Tradescantia virginiana*). Chesser Island.

> Moss verbena (*Verbena tenuisecta*) on Chesser Island.

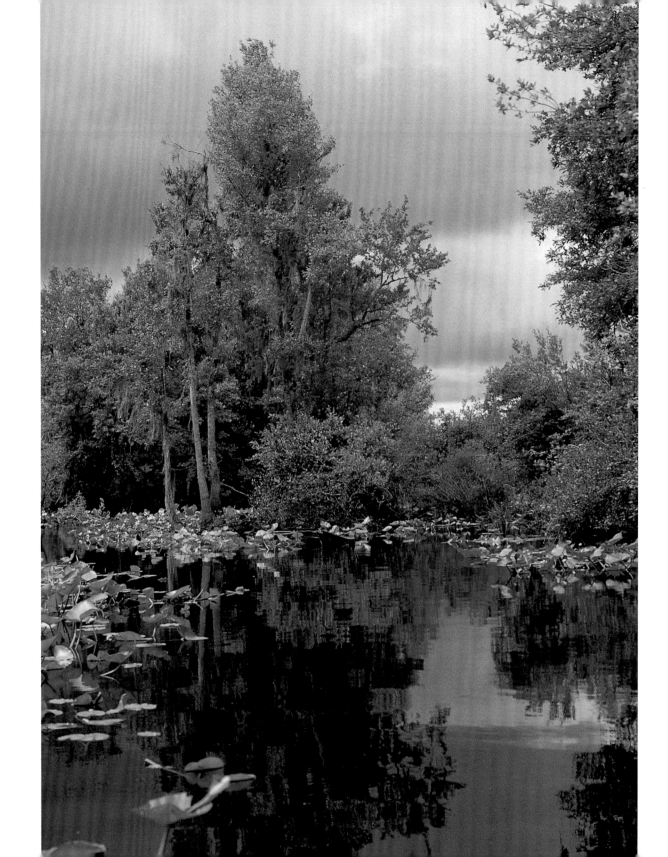

< The tea-colored water is quite free of bacteria, being acidic from the tannin emanating from roots in the swamp. Seen here is three-way sedge (*Dulichium arundinaceum*).

West of the Suwannee River Narrows going to the sill.

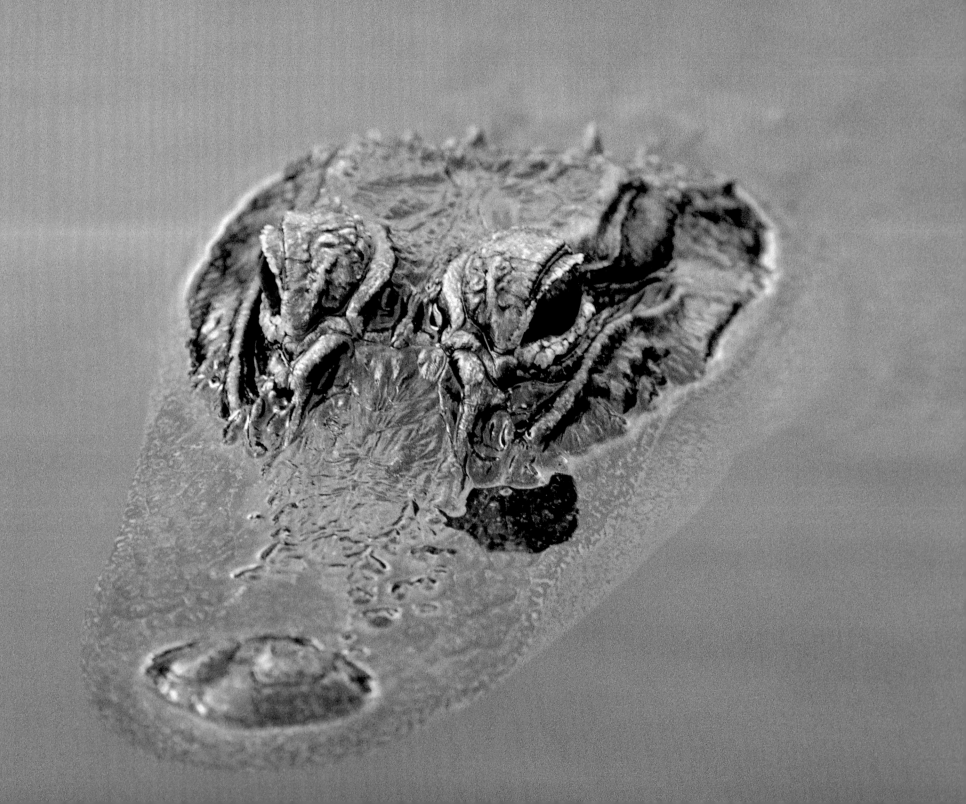

3 A DIVERSITY OF ANIMALS

THE NUMBER OF KINDS of living things that creep upon the earth cannot be exactly known; estimates range from a couple of million to nearly 100 million kinds. By far the greatest number of species occur in tropical regions, the rain forests being famous for their multitudes of species, now rapidly disappearing. A few years back a number of scientists got together and came up with a consensus value for the number of species on earth. The number they finally agreed upon, 13.6 million, is a good rough guess. Of these, probably 12 to13 million are types that we would call animals, the rest being members of the green and pallid kingdoms.

How many species live in a given area, like the Okefenokee, is to some extent dependant on the diversity of habitats and microhabitats that the place provides. Because the Swamp is a mosaic of habitat types and possesses several distinct plant communities, the area should be rich in animals. And it is. But the Swamp lacks significant topographic relief, has no rock outcrops, caves, cliffs, or natural rushing waters, so we would not expect as many species here in most groups as we would, for instance, in Great Smoky Mountains National Park.

By endlessly enumerating kinds we could attempt to mention most of the species here. This volume would then become a book of beetles, because there are probably at least twenty-five hundred species of these worthy insects in the Swamp. We are therefore constrained to meander and hop about among the animals, mentioning those that for some reason are typical, obvious, or of the greatest interest.

• • •

< An American alligator is a very protective mother. Chesser Island.

To many, the mention of the Okefenokee conjures up visions of a primeval and fearsome place, populated with large skulking predatory animals, many of which find humans particularly savory. Almost everyone who visits the Swamp is interested in seeing large predators, and some are satisfied with nothing else. With one exception, however, the average visitor is likely to be disappointed. Not only are large predators secretive, often nocturnal, and able to detect us before we know they are present, but persecution by humans has decimated populations of most sizeable carnivores in North America and has driven some to the fringe of extinction. Several no longer occur in the Okefenokee.

However, concerning one large predator, the alligator, most visitors are not likely to be disappointed. The Swamp is one of the places where catching sight of a gator during a brief visit is almost guaranteed. Many more are present than the average visitor sees. Except during the winter months, alligators are abundant enough in the Swamp so that it is hardly possible to miss them. Even from November through February, alligators can often be seen.

Twenty-two or so species of the ancient crocodilian lineage remain on the earth today, most in the Old World tropics. Although in the past, the American crocodile, now existing in the United States as a remnant population in southern Florida, may have occurred in the marshes near the mouth of the St. Marys River, today the only crocodilian native to Okefenokee country is the American alligator. Once in a while, spectacled caimans brought in as pets and subsequently released turn up in the Swamp.

The largest American alligator reliably measured is one of nine-

teen feet two inches in length. This makes the American alligator the sixth-longest crocodilian in the world, its maximum length exceeded only by the gharial of the Ganges and Brahmaputra, the saltwater crocodile of southeast Asia and Australia, the African Nile crocodile, the American crocodile of the New World tropics (including southern Florida), and the Orinoco crocodile. No alligators approaching the record size have been seen in the Okefenokee, but specimens approaching ten feet are not uncommon and a few larger individuals are present. Females seldom exceed lengths of more than eleven to twelve feet.

Alligators begin their breeding activity in the spring when water temperatures are warming. The bellowing of the males is the most conspicuous signal that the breeding season has started. The bellow of a male alligator, as it resounds through the Swamp, has a quality unlike any other sound. Hearing this low resonating sound is one good reason to visit the Okefenokee. Males are territorial and, if they can, keep other male alligators from invading their territory and having access to the several females with which they may mate.

By early summer, females begin to construct nests of a mound of decaying vegetation lined with mud. Females select sites which are not prone to being flooded. Cooling and lack of gas exchange resulting from immersion will kill eggs in a day or so. The construction of the sill greatly reduced water fluctuation in the Okefenokee and may have reduced flood-caused mortality to alligator nests in nearby areas. The sill also provides a relatively large expanse of firm ground for nest construction. The ditch along the sill provides open water. These may have been factors responsible for an increase in numbers of alligators in the Swamp.

The nest mound may be several feet high and six to eight feet wide. Females remain in the vicinity of the nest during the two-month incubation period and may attempt to drive away any predator threatening the nest. Okefenokee folklore is sprinkled with tales about the best way to get away from a female who has started to chase you after you accidentally stumbled on a nest. Zigzag running is commonly advised. In the few cases in which I have come upon a

< Little blue heron (*Egretta caerulea*) feeding in the Middle Fork of the Suwannee River

nest or a group of recently hatched young, the female has either not been apparent or has kept her distance. Baby alligators will often begin croaking when threatened or attacked, this sometimes bringing the attendant female.

The young tend to remain in the vicinity of the nest for a period, the female possibly remaining with them for up to three years. They are hard to see, their yellow banding camouflaging them so well that I once dipped up a small alligator accidently while trying to catch some whirligig beetles. The young eat insects and small fishes as they grow. As size increases so does the breadth of the diet, with large alligators eating almost anything, including carrion.

Are the Okefenokee alligators dangerous? Certainly! All crocodilians are capable of seriously injuring or killing humans. In the last half century, eight people were killed by alligators in the southeastern United States. The real question is, are the alligators in the Swamp likely to attack a human? In the late 1950s, my friend Al Skorepa and I swam uncaringly in the Suwannee off the dock on Billys Island. In 1968, when Al plunged into the water at the same site, an alligator that had been resting in vegetation about thirty yards away began to move in his direction. After Al hurriedly leaped out we both realized that a change in alligator behavior had taken place since our early visits. Humans had become common in the interior of the swamp again, there having been several decades during which few humans entered the Swamp interior. In the 1960s the number of fishermen and tourists increased. Fisherman fed alligators with fish that they didn't want, with leftover bait, and with the remnants of lunch. Tourists treated alligators like circus bears. As visitor numbers increased, many alligators in the swamp lost their natural fear of humans, and some, perhaps because of the artificial feeding, began to associate humans with food.

Humans are not typical items in the diet of the American alligator, although the size of large alligators enables them to easily prey on our species. Dangerous alligators are mainly creations of those who, in invading the alligator's habitat, have given them little choice but to behaviorally adapt to human presence. Blame for the pitiful

tragedies involving the death and maiming of children and adults in the southeastern United States must be laid at the foot of a society that has overencroached on nature. There have been no reliably recorded tragic encounters with alligators in the Swamp, although some disappearances in the early days were blamed on alligators.

The alligator is the only large reptilian predator in the Swamp. All of the other fabled predators are mammals. Several of the larger mammals that once roamed the Swamp are now extinct in the area, or so rare that they are functionally extinct. The black bear, however, has somehow managed to hold its own. Bears were relatively common in southern Georgia and northern Florida early in the twentieth century. Outside the Swamp they are now quite rare. Bear researchers have documented the presence of several hundred bears in the Okefenokee, far more than they originally thought were present. In 1959, a specimen was on display at Okefenokee Swamp Park with the contention that it was captured in the Swamp, which I assumed was true. Numbers have probably increased since that time. In late 1998, it was estimated that twelve hundred bears might be present in the region from the Okefenokee Swamp south to and including Osceola National Forest in northern Florida. Today, there is a six-day bear-hunting season. Nearly half of all the bears killed in Georgia are taken in Charlton County in the eastern part of the swamp. Although you may never see a bear in the swamp, looking carefully can often reveal claw marks and rub marks on trees that indicate that bears are present.

Bears are among the most general of feeders, taking all kinds of plant and animal material. Ants, yellow jackets, and termites are dug up and eaten. Berries of almost every type are consumed. In the Okefenokee, fruits of swamp tupelo are a major component of the diet. Beekeepers often accuse bears of destroying hives around the edge of the swamp. In importing the honeybee, we seem to have placed in front of bears a delicacy that cannot be resisted. Few other problems with bears occur, although they were sometimes accused of killing hogs kept by the settlers. A couple of years ago a young female got into the habit of raiding the garbage cans at Stephen Foster State Park. She was removed and released elsewhere.

Okefenokee bears are not as large as bears in northerly areas. Although a few males over five hundred pounds have been captured or shot, most weigh considerably less. Reproduction depends in part on the availability of food. In years in which mast production (berries, acorns, other fruits and nuts) is very low, there may be little reproduction. Under good conditions females produce one or two young every other year. In the winter, most Okefenokee bears den up in hollow trees or big stumps. Bears are important in the ecology of the Swamp. Moreover, without them the locals and wildlife personnel would suffer from a critical shortage of story-telling material. Proper management and protection from poaching by gallbladder hunters and others should ensure that the bear will always be present in the Swamp.

The cougar, panther, or mountain lion is the most widely distributed native mammal of the Americas, occurring naturally from Canada to Tierra del Fuego. In the region of the Swamp it has long been called "tiger." This large cat, which preyed mainly on deer, has been very rare in southeastern Georgia since the beginning of the twentieth century. Because individuals, especially males, wander far, it is possible that one of the very few left in the Southeast may be sighted now and then in the general area. Some accounts of panther encounters are probably based on fleeting glimpses of bobcats.

However, recently there were panthers in the Swamp, at least for a while. In 1988 and 1989, the Fish and Wildlife Service released seven panthers captured in western Texas at a site in northern Columbia County, Florida, near the southwestern part of the Swamp. The purpose was to determine if native Florida panther stock could survive if released into the area. The panthers did survive, but had to be recaptured when they left the area of the Swamp and killed some domestic animals. Two were illegally shot. Some uninformed hunters still believe that predators are harmful to the game population. So the motive for the shootings may have been to protect the deer population. However, deer are so abundant in the Okefenokee area that there are plenty for both hunters and panthers.

To me, one of the most chilling yet compelling sounds in nature is the scream of a bobcat. It can still be heard in the Swamp and sur-

rounding area if one sits quietly and listens on the right night. The bobcat is much smaller than the panther and has a short tail. A night hunter, the bobcat catches mainly rabbits, rats, mice, and birds. Early settlers reported being stalked by bobcats on more than one occasion.

Among the clan of dogs, two species inhabited the Swamp from the time of its origin, the gray fox and the red wolf. The former is still common in some areas in and around the Swamp. The gray fox climbs trees readily and feeds to some extent on fruit. Although the red fox is known from southern Georgia and northern Florida, it seems to be absent from the Swamp.

The red wolf is gone from the Swamp, having disappeared in the early 1920s, if local accounts of hearing howling up until that time are reliable. It is claimed that the last wolves occurred on Floyds Island. The red wolf is smaller than the timber wolf, and some feel that it was just a southern timber wolf population. Its main prey was probably rabbits and other small animals, although it undoubtedly also took deer. Accounts of it decimating cattle herds in the area in the 1800s may be the result of a penchant for story enhancement among the tellers. Today the red wolf is probably extinct in the wild except for perhaps a hundred or so at sites in the Carolinas, Tennessee, Mississippi and Florida where it has been reintroduced. A total of less than a thousand individuals of this species remains alive, many at captive breeding projects associated with zoos. Some have proposed to reintroduce red wolves to Okefenokee National Wildlife Refuge to control deer populations. Now that the coyote has moved east and occupied nearly the entire area once occupied by the red wolf, many fear that interbreeding between red wolves and coyotes may destroy the genetic integrity of any populations initiated by release. This may be a problem not easily repaired.

The coyote was thought of as a western animal until the middle of the twentieth century. Then, as a result of the open habitats created by clearing of forests, coyotes began to move east. Now they occur in nearly every eastern state. I have never seen a coyote in the Swamp. However, I have seen one jumping around, apparently after a small rodent, in a field near Valdosta, and others tell me that they can be found all over southern Georgia. Cyndy Loftin recently saw one on the road to Camp Cornelia just east of Refuge Headquarters.

Pogo is the only marsupial native to the Okefenokee. In fact the opossum is the only marsupial that occurs north of Mexico. Opossums can and do live almost anywhere, including most of the Swamp's habitats. They are seldom seen in the daytime, but forage and leap out in front of cars mainly at night. They eat almost anything. Because of the Pogo comic strips, many people think of the opossum as being the typical Okefenokee animal.

Perhaps more typical than the opossum is the raccoon. At least one seems to encounter many more raccoons than opossums. At Stephen Foster State Park, raccoons have become almost legendary. Many who stayed in the old barracks (now demolished) over the years remember the facility with which the raccoons opened and closed the screen doors and jumped in and out of the garbage cans all night long.

Raccoons are camp followers and tend to increase in numbers when humans kill off large predators and supplement food by creation of dumps, garbage sites, tourist feeding. They occur everywhere in the Swamp. Their food preferences include frogs, fishes, turtle eggs, crayfishes, and a variety of berries and other fruits. They become active in the evening and may forage throughout the night.

The armadillo is a newcomer to the Swamp and is not common in the interior portions. The islands provide about the only suitable habitat for an animal that typically inhabits burrows. There is some disagreement about whether the southeastern Georgia armadillos are derived from the population that moved east from Texas over the last half century or whether they are descendents of animals in peninsular Florida populations that originated from the escape of captive specimens. Armadillos arrived in the Swamp area sometime in the mid-1960s.

Armadillos feed, mainly by smell and touch, by snuffling along the ground, sometimes rooting about in pig-like fashion. Their eyesight is poor. I have had specimens walk over my feet as I stood quietly in an area where they were feeding. Folklore about the armadillo

A Ten-Voice Divertimento

Many years ago now, on a rainy summer evening, I drove down the road that leads from the Waycross-Folkston road to Okefenokee Swamp Park, stopping frequently to listen, wander around, and scan the edge of the Swamp with my flashlight. At a point about two-thirds of the way to the Park, I got out and was nearly deafened by the combined voices of thousands of frogs. I had stumbled upon one of these rare events during which many males of several species are calling simultaneously in one small area. The calls of individual frogs were hard to make out, but by walking and crawling along the sloping road fill I was able to pick out individuals that were calling and could distinguish their calls.

All of the frogs that were calling were males, female frogs having little ability and little need to vocalize. At various places on the road fill, usually in shallow puddles, sat tiny chunks, the oak toads, peeping like baby chicks, their vocal sacks pooching forward each time they called. In the aggregate, the toad group reminded me of a gang of elves engaged in a bubble-gum-blowing contest. Among them the squirrel treefrogs rasped and buzzed like wounded cicadas. Although their name is supposedly derived from the similarity of their call to certain sounds made by squirrels, to me they have always sounded more like insects. Male pine woods treefrogs, also scattered along the road edge and in the low spots, seemed to never quite decide whether they really wanted to call. Their staccato sporadic chattering call has given them the name telegraph frog, or Morse code frog, because of the resemblance to the tempo of the tapping of a telegraph key, a sound now nearly extinct in the world. Most of the lithe, agile green treefrog males honked nasally from bushes and shrubs. On the ground at the water's edge, floating in the shallows or in puddles, the heavier and clumsier

barking treefrog males let loose with yauping vociferations. Gray treefrogs could be distinguished here and there by their rough but musical trills. Tiny southern cricket frogs seemed to be clicking pebbles together to make their calls. These were the seven frogs of the edges and puddles. I had to peer out farther, into the open swamp, to catch sight of the rest.

The carpenter frog is the quintessential Okefenokee frog, at least to me. It was at almost this precise spot that I first heard the call of this species in the 1950s. Now, as I listen to this serenade in the late 60s, there are fewer, but with hand cupped to ear I can catch a few of their heavy tackhammering "chuck-up" calls. Normally they call earlier in the year. Pig frogs, larger relatives of the carpenter frog, are more common than the latter. If the call of any North American frog is easy to identify on the basis of common name, it is the swine-like grunt of the pig frog boars from their watery pulpits among the lily pads and bladderworts. Pig frogs are common throughout the Swamp in marshy sites. The final species, the familiar bullfrog, was not common but was easily heard and identifiable. The call of native bullfrogs can be heard from Canada to south-central Florida west to southern Texas. Elsewhere it may be a familiar frog because it has been introduced. "Jug-o-rum" is what it is supposed to say, but to me it more clearly wails with its double bass voice a more dour strain "all be drowned."

Eventually, many of the males calling will attract a female. Together they will go to the water, or if already there to a place good for egg laying. They will cast their eggs and young into the jaws of the Swamp, where most will be eaten by fishes, dragonfly nymphs, diving beetles, herons, snakes and others among the hordes waiting for food. But the frogs have anticipated all of this. Enough eggs will be produced so that some survive to grow up and become members of future choruses.

Since the 1960s I have searched for this chorus several times but have never found it again. Perhaps chance is against me, for I do not live close enough to the Swamp to visit the road nightly or even weekly. But I fear that the frogs of the Swamp are disappearing as are frog

Pig frog (*Rana grylio*) in
Sapling Prairie.

species around the earth. Perhaps I heard the last deafening ten-voice serenade of the Okefenokee. These beings of the world's wet and sodden places are vanishing. Some of the reasons appear to be known, but the causes must be many and are probably complex enough to be nearly indecipherable. What we do know is that the world is sick and that in its stricken state it is losing its tissues and organs. A world without frogs is a world without nightsong, a world without announcements of the exuberance of reproduction. This August I will haunt the Swamp more faithfully in search of the lost serenade. Somewhere among the lilies, cypresses and sphagnum this anuran operetta may still be performed. The libretto will be beyond my ken, but I will grasp the meaning of the music. While the euphony of the frogsong remains, there is hope for the Swamp, hope for the planet.

is common. Some even believe that a name occasionally used for it, "hard shell opossum," portrays its true relationships. But it lacks a pouch and is really a relative of anteaters and sloths. Some of the tales told about the armadillo are true. It always has four identical young. It is the only animal other than humans that contracts leprosy.

Armadillos seem harmless. They can scratch when restrained, but bite very ineffectively, having only a few peg-like teeth. The harm done by armadillos comes from the fact that they are alien invaders, plundering a fauna that is not adapted to their presence. Before the armadillo reached the Southeast, some species of ground-nesting birds, lizards, snakes, ground-dwelling insects, and spiders were much more common than they are now. At any rate, as with all invasions by exotic species, we will have a hard time getting rid of the armadillo, now that it lives here in great numbers.

Otters are still generally distributed throughout the Swamp, but few visitors see them. They are shy and wary and usually detect humans before they are seen. Francis Harper, who studied the Swamp's mammals in the early part of the twentieth century, admitted that he had never seen one in the Swamp. Relentless trapping of otters for their fur ever since Europeans came to the Southeast has not only decreased numbers, but has also probably made for an otter very wary of anything associated with humans. Otters are mainly fish eaters, although turtles, young alligators, crayfish, and other animals are taken when available. Early in the twentieth century, otters were common enough in the Swamp that some became family pets. One of my favorite pictures associated with the Okefenokee is of Pearl Lloyd hugging her pet otter.

Skunks are animals of higher ground and are almost never encountered out in the wet parts of the Swamp. When I first visited the Swamp in the 1950s, striped skunks were common. Evidences of their rooting and digging could be seen on most of the islands and hammocks. Now, for reasons I do not fully grasp, they seem much rarer. Perhaps armadillos compete with them for some foods. Some of my colleagues contend that insecticides have affected them. Oth-

ers think that rabies is responsible. Still others contend that most animals are subject to population cycles, a claim that can be used to explain any decline, but could be correct in some cases. I feel that the demise of skunks in an area is an inauspicious sign. Skunks are catholic feeders, and if they are affected by decay of conditions, most other forms of life must also be suffering.

White-tailed deer were abundant in the Swamp in the late 1800s, declined due to hunting pressure, but are now abundant again. In the absence of predation by panthers and red wolves, deer numbers tend to increase, especially when human activity keeps the vegetation in stages in which their foods are most abundant. Hunting pressure is generally ineffective in controlling deer numbers, because limits are too low and because most deer hunters have never grasped the need to remove females and even fawns from the population in order to have a healthy deer herd. Deer in overabundance have elsewhere been implicated in the decline of a number of wildflower species and in causing changes in vegetation that are to the detriment of many other species. Deer wade out into shallow areas to feed and seem to have little trouble navigating through most of the Swamp.

Two kinds of rabbits inhabit the Swamp. The eastern cottontail is mainly restricted to higher ground and is seldom seen within the Swamp. The smaller marsh rabbit, with its conspicuously shorter ears, occurs throughout the Swamp. Marsh rabbits swim readily and thus can be encountered almost anywhere. In my experience, the

A curious striped skunk (*Mephitis mephitis*). Jones Pocket near Stephen Foster State Park.

A whitetail deer (*Odocoileus virginianus*) with a rare white pigmentation is an omen of good luck. Billys Lake.

best way to see marsh rabbits is to look for them at sunup. They are mainly nocturnal or crepuscular and cease foraging and remain hidden through most of the day.

The Swamp's squirrels number three in kind. By far the most obvious, and perhaps the most common, is the gray squirrel or cat squirrel. No matter where one goes in the Swamp, this squirrel is present. It is less common in the pineland areas. Nests are not only made in tree cavities, but are also constructed of masses of leaves lodged in vines, branch crotches and other sites above ground. The gray squirrel's food habits vary according to time of year. When acorns are available, they may be preferred. Pine cones are cut and scaled to get the nuts. In November, they hang precariously on the dahoon branches to get the bright red berries.

Fox squirrels, somewhat larger than gray squirrels, are animals of the islands and bordering upland forests. I have never seen one out in the Swamp. They have been extirpated from most of the islands.

Some of the fox squirrels of the Okefenokee region are among the most strikingly beautiful types of the species. I recently saw an individual on Cowhouse Island that was a dark chocolate brown with creamy white ears and nose. Other color phases include grayish and tan types.

Because of its nocturnal habits, the flying squirrel is nearly always more common than casual observations indicate. Listening for high-pitched, almost insect-like, squeaking at night will often reveal the presence of this species in areas where it has not been suspected. Flying squirrels occur throughout the Swamp. Like the gray squirrel, they nest in tree cavities but also construct nests of leaves, Spanish moss, and other vegetation in trees or vines. Nuts and berries are preferred foods.

Beavers were nearly extirpated in southeastern Georgia by the early twentieth century but are now abundant again in many areas. But they have not been very successful in colonizing the Swamp. In my experience, beavers and beaver sign are not common in the Okefenokee. Several naturalists familiar with the area have told me that beaver are not uncommon in the southwestern part of the Swamp. Contrary to common opinion, beavers do not need flowing water to colonize an area. They may build lodges in sinkhole ponds and other quiet bodies of water. Francis Harper advanced the idea that the southern edge of the beaver's range was determined by how far north alligators ranged. Although alligators undoubtedly prey on beavers, the reproductive capacity of the beaver, its use of lodges, and the large size of adults undoubtedly means that alligator predation could not entirely exclude the beaver from a portion of the continent. I know of many sites on the Coastal Plain where the two species have occurred together for decades. But high alligator density in the Swamp may have something to do with the failure of beavers to maintain large populations in the area.

Among the most fascinating of the little-known animals of the Swamp is the water rat, or round-tailed muskrat. This semiaquatic rodent is about the size of a domestic rat, being about a foot long including the tail. Its feet are unwebbed, and its tail lacks the lateral

A gray squirrel (*Sciurus carolinensis*) feeding on Chesser Island.

flattening of the larger muskrat, which does not occur in the region. Water rats build nests or lodges which open by downward-slanting tunnels into the adjacent water or vegetation layer. They also make feeding platforms which are obvious as smoothed, compacted mounds with tunnels leading downward on the sides.

The very common rice rat has habits similar to those of the water rat. It is smaller and makes ball-like nests, usually a few inches above the surface. Another rodent of similar size, the wood rat, makes nests of sticks at sites around the edges, or sometimes in stumps out in the Swamp.

Edwin Way Teale, in his book *North With the Spring*, called the Okefenokee "land of the golden mouse." On his quest in search of the advancing spring he had seen a nest of the golden mouse in the Swamp. This small golden-brown rodent is best detected by looking for its nest, a ball of leaves, bark fragments, Spanish moss and other plant materials, nearly as big as a softball. It is placed from a foot to six or eight feet above the ground, lodged in vines, shrubs or sometimes in dangling masses of Spanish moss. These are smaller and always lower than the leaf nests of squirrels. Occasionally, especially at night, a golden mouse will be seen scampering along the vines and branches. The best way to see one is to gently open a nest and hope one will dart out. Put the nest back together and leave it where it is. The golden mouse will probably return.

Bats of at least ten species may occasionally be seen winging over the Swamp after insects during the summer. Most of the bats seen are Seminole bats, southeastern bats or eastern pipistrelles. Most of the species common in the area spend the day hanging in hollow trees or, in the case of the Seminole bat, protected in the interior of dense clumps of Spanish moss. The southeastern bat seems to need caves for reproduction and wintering, as does the eastern pipistrelle. In recent years a vigorous bat conservation and public education program has led to increased public support of bat conservation. It is true that they eat insects, sometimes thousands in a single night. But they are also attractive and fascinating animals once one gets to know them. I found a female red bat hanging on the screen of one of the buildings at Stephen Foster State Park in 1966. She had two small babies clinging to her body.

Many visitors come to see the birds. Birdwatching—some devotees prefer the term "birding" because they claim that "birdwatching" conjures up an idea of fuddy-duddy eccentrics—is an outdoor sport in which the harvest only occurs in the mind or as birds ticked off on checklists. Almost everyone that comes to the Swamp becomes a birdwatcher to some extent. If one ignores the birds, the Swamp is a much less interesting place. Nearly two hundred fifty species of birds may be found in the Swamp, of which seventy-five nest in the region. Of this number, perhaps one hundred may be commonly seen.

Sandhill cranes are among the largest of the Swamp's birds. Rivaled in size only by the great blue heron, the tallest sandhill cranes reach heights of nearly four feet. Members of two races of sandhill cranes may be found in the Swamp in the winter. Several hundred greater sandhill cranes, the larger of the two types, migrate in from northern breeding areas and spend the winter in the Swamp and surrounding areas. Most occur on Chesser, Floyds, and Grand prairies. Greater sandhill cranes are often gregarious and may form flocks of a dozen or so.

The sandhill cranes that breed and permanently reside in the Swamp are members of the race called the Florida sandhill crane, smaller in size than the migratory population. Resident cranes are not gregarious and seldom occur in groups of more than two or three. They tend to nest in prairie areas, usually producing one young. Cranes are not choosy about their foods. They pluck berries from bushes, snatch lizards from trunks, and root up tubers.

Seldom seen in the swamp except as a rare stray is the limpkin, a relative of the sandhill crane. Limpkins are medium-sized brownish wading birds streaked with white, having a long curved beak. Although known to eat aquatic insects, reptiles and amphibians, and perhaps even seeds, the limpkin feeds mainly on apple snails, which no longer occur in the Okefenokee. The call of the limpkin is one of

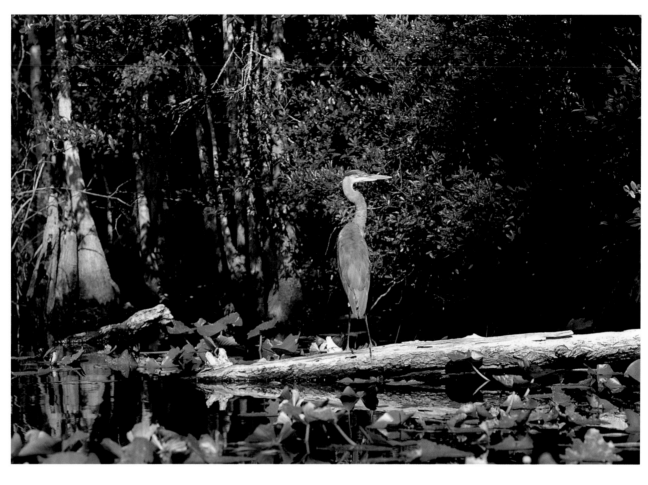

Great blue heron on the edge of Billys Lake.

the sounds of nature that must be heard. William Bartram spoke of it as "the crying bird, another faithful guardian, screaming in the gloomy thickets, warning the feathered tribes of approaching peril."

The remaining large birds seen in the Swamp are members of the wading bird group. The great blue heron is the largest of these. Its long legs enable it to hunt in deep water, but it also feeds in shallower areas and from the bank. The largest of the white wading birds in the region is the great egret. It also feeds in relatively deep waters but cannot wade as deep as can the great blue heron. Great egret populations were severely decimated by plume hunters in the early part of

the twentieth century as a result of the demand for their use in women's hats. Now it has come back, but other dangers still face it. These two large waders eat fishes, frogs, tadpoles, snakes, insects and almost anything they can choke down. They nest in colonies in trees, often together.

Three smaller heron-like birds are frequently encountered. The little blue heron is about half the size of the larger herons. It is dark blue with a maroon neck and dark, greenish legs. Immature specimens are white and can be confused with cattle egrets. The greenback heron is the size of a crow, is mainly greenish-blue, but has a

Cranes of the Fog

Florida sandhill crane in Chesser Prairie.

One fall, early, before the society of humans stirred into its daily routine, I quietly strolled out on the boardwalk that runs west from Chesser Island. Far out I emerged into the portion that provides an unimpaired view of Chesser Prairie. To my right, less than a hundred yards away, two adult sandhill cranes stood, moving only slightly. I stopped.

Wherever sandhill cranes occur there are few trees; the land is open. I have watched them on the shores of the Platte, in Muleshoe Refuge, on the Kissimmee Prairie, and in the wet savannas of the Gulf Coast. In the Okefenokee, it is the prairies that create sandhill crane habitat. It is the prairies that in one sense mimic lands usually found far to the west . . . the true prairies. On this morning the fog lay thick. At times I could not tell whether I was in Georgia or Saskatchewan.

In the places where I have seen sandhill cranes, they have probably seen me first, for the eyes of birds take in more of the world than do those of humans. Sandhill cranes are wary birds and seldom allow close approach. Their cautiousness is one of the reasons for the decline of many populations as people invaded the sandhill crane habitats of the continent. In this case, for a reason beyond knowing, the cranes did not notice me, although they often appeared to be looking in my direction. Perhaps I was merely another wraith in the fog.

This was almost certainly a mated pair, bonded for life, as are all sandhill crane pairs. They had probably spent the night on the prairie. They were now preparing to forage for the day. If they had produced a chick this year, it had already fledged.

I slowly eased myself down and sat on the boardwalk. The cranes paid no heed. They were preening and walking slowly around with that peculiar gait that only cranes have. They were not doing anything that really made much sense. Periodically, they looked directly at me. They almost appeared to be performing. They resembled mimes, acting out a parody of what I thought cranes ought to do and be. They glanced at me for approval. Were they crane-like enough? Was their performance equal to my expectations?

Now they became restless, looking more to the west than toward me. They were taking more purposeful steps. Thicker wisps and billows of murk blew in from the east, from somewhere beyond the Swamp, from the valley of the Thlathlathlakuphka. The cranes both glanced at me with penetrating stares. Then—which was the initiator I could not tell—they raised their wings in unison and headed west. Their voices came to me then, modulated, yet magnified by the fog. I knew that they were calling to me, but I could not follow, not to Bugaboo Island and beyond.

Albert and Anna Wright said that the call of the cranes was "so unbirdlike, and yet, rings so clear, is so far reaching, and possesses such measured qualities, that the listener longs for instant repetition." It is a call that I carry with me, although I can never quite recall its qualities until I hear it again. It is embedded in my soul, but cannot be called forth like a tune or ditty. It is one of the ways that the Okefenokee speaks to us. It is a true voice of the Swamp.

> Florida sandhill crane (*Grus canadensis*) feeding in Chesser Prairie. These large birds, up to four feet tall, stay in the Okefenokee for the winter, while the greater sandhill crane winters in Florida.

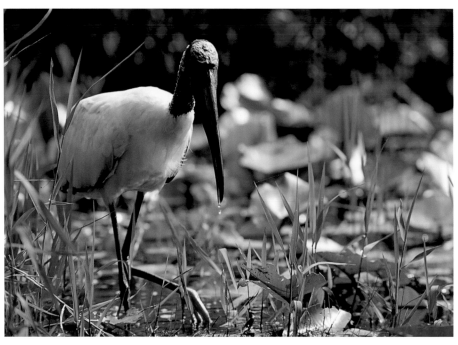

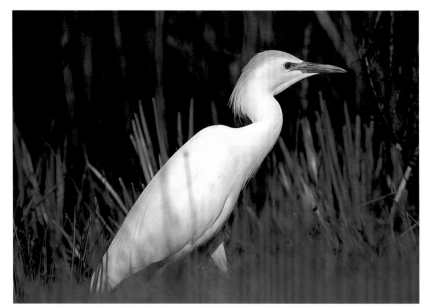

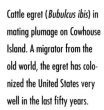

The white phase of the little blue heron begins at birth. In its second year the heron molts to its permanent blue feathers. Billys Lake.

Wood stork (*Mycteria americanus*) feeding near Billys Island. A barometer of nature's health, the wood stork fares well in the Okefenokee Swamp. East Fork, Suwannee River.

Cattle egret (*Bubulcus ibis*) in mating plumage on Cowhouse Island. A migrator from the old world, the egret has colonized the United States very well in the last fifty years.

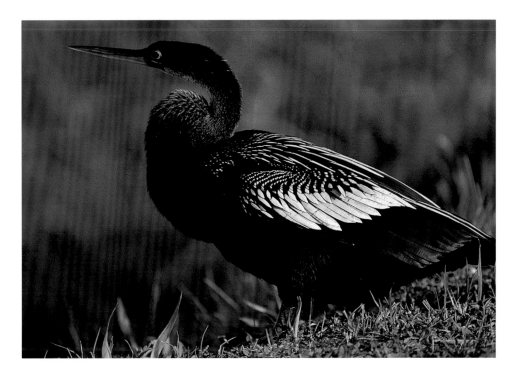

Anhinga (*Anhinga anhinga*) is also called the snake bird, because when it swims only the small head and neck are visible. Cowhouse Island.

rapid loss of habitat. However, in the past few decades, nesting colonies have been found in Georgia and South Carolina, although none presently nest in the Oke-fenokee. Wood storks are white except for the short black tail and the feathers on the wing tips. The head of an adult is featherless and the beak is heavy and slightly curved. Wood storks feed by wading in relatively shallow water, usually less than two feet and more than ten inches. When the beak, which is waved back and forth in the water, touches a fish, it snaps shut in a fraction of a second. Among the wading birds, the wood stork is the only one that may be seen high in the air, riding the thermals, gliding for miles to search for food, seldom flapping.

Water turkey, darter, anhinga, and snake-bird are all names applied to one species, now usually called the anhinga. Anhingas look as if they had come to life from an ori-ental painting. The neck is long and snake-like. The head seems too small. Their posture when they are resting, especially when the wings are spread, is somewhat awkward and strange. When feeding they drop silently from their perches and submerge to spear fishes. Often they swim with only the head and neck above water. When they emerge with an impaled fish, they toss it into the air, catch it in the open beak and swallow it. Anhingas are silent birds of silent places. As T. Gilbert Pearson said in *Birds of America*, "Their whole life seems to be pervaded with a haunting mystery."

One of my most memorable experiences in the Swamp occurred while I was in my sleeping bag in Stephen Foster State Park. As I drifted into that unreal zone between wakefulness and sleep, two barred owls began calling in the trees right above me. In my trance-like condition, it seemed like a fight between demons. It continued

brownish neck and yellowish-green or orangish legs. It often feeds from perches at the edge of the water. They tend to nest as solitary pairs. The last commonly seen wader is the cattle egret, which actu-ally seldom wades. Cattle egrets are most abundant around the edges of the Swamp. During the past half century this bird has become familiar in the Southeast, flocks often being seen in pastures where they feed on insects and other animals disturbed by grazing cattle. Cattle egrets invaded North America from South America, perhaps as early as the 1930s. They were able to colonize the New World because colonists opened up the forests and created habitats similar to those in the bird's native African savannas.

One other member of the wading bird group deserves mention. The wood stork, or gourdhead, was nearly driven to extinction in North America and is still declining in southern Florida as a result of

on with repeated cawing, whooping and hooting sounds over and over, keeping on much longer than a typical calling owl does. When I became fully conscious I sat up suddenly and banged my head on the picnic table under which I was sleeping. The owls continued to call, and as I gradually gathered my senses again I realized that rather than it being a convention of gargoyles, I had been hearing sparring male barred owls. It occurred to me then and I still feel today that the owls may have been talking to me, for there was no one else around. But what were they trying to articulate with their long and varied repertory? I could not grasp the meaning. Perhaps I had desecrated their Swamp with my rank human presence. In the end, I came to believe that it was a welcome, an invitation to camaraderie. We were beings of the Swamp that night, and I was being initiated into the fellowship. Perhaps I flatter myself.

Barred owls feed mainly on mammals, including mice, rats, and rabbits. Their flight is silent as a result of the down-like feathers on the edge of the wings. Nests may be found in cavities, usually where other birds have nested previously. Barred owls are truly the owl of the Swamp. At dusk, when their eight-hooting begins, no matter where one hears the sound, it is possible to briefly savor the depth of these mystic solitudes.

Among the hawk-like birds, at least fifteen species may be encountered, although some are rare. The bald eagle is occasionally seen but is not known to nest in the Swamp. The common medium-sized hawk is the red-shouldered hawk, which feeds on almost anything that moves, including mice, birds, snakes, frogs, fish, grasshoppers, spiders, worms, and snails. More red-shouldered hawks are present than one might suspect, for many keep to the shade of the woods and perch among the branches.

Once in a while, during all seasons except winter, swallow-tailed kites pass through the Swamp. If you have never seen a kite of any kind, the name "kite" will not mean much. These birds do seem to hover in the wind like kites, teetering and rocking with the gusts and eddies almost as if inanimate. To me, swallow-tailed kites are among the most beautiful of the birds of prey, their grace and beauty unmatched, their lightness in the air nearly beyond conception. They

feed on the wing. I have seen them snatching cicadas from the leaves of sycamores. They will take lizards, snakes, grasshoppers, frogs, and occasionally will attempt, usually unsuccessfully, to snatch a baby alligator.

It would seem like the Okefenokee should be burgeoning with waterfowl, but only four or five species may be commonly seen. The shallow vegetated flats and wide expanses of open water that many ducks and geese prefer are not common in the Swamp. Mallards, ring-necked ducks, green-winged teal and hooded mergansers are species often encountered, but the wood duck is the real duck of the Okefenokee. Male wood ducks, with their crested white-lined heads, colored above with iridescent green and purple, are among the most resplendent of the waterfowl. Females are duller, their somber colors serving as effective camouflage, for only they care for the nest and young. Heavily wooded wetlands are the preferred habitat. Nests are made in tree cavities, from a few to forty feet above the ground. When the young leave the nest, in response to calls from the female, they launch themselves into the air and bounce like Ping-Pong balls when they hit the ground below. Natives sometimes call this duck "squealer" because of its whistling call.

The birds of the goatsucker family are largely inscrutable. They are seldom seen but often heard. They perch lengthwise on limbs instead of across the limb, like normal birds ought to. Their mouths are surrounded by bristles. One species, the poorwill, hibernates like a mammal. The nighthawk, chuck-will's-widow, and whip-poor-will occur in the Swamp area, but the latter is an uncommon visitor and found only in winter. The call of the chuck-will's-widow, sounding much like its name, is familiar to most who live in the area. In the Swamp proper it is restricted to the islands for nesting but hunts insects over the water during the night. The camouflaged eggs are laid on the ground, no attempt being made to construct a nest.

The last time I passed through Billys Lake there was a kingfisher perched on a branch above the water. Along the narrow more heavily shaded waterways it is seldom seen. I find the presence of kingfishers in the Swamp to be anomalous in one respect, for they nest only in exposed banks, which are very rare in the Swamp.

A Bird as a Corporate Acronym

A biologist friend of mind recently told me that he had come across a colony of RCWs during a recent visit to one of the islands in the Swamp. Not being very good at mod acronyms, I at first thought he was talking about a group of rusted-out Winnebagos, but then remembered that these would be SUVs or maybe RVs or something like that. After further contemplation I decided that he was referring to a pile of antique radios. No!!!! That would be RCAs. Hmmmm? Surely no one had discarded a bunch of copies of the Revised Code of Washington on an island in a swamp in southeastern Georgia? Nor did it seem likely that those mean and muscled stars of River City Wrestling in Canada were holding a training camp way down here. After contemplation, I was also fairly sure that he had not set up complex astronomical equipment on the island and discovered more items related to RCW103, that supernova remnant located about six and a half kiloparsecs away. Aha, I had it! He had the good fortune to encounter a bunch of new carnival rides put up on the island by Roller Coaster World.

As it turned out, I was wrong on every guess. He had been talking about a bird. Evidently, RCW refers to "red-cockaded woodpecker." Well, why didn't he just say so instead of leading me off into the acronymic morass of postmodern materialism. Heck, if I had known he had been talking about an animal, I could have had a decent conversation with him. Just the day before I had seen a flock of SHCs out beyond Chesser Island. And, come to think of it, I turned a log near Homer the other day and saw an SKS, an SS, a couple of SFLSs, a bunch of BBs and EWs, and a very pretty BWS. This is not to even mention the pink AE that I think I saw on the way back from my AA meeting at A.

But, in a sense, my friend was right. The red-cockaded woodpecker has become a corporate acronym. Like most species protected by the Endangered Species Act, it is despised by most corporations as what they believe to be an insignificance in the way of progress. "Progress" usually translates as "profit." To the large corporations who extract gain from the land, the acronym "RCW" means "Really Costly Waste." The corporate view tends to be that humanity's relationship with the land is an economic one that can be primarily framed and understood in light of dollars, cost, profit, jobs, and whatever the shareholders want. For some reason, CEOs, other corporate executives, and many associated with large commercial entities have failed to grasp or retain a fact taught to most second-graders, that people's relationship with the land is, in the end, entirely biological. The fact that we cannot eat, breathe or drink profit plainly tells us this. We cannot live by bread alone, but we cannot live by lucre at all. Even so, the lure of dollar value is insidious. It has even pervasively invaded the conservation community, for in the struggle to preserve natural communities and declining species many seek to assign some type of dollar value to components of the natural earth in order to justify their existence. In the end, this method leads to resource loss if only because agreeing to do battle with the weaponry of the other side usually means defeat. Many well-meaning environmentalists, biologists, and conservationists have succumbed to the belief that the only way to preserve resources is to compromise with those who would seek to destroy them, and not only meet them halfway, but meet them armed only with the inapplicable logic that they have duped us into accepting.

Ample recent evidence exists to support the contention that there are many who would gladly pick apart the vital fabric of the world in order to supply themselves with ephemeral inessential luxuries. It is the same philosophy and avarice-based viewpoint that concludes that when it comes time to cut timber, to mine ores, to dam rivers, to build plants, to construct roads, or to lay pipeline, "Well, . . . sorry, but red-cockaded woodpeckers, louseworts, sturgeons, salamanders, bears, lilies, wolves, and orchids just have to go." In part, this belief results from the distorted concept of ownership that characterizes western, particularly American, society. We believe that if we own land, it is our

right to do anything we please with it. At the extreme all would agree that this is obviously not true. I cannot shoot nuclear cannon off on my land, because the shells and the radioactivity end up on the land of others. It is the same with destruction of any component of the natural world, even though it may be less obvious. Allowing populations of red-cockaded woodpecker to disappear because they are in the way of profit assumes that red-cockaded woodpeckers and the natural system which they need to survive are not connected in any positive way with other parts of the natural earth. We know this to be false. Logic tells us that it must be false. The simple wisdom of a child demonstrates that it is untrue.

As I sit this evening among the lushness of the herbs in the open pinelands at the edge of the Okefenokee, I can feel the low and often subliminal throbbing that comes from the functioning of a natural system. If we release for a moment our frantic clutch on the mundane and the mechanized, we can all feel it, for every one of us is a part of the rhythm and the melody, even though now we sing largely off-key and without a conductor. As dusk approaches, the red-cockaded woodpeckers silently return to their holes high up in the larger trees. I watch their flight and wonder how many others that follow after me will have the privilege of this experience. Humans are made to love nature. Without this love they despoil nature and destroy themselves. These flittering figures of the gloaming, now at rest in their homes, are not RCWs to me. They are friends, companions, partners, comrades. Tomorrow I could come back here with a chainsaw and fell these trees. Tomorrow I could take a knife and slash my wrists or run amok with murderous intent in the local towns. In the end all of these actions are the same. But I will do none of them, because I am a person of woodpeckers, as are we all.

Kingfishers dive into the water after small fishes from a fluttering halt in the air after they have located a fish. How they can see small fishes below the surface and accurately plunge to catch them is worth some contemplation.

To me, an abundance of woodpeckers makes the natural history of any area all the more interesting. In addition to the birds themselves and their activities, the presence of woodpeckers predicts the presence of trees of various ages and of dead trees in varying states of decay. Many other animals, and even a number of plants, depend on dead trees, decaying wood, downed logs, and floating logs. If a swampy forested area lacks dead trees, it will have fewer woodpeckers, fewer salamanders, fewer click beetles, fewer bugleweeds, fewer mushrooms, and even fewer tiny pseudoscorpions, some of which feed entirely on the termites living beneath the bark of recently dead trees. A forest without dead trees is not whole.

Eight kinds of woodpeckers may be seen in the Swamp, and a ninth formerly occurred. Three of these species deserve mention. The red-cockaded woodpecker was once common in the pinelands on the islands and around the edge of the Swamp. This species needs living pine trees older than about forty or fifty years in order to excavate a nesting cavity in the heartwood. It will nest only in open stands. Thus fire is necessary to keep broadleaved plants from invading a site and encroaching on the nesting trees. Current methods for the production of pulp trees do not allow any trees to get old enough to become suitable for red-cockaded nesting sites. Because much of the Southeast is now devoted to pulp production, because the fire regime has been altered, and because agriculture and development have replaced forests, the habitat for red- cockaded woodpeckers has become scarce. It has become necessary to list it as an endangered species under the provisions of the Endangered Species Act. Some controversy has resulted, because a large component of the public does not understand that preserving natural systems and their component species is vital to maintaining conditions under which humans can happily live. We cannot pick apart and destroy pieces of the natural structure that has kept humans alive throughout all of human history. . . . not for a few dollars more, not for a few more

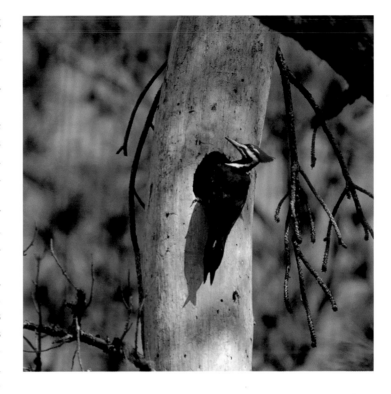

A pileated woodpecker (*Dryocopus pileatus*) on Jones Island. The swamp was once home to the ivory-billed woodpecker, a smaller cousin, which is now considered extinct.

jobs, not to fill the many-mouthed hydras of greed and not to feed our insatiable gluttony for paper.

The largest woodpecker that currently inhabits the Swamp is the pileated woodpecker. Almost impossible to confuse with any other bird, this crow-sized woodpecker is easily identified by the red crest on the head and the mainly black body with white on the front of the wings and side of the neck. In southern Georgia, I have often heard it called the "Lord God." Clearly, this is a corruption of another name, "log cock," which is more understandable.

The ivory-billed woodpecker was half again as large as the pileated. The last ivory-billed woodpeckers in the Swamp were seen in the mid-1940s, with some probably valid reports into the 1950s. There is no hope that this bird survives in the Okefenokee. The large areas of virgin forest that it seems to have needed are gone. There is a minus-

• • •

A prothonotary warbler (*Prothonotaria citrea*) singing a lovely melody. East Fork, Suwannee River, near Billys Island.

cule possibility that it survives elsewhere in the Southeast, but most biologists feel that it is extinct. Without the large tracts of undisturbed swampland that were once its home, the ivory-billed woodpecker cannot endure. The fate of the Cuban populations remains unknown, but they are probably gone also.

In March and April, the Swamp is alive with thousands of brightly colored motes moving from tree to tree. These are the migrating warblers, most headed north to nest in other areas. Members of a few species will remain to mate and reproduce in the Swamp. Among these the prothonotary warbler is perhaps the most conspicuous. The bright golden-orange plumage of the males makes this warbler easy to spot. Their preferred habitat seems to be edges where woody vegetation and open water meet. They often fly across expanses of open water. Nesting is typically in tree cavities that overhang water. Once in a while, as one canoes along, it is possible to peer into a nest and see the eggs or young.

Although the alligator is the reptile seen by most visitors, a number of species of turtles, lizards and snakes represent the rest of the reptilian world in the Swamp. Among the fifteen or so turtles of the Swamp region, the Florida cooter is the one most often seen out in the Swamp. This turtle, often seen basking on logs, reaches lengths of over a foot. It usually has conspicuous light stripes on the head and neck.

Rivaled only by the giant narrow-headed softshell of the Indian subcontinent, the alligator snapping turtle is one of the world's largest freshwater turtles. Specimens caught in the wild have weighed 180 pounds, and a turtle long kept in the Brookfield Zoo reached over 260 pounds. Large alligator snappers keep to the holes and overhangs and are seldom seen. Hatchlings and small specimens are more often encountered. The three-ridged shell with a jagged back edge makes it hard, through the inky water, to see one on the bottom or to differentiate turtle from log or stump. Alligator snapping turtles feed on almost any animal they can eat, including carrion. At times one may lie with its mouth open and use a mobile appendage of the tongue to lure in small fishes. There are no reliable cases of humans having been bitten while in the water. Tales of how easily a large specimen can "snap a broomstick in two" are exaggerations. I tried a variety of broomsticks on a 157-pound specimen. At most, it could only mar the wood. The related common snapping turtle is present in the Swamp but is more abundant in smaller bodies of water around the periphery.

The Florida softshell is also a large turtle and is common in the Swamp. Females, which generally are the larger sex in turtles, may reach twenty-two inches in length. Like all softshells, it has a soft leathery shell and a long neck and head with a snorkel-like snout. Florida softshells hunt prey from ambush while buried in the bottom but are fast swimmers and can also chase down some of the fishes and other aquatic animals that they eat. Large females may be encountered when they are out of the water laying eggs or basking. The speed with which a softshell can run on land shows that lore

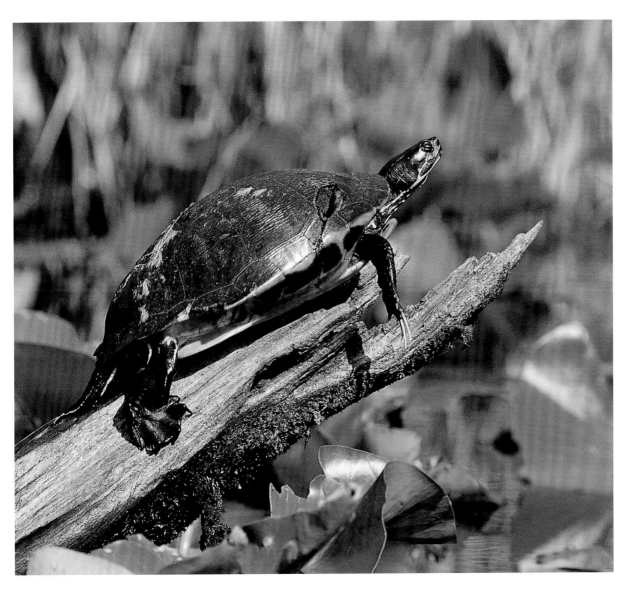

Alligator snapping turtles (*Macroclemys temmincki*) weigh up to 250 pounds and are rarely seen, remaining on river bottoms to feed. Near Stephen Foster State Park.

A turtle has been mishandled by an alligator. The larger animals often use the smaller ones as toys. This turtle will heal to sun itself again on a log being used by an alligator. Billys Lake.

about the slowness of turtles is not always applicable. Among the dozen other turtles that may be encountered are several little musk and mud turtles, three or four other sliders related to the cooter, the beautiful chicken and spotted turtles, and two terrestrial turtles found on the islands and around the edges of the Swamp.

The box turtle is the common land turtle on the islands and in most habitats around the edges. The gopher tortoise is the other land turtle. It only inhabits high dry sandhill and scrubby areas, where it makes long burrows. The gopher tortoise is often considered to be a keystone species in its habitat because its burrow provides shelter and escape for so many other species of the sandhill habitat. Considered a delicacy by some, and eaten by settlers since the earliest days, the gopher tortoise is nowhere abundant on the Swamp's islands, but may be encountered in the sandhills around the periphery of the Swamp. Destruction of its sandhill habitat, gassing burrows to drive out snakes, and pulling or hooking them out of their burrows in order to eat them have made the gopher much less common throughout its range.

The southeastern part of the continent is poor in lizards, the Okefenokee region having only about a dozen species compared to over forty species in southern Arizona. Six or seven of the local species can often be seen in the Swamp area. Two types of skinks, smooth-scaled shiny lizards, are commonly seen. In these species the tail is bright blue, especially in younger specimens. Bright tails attract the attention of predators who may break off the tail, allowing the lizard to escape. Detached tails coil and wiggle vigorously for a minute or two after breakage, retaining the attention of the predator while the lizard reaches safety. Perhaps because of the bright tails, locals often erroneously think skinks are poisonous and call them "scorpions."

The fastest of the Swamp's lizards is the six-lined racerunner, called "race mare" or "race nag" by some of the Swampers. It is by no means a wetland animal. Rather, it lives in the highest, driest, sandiest areas on the islands and peripheral sandhills. How fast can this lizard run? Occasionally, speeds of nearly ten miles per hour may be

reached, not a rate of progress that has to be measured in Mach numbers, but fast enough to outrun a pursuing human, and fast enough to elude many predators.

Glass lizards, those beautiful legless lizards with long fragile tails, are called "grass lizards" by the locals, a not inappropriate name. In some areas they are called "joint snakes," and are believed to have the ability to break apart and come back together again. Some rural people believe them to be venomous. Glass lizards are often more common than one might think. They often forage beneath the litter or underground and hence are seldom seen.

More misinformation about snakes exists in the minds of the general public than about any other group of living things. Although few would challenge their physicians on health care, and even fewer would contest information coming from their tax accountant, most believe that what they "know" about snakes is true, regardless of what an experienced herpetologist might tell them. In reality, most people are not capable of making rational judgements about snakes that they encounter in the wild. The early Okefenokee settlers knew a lot about snakes, most of it correct, although they believed that some harmless types were poisonous. However, most average citizens are ridden with erroneous snake folklore learned from their early youth, and most want to believe that they are knowledgeable about snakes. The claim to know snakes and something about them is most common among fishermen, hunters, and others who may have spent some time outdoors. It tends to be a component of their machismo. In many cases, these individuals have less reliable information than a well-informed kindergarten child, partly because they have received large amounts of folklore and heard dozens of inflated tales and lies from others in their groups. Little I can say here will convince those with crippling misinformation, but I will make a stab at it anyway.

In the Okefenokee Swamp and surrounding environs, nearly forty species of snakes may be found. Many that are small and secretive, like earth snakes, crowned snakes, and worm snakes, are seldom seen. These species live out their lives under logs, in small burrows,

and among decaying litter. They feed on small invertebrates of various types. The tiny crowned snake is actually poisonous, producing a weak venom that is injected by grooved teeth in the rear of the mouth. Under no conceivable set of conditions could the bite of an eight-inch crowned snake ever harm a person.

Many of the larger snakes in the Swamp are also secretive and hence are seldom encountered. Rainbow snakes and mud snakes burrow at the edges of bodies of water or live among mats of vegetation. The rainbow snake, with its iridescent stripes of red on the back and its yellow-and-red belly with rows of black spots, is one of the world's most beautiful snakes. The significance of such an array of color in a secretive snake that feeds mainly on eels has yet to be ascertained.

Mud snakes feed mainly on two-legged elongate aquatic amphibians called sirens. Both mud snakes and rainbow snakes have a hard pointed scale at the tip of the tail and seem to be the basis for the hoop snake story. No snakes can sting with the tail, nor do any have the ability to grasp tail in mouth and roll along like a hula hoop. At least I have never been fortunate enough to witness this display in the Okefenokee, or elsewhere. My friend, the well-known biologist and archaeologist Winston Baker, once found, under a log at the edge of Billys Island, a female mud snake coiled with fifty-two eggs.

In the watery reaches of the swamp, the most commonly seen snakes are water snakes. By "water snake" we mean one of a group of nonpoisonous rough-scaled snakes that live in and around bodies of water and obtain much of their food from the water. At least six species of this group inhabit the Okefenokee. However, in my experience, only two are frequently seen out in the swamp. One of these, the brown water snake, is quite common. Of the snakes seen basking in the bushes and draped over low limbs, this is the commonest. However, the banded water snake is also relatively common in some areas. Brown water snakes are often mistaken for cottonmouths. Although they willingly and vigorously defend themselves, they lack venom and can merely lacerate. Snatching brown water snakes from branches is great sport.

On the islands and around the edge, corn snakes and grey rat snakes are commonly seen in trees. Racers and coachwhips are also often encountered, the latter species seldom venturing into the watery reaches. King snakes used to be very abundant on the islands and edges but seem to have declined in recent years. Many readers are probably familiar with the oft-told tale "Ol' Rattler and the Kingsnake." It comes in dozens of versions but always details the struggle between a massive rattlesnake and the noble kingsnake. In nearby northern Florida, one version has the kingsnake leave the struggle, take a bite of a milkweed pod, and then return to vanquish the rattlesnake. Presumably, milkweed juice enhances the kingsnakes immunity to rattlesnake venom. Although it is true that kingsnakes may occasionally feed on rattlesnakes, many other items are more common in the diet. Swamp kingsnakes seem to eat large numbers of turtle eggs, in addition to consuming a variety of snakes, lizards, and some mammals and birds.

The dangerously venomous snakes of the Swamp include five species, four pit vipers and the coral snake. Among the pit vipers by far the commonest is the cottonmouth. The common name "cottonmouth" is generally reserved for this snake, whereas the name "water moccasin" can include almost any type of aquatic serpent. I once measured a cottonmouth killed by hikers in Alachua County, Florida, at six feet one inch. Animals of this size are exceptionally rare. None I have encountered in the Okefenokee were over four and a half feet, although undoubtedly some larger ones are present. Cottonmouths climb poorly and thus, despite innumerable claims to the contrary, are seldom seen on branches above the ground. Essentially all of the "moccasins" that have dropped from limbs into boats in stories from the Okefenokee and elsewhere have been harmless water snakes. The most common tall tale about cottonmouths is the "water skier and the bed of cottonmouths" fable. I know at least two dozen people who swear that this happened in a lake or pond near their home, and that they knew personally the person who died or came on the scene right after it happened. Yet, this event never happened. It is biologically impossible, because cottonmouths do not

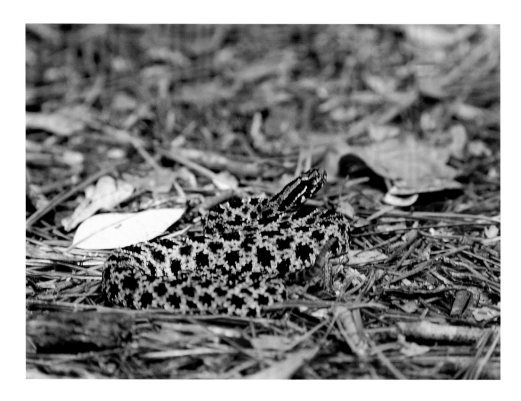

This dusky pygmy rattlesnake (*Sistrurus miliarius barbouri*) had just shed its skin. The photographer had stepped over it before his wife spotted it. Billys Island.

The eastern diamondback rattlesnake is the nation's largest venomous snake and one of the most dangerous. In the Okefenokee area, it occurs in the peripheral pine woodlands and on the islands. None recorded from the Okefenokee have approached the record length of eight feet. This snake, like most, would rather flee than bite. The common idea that rattlesnakes always warn an intruder before they bite is proven wrong. Some diamondbacks never rattle. Others will start buzzing long before you are within striking distance. The large size, long fangs, and large amount of venom mean that this snake can easily cause mortality in humans. William T. Chesser, the colonizer of Chesser Island, lost a son to a rattlesnake bite and eventually lost his wife, who died of a broken heart. Most bites happen when people are trying to kill rattlesnakes or are purposefully handling them. Habitat destruction and rattlesnake roundups have decimated populations of this snake in the last half century. Large predators are vital to the health of natural systems. The eastern diamondback is no exception and should be protected. To those who claim that all potentially deadly animals should be exterminated, I point out that honeybees kill more people each year in the United States than the eastern diamondback does in a decade. It may also be of interest to note that more than one hundred people a year are killed in deer-car collisions.

Second in size to the diamondback is the timber or canebrake rattlesnake. Canebrake rattlesnakes are not common in the area of the Swamp in my experience. I have never seen one out in the Swamp or on one of the Swamp islands, although records exist. These snakes are also potentially deadly. Recent research has found that canebrake rattlesnakes in an area extending from southeastern South Carolina through eastern Georgia to northeastern Florida have venom with a very high level of neurotoxin, a component that effects the nervous system. This means that a bite from an Okefenokee canebrake could be far more dangerous than one from an Albany, Georgia, specimen.

The tiny pygmy rattlesnake has such small rattles that they are often not noticed when one is found. The high-pitched buzzing of the rattles is not audible for more than a few feet and cannot be

and cannot hang out in "beds" under the water in an open lake. I have personally tested the behavior of cottonmouths to determine their reaction when a heavy human body splashes into the water near them. They leave as fast as they can. This well-known fiction has never been shown to be based on even a shred of truth by many who have investigated it. Neither do cottonmouths chase people, nor do they always stand their ground. Of the several thousand cottonmouths that I have come across in the last forty years, I would estimate that four-fifths took to the water or immediately attempted to escape. Of the dozens I have seen in the Okefenokee, I can remember only two or three that coiled and gaped rather than trying to escape. There is little doubt that serious envenomations can occur from a cottonmouth bite, but such bites are seldom fatal.

In Search of the Star-Nosed Mole

Biologists who study living things in their natural settings have many goals. Among them each has a number of experiences that they have wished for but which have eluded them. I regret that I have never happened on a Louisiana pine snake in the woods along the Gulf Coast. Although I have found their nests in the Northwest, I have never caught even a glimpse of the red tree vole. I have failed to find so many of the species for which I have searched. But I have had some successes, or what to me were exceptionally rewarding moments. I have seen a peregrine falcon perched in a boojum tree. Once I crawled over a ridge and came face to face with a mountain goat sitting on a patch of snow. While sitting among the marine iguanas at Punta Espinosa, I watched the great shield volcano, Fernandina, steam and glow. I have looked into my dipnet and realized that a creature unlike any known to science lay before me. I have seen a spotted turtle in the Swamp, and have had many other memorable Okefenokee experiences. Even so, there are innumerable things that I yet must see. There is one elusive creature of the Swamp that I am most eager to catch sight of. It is the star-nosed mole. I sometimes ladle the scientific name of this animal around on my tongue . . . "*Condylura cristata*" . . . hoping that it will somehow help me in my search.

The Okefenokee is an anomalous place for star-nosed moles to live, for they are not known to occur elsewhere in Georgia, with the exception of one old record from near the Savannah River. Their main range lies to the north, from eastern Canada and the northeastern United States, west to Indiana, and south along the mountains to the Carolinas. Along the Atlantic Coast, records are sparse.

The first report of this creature from the Swamp was made by the famed Okefenokee naturalist Francis Harper. In the early 1900s he recorded that, in a bay stump, Sam Mizell found a nest containing baby moles. If I ever chance on such a nest, especially if baby moles are present, I hope no one is with me. I will lose the prim, straightlaced decorum that typifies all of my activities. That cool detachment, that hand-on-the-chin, carefully practiced look of deep scientific thought that all of us real scientists have will disappear. I will leap about with glee. I will shriek and giggle. I will embarrass myself.

Harper recorded two more occurrences of the star-nosed mole in the Swamp, a mole found by Lem Griffis in 1921 and a nest found by Lone Thrift in 1924. Since then, to my knowledge, only one more has ever been seen in the Okefenokee, a specimen taken by James Satterfield while seining.

Among the family of moles, the star-nosed mole is surely the strangest. It diverged from the main stem of mole stock long ago, before its group even colonized North America. Thus, its lineage is much older than any of the habitats in the region of the Swamp.

The star-nosed mole is one of the few moles that is semiaquatic. It can swim. Its burrows are often made in wet mucky soils. They frequently open into the water, making them hard to find. Individuals forage on the surface in runways, in the burrows, and on muddy bottoms for worms and other small animals.

But what about the nose? The nose of the star-nosed mole is one of the strangest of animal appendages, ranking with the noses of elephants, weevils, and flamingoes. Projecting from the tip is a writhing fringe consisting of twenty-two fleshy tentacles. No other moles have even a trace of tentacles, much less nearly two dozen of them. Zoologists have always assumed that the tentacles have a tactile function, that their delicate sense of touch enables the mole to find food items and find its way about in its dark watery habitat. This supposition is almost certainly true. Observations have revealed that the tentacles are also grasping structures, which perhaps could have been assumed. But this is not the entire story. Recently, investigations have strongly suggested that the tentacles are electroreceptors and are able to detect tiny electrical fields produced by the bodies of prey animals, enabling the mole to locate prey at a distance, without sight or con-

tact. The only other tact. The only other terrestrial mammal known to possess such an ability is at least as strange as the star-nosed mole. It is the platypus, that duck-billed egg layer of Australian streams. It locates crayfish and tadpoles by detecting their electrical fields.

The more we find out about the star-nosed mole, the more enigmatic and interesting it becomes. But I have never seen one. I could perhaps put out traps, or spend days seining in the shallows of the Swamp, and maybe catch a specimen. But this is not really what I desire. I want to see the star-nosed mole going about its life, in its habitual activities. I want to sense it as a part of the Swamp, rather than possess it or subdue it as a specimen. Some day, this year or next, as I walk a shoreline, wade among the lilies, or paddle through the bushes, that nose of all noses, that tentacled proboscis that almost cannot be, will emerge from the water or the muck. Somehow, I will catch a fleeting glimpse, perhaps more, of *Condylura cristata*.

heard by people whose ears have lost the ability to hear high-pitched sounds as a result of age or too much loud rock music. Pygmy rattlesnakes seldom exceed two feet in length. Although they possess venom, there are no documented cases of human fatality. However, one of the early inhabitants of the Swamp, the Native American Hopoithle Tustunnuggee Thlucco, related to the Creek Indian agent Benjamin Hawkins that "a small snake with a button at the end of the tail like a rattlesnake" had killed two people in the Swamp. A few months ago, when leading my class into a swamp in northern Florida, I walked over a pygmy rattlesnake without noticing it. This probably often happens in the Swamp, where this snake is second to the cottonmouth in abundance among the pit vipers.

Coral snakes are present in the Okefenokee region but are seldom encountered in the Swamp. I have not heard of one being found on any of the islands. As far as venom is concerned, the coral snake is more poisonous than any other North American snake, the main component of the venom being a powerful nerve poison. But as far as danger to humans is concerned, the coral snake is essentially harmless. First, it is secretive and seldom encountered. Second, it is so reluctant to bite that many individuals can be picked up and handled without making any attempt to defend themselves. Third, its short fangs cannot penetrate normal shoe leather. Far less than one percent of all poisonous snake bites can be attributed to coral snakes in the United States. Since antivenin became available, there have been no deaths from this species in this country.

I find that coral snake watching is an enjoyable pursuit. Luck has allowed me to observe the activities of coral snakes on several occasions. A coral snake banded in yellow, black, and red on a background of leaves and needles is breathtakingly beautiful. When they are foraging, they probe around with their head, sticking it into holes, under leaves, and generally examining every cavity while flicking the tongue rapidly. Their probing eventually seems to yield a signal that something edible is present, whereupon they follow a hole down or crawl under a log and often disappear. At other times they probe deeply with the front half of their body and then withdraw.

They are hole followers, but I can't really call them burrowers, because I have never seen one make its own hole or even attempt to do so.

One would think that a place like the Okefenokee would be one of the froggiest. Surely with all of this water, frog diversity must be as high as anywhere on the continent. But this is wrong. There are a lot of frogs in the interior of the Swamp, but the islands and edges tend to harbor more species. Frogs, one must remember, are amphibians and lead two lives, one in the water, the other perhaps dependent on land. Where no land exists some frogs cannot survive.

The frog which typifies the Swamp is the pig frog. Experiences in the Swamp always carry with them the background provided by the deep bass grunting of this large olive-brown frog. Adults never leave the water and are easily seen at night by their eye shine.

A close relative of the pig frog is the carpenter frog, which is most common in the eastern portion of the Swamp. The call of the carpenter frog, a repeated "tack-up, tack-up," has given it its name. When the call is heard at a distance, the resemblance to hammering is remarkable. I remember nights in the late 1950s when the din of carpenter frogs on Cowhouse Prairie was, although not deafening, loud enough to occasionally interfere with conversation among those of us who waded there. At that time, the area was much more open than now, and sphagnum was more abundant. Shrubs and trees have since invaded, the fire regime has changed, and carpenter frogs seem scarcer.

Salamanders comprise the other major group of amphibians but do not tend to be nearly as familiar to us as frogs. Salamanders have no voices or only the tiniest voices. They neither hop nor leap. They are secretive, some coming out only briefly to breed. They resemble lizards to the extent that some call them "spring lizards," but they lack scales and other reptilian features.

The Swamp and environs harbor at least a dozen kinds of salamander, and a few more may occur here and there on the periphery. Deserving of mention are the sirens, eel-like, permanently aquatic

salamanders with a tuft of external gills and only two pairs of legs, the front ones. At least three kinds populate the Swamp. The smallest, less than a foot long, is about as thick as a pencil and has stripes running the length of the body. They are seldom seen. The two larger types lack prominent stripes and are generally dark in color. The larger of these, the greater, or giant, siren, may reach a yard in length and is sometimes caught on hook and line. Sirens only occur in southeastern North America.

The rare flatwoods salamander, a beautiful gray animal with a net-like pattern of white, may occasionally be found under logs in moist open pine forests. Flatwoods salamanders need relatively undisturbed pinelands in which to forage. They breed only in temporary ponds free of fishes. Recently, when this species was proposed for protection as a threatened species under the Endangered Species Act, strong objections came from representatives of the forest industry. Here again, as with the red-cockaded woodpecker, some believe that if they own land it is their right to treat it however they want to even if things done on their land have detrimental results for natural places and people outside of the property boundary. Somehow, the respect with which the original inhabitants of the Okefenokee treated the land must again come to dominate our ethic. Those with bedsheet faces who dwell in the penthouse office suites in the megalopoli should perhaps spend a few weeks in the Swamp.

There are many fishes here, but not a large number of kinds, Josh Laerm and Bud Freeman reporting thirty-six species in their thorough study. It is easy to understand why fish diversity in the Okefenokee is low. The Swamp lacks many kinds of fish habitats, including rocky streams, spring runs, muddy rivers, and estuaries. Even so, the fishes of the Swamp are an interesting group. One has to seine, dip, trap, and fish by various methods to really become familiar with them. My knowledge is largely limited to those that have appeared in my dipnet, some that can be seen by peering into the water, and a few that I have seen fishermen hook.

The Swamp is a place of sunfishes. Members of this fish group are generally denizens of slow waters, pools, and vegetated habitats.

Around a dozen types may be found, making up a third of all types in the Swamp. Some, like the largemouth bass, bluegill, and black crappie, are common game or panfishes and are familiar inhabitants of many waters in the eastern United States. Others, like the warmouth and spotted sunfish, or stumpknocker, are known to most fishermen but not to others. The rest of the sunfish are obscure and little known except to scientists and those whose interests run to the obscure. These are the ones that are the most fascinating, maybe because to know something about them is to have knowledge that most lack.

The beauty of the sunfishes is nearly unsurpassed by any other group of fishes, although it is a more subtle resplendence than the gauche and blatant displays seen in the average aquarium. My favorite is the bluespotted sunfish, a jewel of a fish that seldom reaches more than three inches in length. A well-colored specimen has rows of shining silvery blue spots along the sides which change in iridescence as the fish swims past. The anal fin may show delicate pinkish-orange hues. The second word in the scientific name of the species, *gloriosus*, shows that at least one other shared my feeling about its beauty. The related blackbanded sunfish is also a handsome fish, having irregular vertical black bars on the side and with the leading portions of the dorsal and pelvic fins often having bright red-orange and black markings.

The tiniest gems among the sunfishes are the pygmy sunfishes, none of which reach even two inches in length. Males have shimmering iridescent blue bars on the sides. Two species occur in the Swamp, both inhabiting areas of dense vegetation and feeding on any tiny moving animal. I have always found it a little disconcerting that of these two, the Everglades pygmy sunfish seems to be more common in the Swamp than is the Okefenokee pygmy sunfish. The Okefenokee pygmy sunfish was given the name because it was first discovered in the Okefenokee area, even though it occurs throughout southern Georgia and northern Florida.

The largest of the Swamp's fishes, the Florida gar, is also one of the most fascinating. It reaches lengths of a yard or slightly more. Groups of Florida gars may be seen hanging quietly near the surface

in still-water areas throughout most of the Swamp. Their long snouts and numerous needle-like teeth are adaptations to facilitate rapid sideways grabs of the fishes on which they mainly feed. They are seldom caught, because their mouths lack fleshy tissue in which a hook can lodge. If they are to be eaten, they have to be shucked first, which entails removal of the heavy shell-like covering of quadrangular scales. As with all gars, the eggs and larvae are poisonous to warm-blooded animals. The significance of this may be that some of the predators and scavengers of the Swamp leave gar eggs alone. But is this really of any significance when one considers all of the potential egg and larval fish eaters, from amphipods to amphibians, most of which are unaffected by the toxins? Maybe the toxin has other purposes.

The other large fish of the Okefenokee is the bowfin, also called dogfish, grindel, or mudfish. It may reach lengths of over two feet, although most adult bowfins one sees are around eighteen inches or so in length. Males are smaller than females and have a black spot surrounded by orange or yellow at the upper base of the tail fin, as do all young bowfins of both sexes. The eggs stick together in a clump and are guarded by the male.

A few years ago as I walked along the western point of Mixons Hammock, I saw a dark circular mass in the water. Closer inspection revealed it to be a mass of baby bowfins. Hovering at the edge of the group was a large male bowfin, guarding his young. After hatching, bowfin young stay together in a tight group as they move around feeding. The male stays with them until the group breaks up when the young are about a month old. Such tight groups of young may look like a large animal to predators, offering the young some protection until they reach a size which enables them to successfully fend for themselves.

The most famous fish of the pickerel family are game fishes such as the muskellunge and northern pike, of more northerly waters. The pickerels of the Swamp are much smaller, although their predatory habits and behavior are similar. The chain pickerel, or jack, may reach lengths over two feet. The smaller redfin, or grass pickerel, is usually less than a foot in length. I have often watched grass pickerels

hanging partially concealed among the vegetation waiting for something of edible size to venture by. When prey is detected, their rapid rush raises a characteristic ridge on the water surface. Capture is usually too rapid to be clearly seen. Grass pickerels seem to have a favorite spot from which to hunt. I have seen what appeared to be the same fish lying in wait in the same spot day after day.

One fish seen by essentially everyone that visits the Swamp is the inch-and-a-half-long star-headed topminnow. At least it used to be called by that name. Currently, to be technically correct, we must call it the lined topminnow, for the star-headed species was found to really be two species, and it clearly wouldn't work for both to have the same name. But the old name is still apt, and the fish is very easy to spot, because in addition to having many conspicuous black lines on the side, it has the star, a clearly visible light-colored white blotch on the top of the head. Topminnows, with their upward pointed mouths, take advantage of the high amount of oxygen in the surface layer of the water and thus can live in places where the lower part of the water column is deficient in oxygen.

The tiny mosquitofish, the larger females seldom reaching more than two inches, may be the commonest of the Swamp's fishes, occurring in abundance in most shallow quiet areas. It is capable of colonizing almost any body of water that is connected to permanent water by a trickle or freshet. Its upturned mouth allows it to pass water from the well-oxygenated surface layer past its gills, enabling it to survive in habitats where most other fishes cannot. Although it does feed on mosquito larvae, other small animals and even some plant material may be included in its diet.

Even though we concentrate on mammals, birds and the larger animals of the Swamp, the smaller and, to us, lowlier forms of life are much more numerous in kind and numbers. More than dozens of lifetimes would be necessary to catalog them all. Little attempt to do so has been made up to this time. Most visitors will never see the smaller species, either because their observational abilities have not been honed to do so, or because they lack the proper aids to sight, hand lenses or microscopes. A completely different world emerges

when a part of nature is magnified. One of the most captivating is the life in a cup of swamp water. At times, usually in the winter when the colder water holds more oxygen, a cup of water dipped from a site near the edge of the Swamp may literally seethe with life. Green stentors, large one-celled animals, revolve about with a peculiar rhythm. A half a dozen kinds of copepods, small crustaceans, oar themselves through the water with their antennae. Tiny spheres buzzing here and there are seed shrimp, their bodies protected by a two-valved shell, their legs reaching out and propelling them at amazing speeds. Water fleas jerk along. Sac-like bright-colored mites slowly propel themselves. On the bottom, tiny plump green planarians slide slowly through the ooze. Stalked goblet-like vorticellas jerk back when disturbed. At this scale, the natural system is as complex as it is to our unaided sight, and far more mystical.

Many of the Swamp's insects are large enough to see with the unaided eye, especially when in their adult stages. How many kinds of insects occur? My rough guess would be that a minimum of ten thousand types are present, quite a few of which have yet to be discovered by science. Every insect of the Swamp has a fascinating story, some of which are not yet known and most of which are seldom told. I will resist the temptation to relate to you all of the accounts of these small lives that I have come to know. Instead, I will merely wander once through the Swamp and tell you about a few that I have seen.

Out near the end of the Pocket, I rested my hand on a small oak, only to discover that I was also leaning on a soft grey caterpillar whose back was colored so much like the lichens on which it rested that I probably wouldn't have seen it had I looked. Even the closest glance at a part of the natural world seldom reveals all that is there. This caterpillar would eventually turn into one of the underwing moths who, as adults, also rest on tree trunks. Their front wings, which cover the body when at rest, are colored like the bark. But their hind or underwings are often brightly colored with orange or red with black bands and tend to startle animals or humans when they are suddenly flashed from behind the camouflage of the front wings. Many of the caterpillars of this group feed on hickory leaves, but a fairly common one in the Swamp, sometimes called the little wife,

feeds on wax myrtle, which few insects can eat because of the toxic substances in the leaves.

One of the rarest southern moths is the Okefenokee zale, a member of the underwing family of moths. Its food plant is the vine wicky, mentioned earlier in the chapter on plants. Its beautiful red, black, and white larvae are present in the spring. Finding one of these larvae is one of the rewards of learning the strange under bark habit of the wicky.

Butterflies of many types are abundant here, but up in this water oak, I see one that is rarely caught in its present activity. Around the many clumps of mistletoe on the tree, flittering shapes can be seen. These are adult purple hairstreak butterflies, one of the most beautiful North American species. Hairstreaks have those strange antenna-like appendages on the ends of the wings. By moving these they reduce the success of bird predators, because the false antennae make the bird misinterpret which portion of the body is the head and in which direction the evading butterfly will take off. These hairstreaks are looking for mates and for places to deposit eggs. In the spring and summer, examination of mistletoe will often reveal the handsome, green, almost slug-like caterpillars.

On April 18, 1922, Francis Harper, the Okefenokee biologist who was staying on Chesser Island with Miles Pirnie and Albert Hazen Wright, wrote in a letter to a friend back at Cornell University, "We are well protected while working, eating, and sleeping, from the mosquitoes and gnats, and they are not even very bad outside." So even then, the Okefenokee was not erupting with pestiferous insects. During most times of the year, the central area of the Swamp has few mosquitoes. More acid water may affect the reproduction of some mosquitoes but others are not impacted. Maybe when the cypresses age, the treehole species of mosquitoes will become more abundant in the Swamp. Regardless, biting fly numbers in the Okefenokee have never been comparable to the marauding, maddening mosquito densities of places like the Fakahatchee Strand, Flamingo in Everglades National Park, or Malheur Refuge in Oregon.

No-see-ums, horse flies and deerflies abound in areas around the edge of the Swamp but are seldom impossible to tolerate. At Stephen

Foster State Park I once saw the beautiful green horse fly, *Chlorotabanus*. I ask you, probably futilely, to look closely at the eyes of horse flies. They are the stained glass windows of the insect world, being patterned with multicolored iridescences beyond description. Looking horse flies in the eye can be a pursuit akin to birdwatching.

Dragonflies perch and hover throughout the Swamp. I have seen what appear to be at least a dozen species. Far back in time, as the coal we burn today was being formed in ancient swamps, dragonflies with fifteen-inch wingspans patrolled. Today, the wings of the largest in our area span about seven inches. Nowadays birds are the large flying predators of the daylight. Dragonflies capture small insects in the air and eat them while on the wing or while perched. Several hundred small flies and mosquitoes may be seized and consumed in a single day. Below, in the inky water, dragonfly nymphs extend their scoop-like lower jaws to capture tadpoles, small fishes, and other aquatic life. On a road leading into Seldom Seen Point in the northwestern Swamp, I once saw two dragonflies collide and tangle in the air, with a great amount of papery buzzing. Shortly, one fell to my feet and I saw that it lacked a head. What had happened? Territorial disputes are common among male dragonflies, but I had not realized that sometimes these are battles to the death.

In the quiet shallows at the edges, swarms of shining black motes can be seen revolving and circling. When approached, the swarm turns into a mass of confusion as each mote accelerates and the circles widen. These are the fat-bodied whirligig beetles, the common surface beetle of the Swamp. A swarm may sometimes contain thousands of individuals. Exactly what they are doing on the surface no one knows. They are said to feed on small insects that fall onto the water and become entrapped in the surface film. The eyes of whirligig beetles are double, one part being adapted to seeing under water, the other to detecting events above in the air. Their legs are the most efficient paddles ever devised by nature. When agitated they speed along at a rate which would equal sixteen hundred miles an hour, were they as large as a Volkswagen Beetle. Each type of whirligig beetle has its own peculiar odor, some smelling like apples, others like indefinable concoctions of natural essences. These aro-

A black swallowtail butterfly (*Papilio polyxenes*) on Chesser Island.

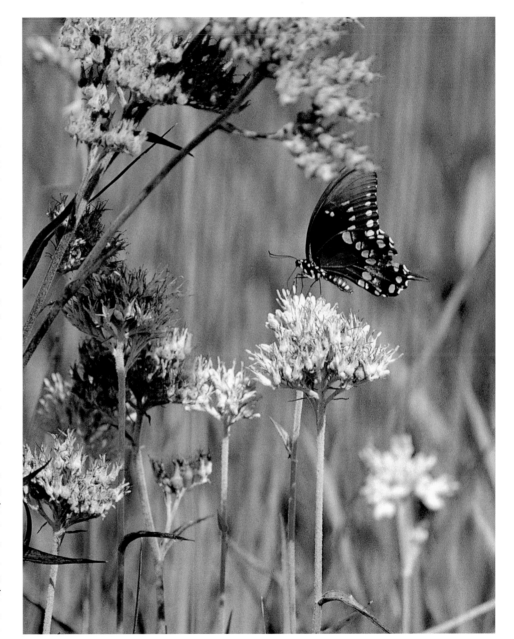

Damselfly (Zygoptera family).
Big Water.

Orb weaver spider in the center of its web. Suwannee River Narrows.

mas may come from secretions designed to make them impalatable to fishes. A book could be written on the wonders of whirligigs.

Wandering among the wooded parts of the Swamp, especially in the late summer and fall, often involves walking through the webs of spiders. Many are horrified by such an experience, especially if one of the eight-legged inhabitants of the web ends up stuck to the face. However, none of the orb-weaving spiders that build the symmetrical webs with the many radii and circles can harm a human in any way. The strongest web that one might walk through would be resistant enough to breakage that the extra effort needed to push through it would be noticeable. This would be the web of the largest spider of the Swamp, the golden silk spider. The web is also large, sometimes being ten to fifteen feet from one corner's anchorage to another. The females in the web have bodies like short sausages, tufts of hairs on the legs and usually rest facing downward in the center of the web. One or several males may eventually be found in the web with the female. Also frequently present are small spiders shaped like and with shiny surfaces like water droplets. These unrelated species live in the webs of larger spiders, where they seem mainly to feed on insects too small to be worthy of notice by the owner of the web. Golden silk spiders of various types occur throughout the tropics and subtropics of the world. Some of the species have webs strong enough to entrap bats and birds.

As I look at all of the living things that strive here in this sodden kingdom, I am reminded that no single animal or plant is ever really alone. Neither are you nor I. Dwelling in the innards and clinging to the surfaces of every species mentioned or seen are beings who make their living by taking their sustenance from the bodies of others. Their Swamp is the watery folds of the intestinal linings, the heaving pockets and chambers of the lungs, the pulsating surges of the blood. I have ignored these entities for too long, because their role in the Okefenokee is probably more important than that of many animals mentioned conspicuously in these pages. Parasites can moderate competition, control population levels, affect behavior, alter reproductive success, and reduce their hosts to carrion. Who runs the

The Kinds of Gator Fleas

Somewhere about ten miles northeast of Edith, east of the Suwannee, in the southern part of the Swamp, I wade out with my dipnet, hoping to capture something of interest by randomly dipping here and there. As I leave dry land I gradually sink deeper and deeper into sphagnous masses of vegetation interspersed with tiny pools. Cottonmouths, alligators and other fabled "dangers" of the Swamp never cross my mind. None really offers much of a threat. I come here to look for beetles, bugs, tadpoles or any other inhabitant of these waters that I can temporarily capture with my net. As I wade about, from the waist down I more or less become one with the swamp. Suddenly a sharp burning needle stab affects my left calf. I draw my leg up, hobbling and hopping on my other leg, using my dipnet as a crutch, barely maintaining my balance on the peaty underfooting. I slap and rub at the affected area and the pain diminishes. I can't determine by feel whether I mashed, removed, discouraged, or somehow set back the intentions of the attacker, or even if there was an attacker at all. Between my skin and my pant leg there are hundreds of particles of peat, leaf fragments, half-decayed wood, and other detritus. It seems like any of these could have been the offender, unless it was a creature of some kind. Actually, I know that the attacker is, or was, something alive, and know with some surety what it was. I am something of a taxonomist of minor pains of the kind one experiences when wading in swamps. I am among those unfortunates that will invariably be bitten, stung, chafed, or inflamed by anything that has the equipment to do so. Poison ivy vines cackle and clutch at me as I pass. Ticks assemble in joyous celebration when it is rumored that I am around. I hold international records for lesion size, number of suppurations, and welt longevity.

In this case, the pain was caused by a type of large backswimmer. These common aquatic bugs live their lives upside down, rowing about with long middle legs, attacking and sucking the life from smaller entities. When they are disturbed, such as when they are washed up the pant leg of a wading human, they attempt to puncture anything handy, in the hopes that it will deter the annoyer.

The beak of a large backswimmer is about a tenth of an inch long, although it feels more like a yard-long flaming sword. Its tip is needle-like. When it punctures prey or person, a fluid is injected which tends to cause intense localized pain. I try to keep from thinking about how this process may feel to the tiny aquatic beings on which the backswimmer preys.

The pain diminished, I wade on. Several yards and half an hour later I again leap about like a hooked bowfin. This time the pain is on my right instep, and I can feel something writhing and scuttling inside my sock. I reach down and hammer the area madly with my fist. I succeed in driving the wounding object in farther. The pain intensifies and then fades. Pulling down my sock, I discover a dark green flattish oval animal about a third of an inch long. It has what, under the circumstances, appear to be malevolent crimson eyes. It is the red-eyed bug, the creeping water bug, an animal that for its size is one of the most powerful predators in these waters. Equipped with muscular forelimbs, it crawls about among the vegetation preying on anything it can subdue.

The backswimmer and the red-eyed bug are among the many crawling, swimming, squirming things in the Swamp that natives in the mid-South often call gator fleas. Few of them ever bother alligators, but the name reflects the fact that they are biting creatures that often pester humans who stray into alligator habitat.

The largest of the gator fleas are the giant water bugs, fairly common in some waters but more often encountered when they are attracted to lights near human activities. They are leaf-shaped and range to over two inches long. The predatory beak of the largest ones can be nearly half an inch in length. A friend of mine, who happened to get one lodged between his collar and his neck, screamed profanities at a high decibel level for several minutes.

Among the other gator fleas are the water tigers, larvae of large

aquatic beetles. Their scimitar-shaped hypodermic jaws can inject a venom that causes intense pain. Itches and inflammations of a variety of types may be caused by the larvae of small parasitic worms which seek to burrow into the skin of any animal that resembles their normal hosts, usually waterfowl. I calculate that there may be a total of over three hundred types of insects, worms, crustaceans, mites and other swamp-dwelling animals that can administer small painful experiences.

Lest you get the wrong idea, the presence of gator fleas does not lessen the joy of wading in the Swamp. These experiences bring an intimacy with the Swamp's living things that can be gained in no other way. When others are present, they offer interludes of unparalleled humor.

The gator fleas are as much a part of the Swamp as the alligators. One cannot deeply understand the Swamp without some experience with them. Those of us who commonly meet them value our skirmishes as much as we would cherish an encounter with a bobcat or swallow-tailed kite.

Shadows now advance upon the waters in which I slog. Barred owls begin to ask their eternal question. Frogs inaugurate an evening of invocations. While there is still enough light to see, I wade out to the road, wearing my blisters and blebs like badges of honor, ephemeral souvenirs of today's encounters with some of the beings of the Swamp.

Swamp? Maybe in their peculiar writhings, the malarias, tapeworms, spiny-headed worms, flukes, ticks, mites, and leeches speak with some authority about the fate of all things here. Too often we withdraw from what seems hideous. More often we seek to expunge the strange, the clinging, the worm-like beasts. Sometimes we have to in order to survive. But there is good reason to hug a maggot, to respect the leech, and to salute the tapeworm. If you can begin to believe this, you have come a long way toward the true ethic of conservation.

The original animal life of the Swamp can only be imagined. Panthers, red wolves, ivory-billed woodpeckers, Carolina paroquets, limpkins, and snail kites are gone or reduced to insignificant rarity. Although there are nearby places, such as Pigeon Bay in Clinch County and Pigeon Branch in Glynn County, that commemorate the abundance of the passenger pigeon in south Georgia, no one alive has ever seen their thundering flocks. Our culture, our countrymen exterminated the most abundant bird in the world. Alienated from nature by technology, greed, and ignorance, we are not likely to ever experience these animals again nor the Swamp as a really natural place. Those who think dominion means domination and that it allows destruction now control all life on this planet. A wastrel society rules more of the earth each day. But this too shall pass. There will come again a time when the howls of the red wolf, the scream of the tiger, and the cry of the limpkin will return. But it may take a gentler, more tolerant and much wiser culture to again experience these sounds.

A wolf spider (Lycosidae family) camouflaged by the lichen and the gray bark of the tree. Suwannee River Narrows below Billys Lake.

Orb weaver spider (Araneidae family) at Craven's Hammock.

Cicada in the Middle Fork of
the Suwannee River.

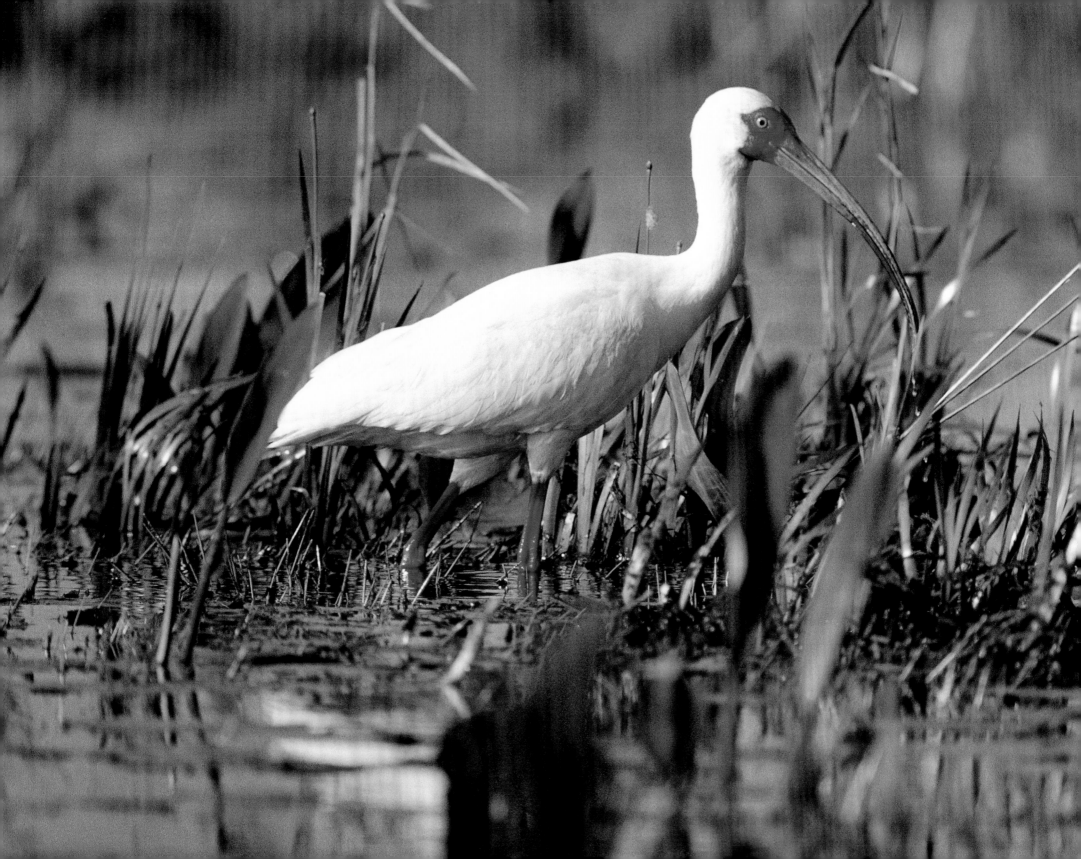

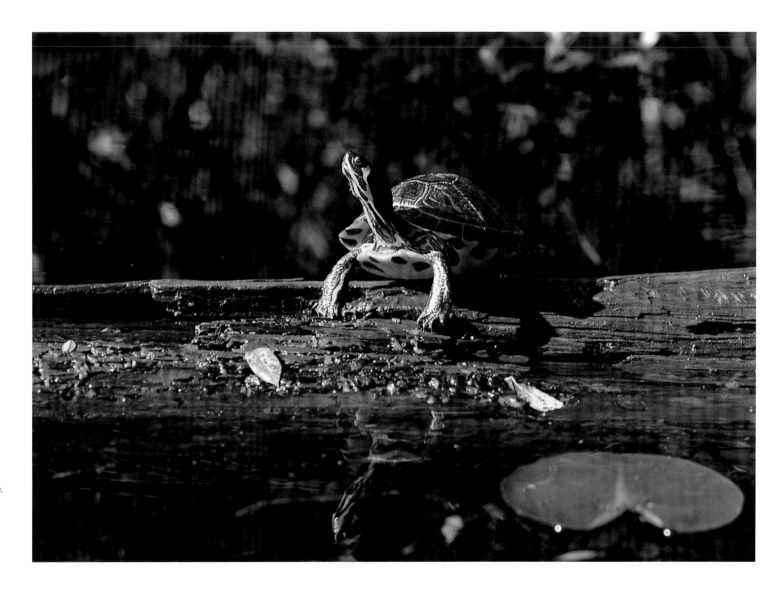

< White ibis feeding in the shallow prairie. Chase Prairie.

A turtle (*Chrysemys scripta*) keeping a wary eye. Middle Fork, Suwannee River.

> American alligators abound
in the swamp, having recov-
ered from being overhunted.
The alligator, along with the
osprey and the bear, is at the
top of the food chain.

The claw of a large American alligator. Suwannee River Narrows to the sill.

> An American alligator (*Alligator mississippiens*) guarding its territory on the boat trail to the sill in the Suwannee River Narrows.

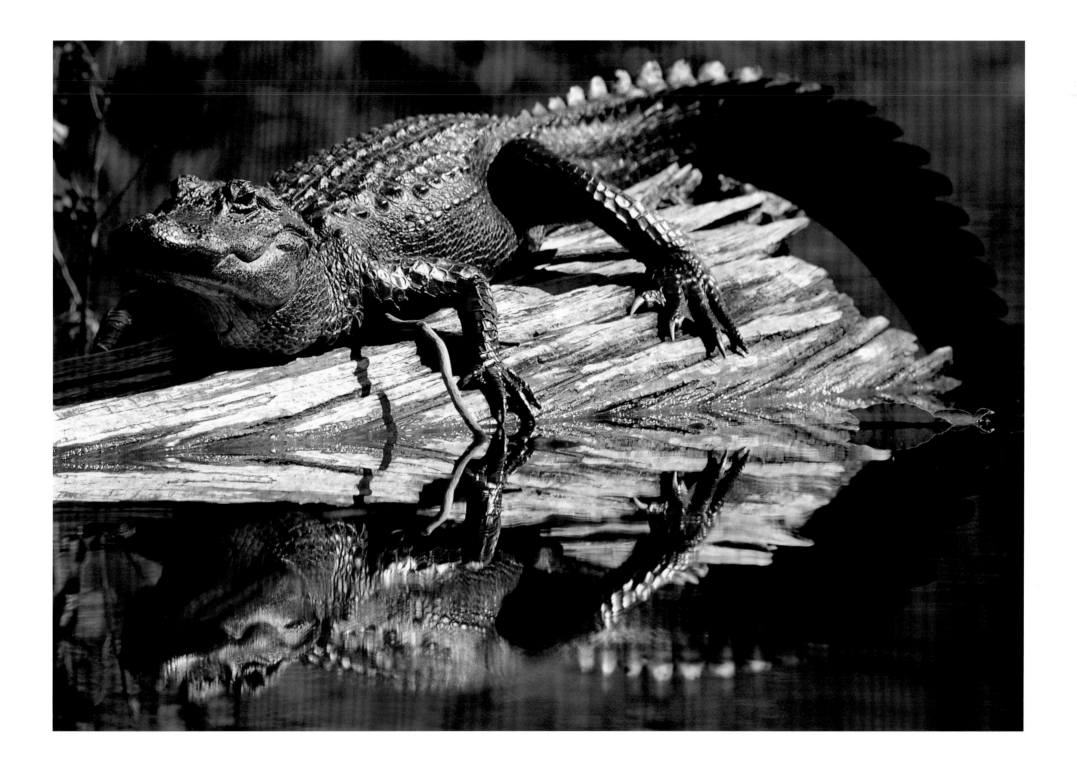

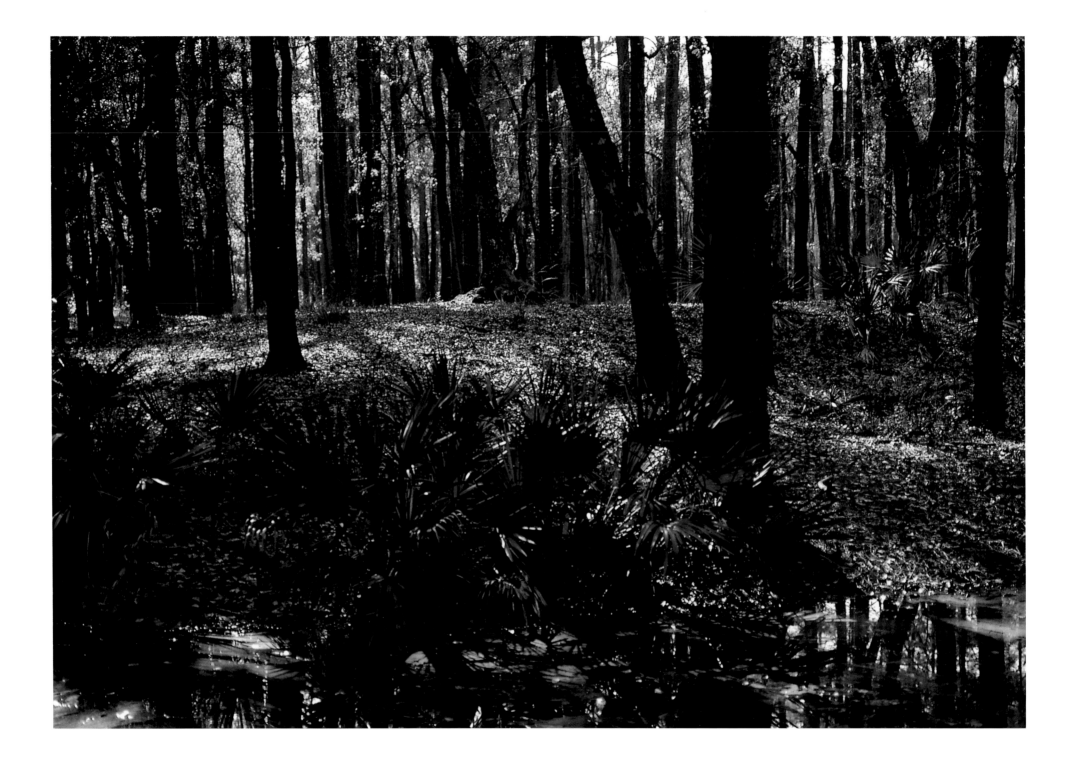

4 HUMANS AND THE OKEFENOKEE

"What is man that thou art mindful of him?" These words of the psalmist remind us that we are but one of the many species dwelling on this orb. In our frailty, our insecurity, we tend to view ourselves as the zenith of creation, as a shining pinnacle of evolution, as the only essential being. This perspective tends to dominate our study of history and colors our relationships with all life. Western societies cling especially hard to this fiction, using it to justify the consumptive use of the world. This sentiment has shaped most recent human interactions with the Okefenokee and continues to do so today. It clearly shapes this book, because I devote this chapter mainly to one species, *Homo sapiens,* as if we are the most important type of organic being on this backwater sphere, other less significant species having all been consigned to previous chapters.

How far back do we have to go to understand the history of our relationship with the Swamp? If we view our culture from a realistic historic perspective, it hardly exists at all? Although the Swamp in its present form is also relatively young from a geological perspective, all of its components are much older, and the processes that have formed this wetland are ancient beyond reckoning. Hints of the birth of the Okefenokee existed along the abyssal length of the mid-Atlantic ridge as its fiery burblings and moanings drove the floating continent of North America westward, separating it from the rest of the pieces of the ancient Laurasian land mass. As repeated cycles of warming and cooling, associated with glacial events, flooded and then exposed the land where the Swamp now rests, the Swamp's embryo was forming. Nearly a quarter of a million years ago, sand began to pile up along the Atlantic Coast, eventually creating that spine of sand that now forms the eastern boundary of the Swamp. This feature, Trail Ridge, soon lost its contact with the coast, becoming an inland feature before the first human wanderers reached the Swamp. At the same time, cave-ins resulting from dissolution of the underlying limestone bedrock were perhaps participating to form the beginnings of the Okefenokee depression.

When did humans first see the Okefenokee? Currently, archaeologists are embroiled in a controversy about when people first reached North America and are beginning to revise traditional ideas, at least to some extent. Perhaps ancient seafarers from Europe or European migrants to Asia also participated in the early colonization of North America. Some think that the eastern seaboard could have been colonized as long ago as eighteen thousand years before the present by a group from southwestern Europe called Solutreans. Projectile points associated with the Solutrean culture in Europe are essentially identical to the famous Clovis points associated with early human evidence in the western United States. However, no Clovis points have ever been found in the Swamp proper, and no strong evidence exists that the Solutreans ever tread the Southeast.

Controversy aside, sometime between eighteen thousand and eleven thousand years ago, human beings first looked upon the Okefenokee, or at least the place which became the Okefenokee. Recent finds of a twelve thousand-year-old point in Darlington County, South Carolina, indicate that humans had colonized the southeastern portion of North America by then. At least by twenty-five hun-

<After a four-thousand-year-long occupation of the swamp, Native Americans departed leaving burial mounds and artifacts behind. Billys Island, 4 1/2 miles long and 2 miles wide, is the site of this mound. They also left us the gift of the swamp's name. The word *Okefenokee,* meaning land of the trembling earth, refers to the islands of floating masses that support trees and bushes and move when someone walks on them.

dred years ago, and probably long before, native peoples had made the Swamp their home during some seasons of the year. Pottery made by these peoples is among the earliest known in North America. The clay from which the pots were made often contains remnants of plant material which seemed to have been mixed with the clay before firing.

The earliest potters were followed by peoples of groups now referred to as the Depford, Swift Creek, and Satilla cultures, who perhaps settled the area as early as 500 B.C. Exactly how these people lived is open to question. There is little evidence that they were agricultural. They probably subsisted by gathering foods, hunting, fishing and trapping. They seem to have moved in and out of the Swamp as seasonal changes occurred.

People of the Weeden Island Culture colonized the Swamp area around A.D. 500. In contrast to the earlier groups, Weeden Island peoples made permanent villages which were built in association with burial mounds. Evidence indicates that the burial mounds were prepared when a chief or important person died. The mounds left by the Weeden Island groups still can be found at sites around the edge of the Swamp, notably on Chesser Island, Cowhouse Island, Billys Island, and Mixons Hammock.

Our understanding of the earliest native Americans is made difficult by the absence of a written history. No groups in southeastern North America had developed a written language. This sometimes causes us to act as if these peoples did not exist. However, in the proper perspective, we must acknowledge that most of the history of human interaction with the swamp is a history of these peoples. Humans of European ancestry have been on this continent for a few hundred years, a wink of time compared to the hundreds of generations of American Indians who lived and died with the Okefenokee and its environs as their home. The history of the accumulation of facts about pre-Columbian native American cultures seems to indicate that these peoples were more abundant and their cultures more complex than we usually imagine.

Indian residence in the Swamp continued to the time when the first contact with Europeans occurred. Although no precise date can be given, Spanish explorers, missionaries, and military groups probably entered the area in the late 1500s. In the early 1600s, maps made by Spanish cartographers call the Swamp "Laguna de Oconi." At this time, missions had been established at Timucuan Indian towns around. Historians believe that these towns were established by Native Americans driven north from Florida by the Spanish. If so, their flight did not protect them for long, for in 1656, Spanish soldiers burned their villages.

For some reason, members of the Creek group of Indians seem to have never colonized the Swamp, although they inhabited the surrounding lands. What were the reasons for their absence? Perhaps remnants of earlier peoples still inhabited the Swamp, causing the Creeks to avoid an area already being used. Possibly some superstitious avoidance was associated with the Creeks' idea that the mystical Tasketcha tribe inhabited the Swamp. The Creeks, like all previous groups that came into contact with whites, were eventually driven out or eliminated, the Creek Nation being forced to give up its lands in southern Georgia in the early 1800s.

At about the middle of the eighteenth century, the Seminoles began using the Okefenokee as a refuge. They continued to use the Swamp sporadically until about 1840. There is little archaeological evidence to tell us much about their activities in the region.

The period from 1835 to 1840 marks what must be considered the most trouble-ridden time in the Swamp's history, as least as far as conflict between whites and native peoples. This period is often referred to as the Second Seminole War. Following Dade's massacre in northern Florida, in which thirty-four members (all but three) of the Third U.S. Artillery unit were killed, passions seemed to increase in the region. The Seminoles who won the battle at Dade's massacre were responding to the U.S. government's expressed intentions to make them leave their Florida homes and be shipped west to Oklahoma.

In 1836, whites took what they considered to be partial revenge for Dade's massacre when a small group of militia under the com-

Sardis Baptist Church was established in 1821 by American settlers on the east side of the Okefenokee Swamp. Folkston, Georgia.

mand of Captain William B. North ambushed a group of Indians near the site of the present-day Griffis Fish Camp. Fourteen Indians were killed. This conflict is sometimes referred to as "Battle Bay."

In 1838, a small band of Seminoles under the leadership of Caocoochee (Wild Cat) moved into the Okefenokee. After various alarms, rumors, skirmishes, and the Indian massacre of a white family near the site of present Waycross, General Charles Floyd took his troops into the Swamp, determined to cleanse it of Indians. They found only one small band of Seminoles, and killed one of them. This skirmish seems to mark the end of an Indian presence in the Swamp. At least General Floyd claimed that the Indians had left the Swamp and gone south.

In 1891, the Suwannee Canal Company paid the State of Georgia 26 cents an acre for 380 square miles of the southeastern portion of the Swamp. Captain Harry Jackson, a well-known lawyer from Atlanta, became the president and was the main force behind the company. Their plan was to dredge a canal from the Swamp to the St. Marys River and also into the southeast portion so that the virgin cypress could be removed and barged to sawmills along the Atlantic

Coast. Drainage of the Swamp was foreseen as another benefit of canalization, allowing development of the land for crops such as cotton, sugarcane, and rice. From Camp Cornelia (named after Harry Jackson's daughter), now better known as Refuge Headquarters area or the Suwannee Canal Recreation Area, they began dredging westward into the Swamp, using massive steam dredges. To the east the drainage ditch was attempted toward the St. Marys, cutting through Trail Ridge. This latter trench was not easy to construct. The unsloped banks of the initial attempt, constructed by convicts' hand labor, collapsed during heavy rains. Even steamboat dredges accompanied by hydraulic dredging methods eventually failed, causing the emphasis to be diverted to the canal running into the Swamp. In 1894 a sawmill was constructed at Camp Cornelia. During the three years that followed, millions of board feet of cypress lumber and shingles came out of the mill. The Suwannee Canal, running westward, eventually reached over eleven miles in length.

Perhaps the factor that saved the Okefenokee was the untimely death of Harry Jackson. In late 1895, at the age of only fifty, he died following surgery to remove his appendix. As a result of financial problems, partially resulting from inept management, the Suwannee Canal Company ceased operations in mid-1897 and eventually went into receivership. The Swamp folk came to think of the efforts of the Suwannee Canal Company as Jackson's Folly, deriding but still commemorating the man under whose leadership the project was initiated.

The legacy of the Suwannee Canal Company remains today in the form of the Suwannee Canal, the major method of access to the southeastern region of the Swamp. From the air, one can easily make out the remnants of side canals from the Suwannee Canal and see the remnants of the pullboat runs in some of the areas logged. The ditch through Trail Ridge also exists as a leftover of this effort.

The drainage of wetlands continues today. Other canalization schemes such as the Tennessee-Tombigbee Waterway, although clearly follies worse than Jackson's, have succeeded as a result of more sophisticated technologies, more effective lobbying and pork

The Hebard hunting cabin on Floyds Island, accessible by canoe and only with a permit. The island is 4 1/2 miles long and 3/4 of a mile wide.

of the Swamp built much of this mileage. By 1927, much of the cypress easily reached was gone, and Hebard and several other companies ceased operation. But smaller groups continued logging, some into the 1940s.

There are a few small stands of old-growth cypress left in the Okefenokee, but the grandeur of the ancient cypress groves which once dominated much of the Swamp will have to be imagined, because no one alive today has ever seen these stands or will live to see them regrow. Baldcypress over one thousand years in age are known from many portions of the range of this species in North America. Most of the baldcypresses in the Swamp today are less than a hundred years old. Near Dinner Pond, and perhaps in a few other tiny spots, one can catch a glimpse of what once was. But a millennium must pass before the Swamp again resembles its primal state.

Although logging is no longer done on the Refuge, much of the Okefenokee system is still subject to damage by forestry practices that do not consider the long-term health of the land. In 1902, Roland Harper noted that the yellow pitcher plant, although not abundant in the flat country along the coast, grew "in the countless millions in the rolling pine-barrens a little farther inland." In the 1950s, and even up to the very early 1970s, this plant was commonly seen in southeastern Georgia. In those days I once counted more than a hundred sites where it grew along the road from Tifton to Waycross. Yet today, one can drive that same stretch of road and be lucky to notice a clump or two of the plant. The open pine forests, which frequently burned, have been replaced with even-aged closely spaced pines which grow up and are cut for pulp in twenty to thirty years and then replaced by more of the same. Fire is carefully suppressed. The domination of southeast Georgia by this type of forestry eventually spells the doom of all natural systems in the region, even the Okefenokee, because no natural site can exist in isolation from other wild places. Although this region of Georgia was cut over early in the century to the extent that it was described as "a forest of stumps," the forests that grew back did so by more natural processes than those of the current era. The closely spaced pine plan-

barreling, and bureaucratic egomania. During the century since Harry Jackson attempted to drain the Okefenokee, much has been learned about the value of wetlands and their importance to the future of our planet. This knowledge has had small total impact on the activities of our culture. Harebrained destructive schemes proliferate still.

In 1901, the property formerly belonging to the Suwannee Canal Company was sold to the Hebard family, who formed the Hebard Cypress Company in order to extract cypress timber from the Swamp. Starting in 1901, this company, along with another group who mainly wanted the pines from the islands, began building logging railroads into the Swamp. On the Pocket, near where Stephen Foster State Park now stands, and on Billys Island, logging camps very much like small towns were built and were the homes for hundreds of workers for several years.

Over the years nearly five hundred miles of railroads were built in the Swamp. Other companies that worked mainly in the western part

The Lees Leave Billys Island

The idea of "property rights" is a phenomenon peculiar to the modern age. Throughout human history most of the earth's peoples had little concept of "ownership" of land. Native Americans were continually puzzled and confused by European ideas of "title," "buying and selling of land," and expressions such as, "This is my land!"

The Lees of Billys Island created a home on land that was unoccupied and became theirs because they made there a happy place to live. They had no legal title to the land. Unlike the Chessers of Chesser Island, they had made no agreement with Hebard Lumber to have legal rights to their land. Because the Homestead Act did not apply to Georgia, it did not protect their ownership. Their rights were gained by what they had created on the island and were respected by other families of the Okefenokee community. For the Lees, Billys Island was a felicitous home. To quote Eugene Velie, a Lee family member, they existed in a state like that described earlier by William Bartram, in which their life " was like that of the primitive state of man, peaceable, contented and sociable. The simple and contented calls of nature being satisfied, we were together as brethren of one family, strangers to envy, malice and rapine." If you cannot imagine what such a life was like, and for most of us it is quite impossible, contemplating the picture of Noah Lee eating huckleberries on Billys Lake in 1921, reproduced on the cover of Francis Harper and Delma Presley's *Okefinokee Album*, may help.

James Lee, of the same Lee family as Lighthorse Harry and Robert E., settled on Billys Island sometime in the mid 1800s. Until 1891 the land was unsurveyed, was in the hands of the State of Georgia, and was considered worthless. It seemed natural to use some of the area as a home. The early pioneers usually felt like they were doing something good in taking up residence on the land. It was consistent with how America had been settled in earlier days.

Like most of the settlers around the Swamp, the Lees created a comfortable and attractive existence on Billys Island. Their sturdy log house was by no means a shack. Their gardens were well tended. They disturbed nature little. This is how they lived until the land was purchased from the State of Georgia by the Hebard Cypress Company.

When the two hundred or so loggers and railroad men arrived at Billys Island in 1915 and 1916, they had little respect for the Lees or what they had created on the island. After all, the Company had "bought" the land. They took over the Lees' fields and gardens. The quiet of the island was jarred by the sound of buzzsaws and that diabolical static generator, the radio. A town, including a hotel, store, movie theater, and church, was built on the Lees' homestead land. The outside world had invaded the Lees' world. From this time on, life on the island could never really be the same again.

But the supply of cypress was finally exhausted. In the mid 1920s the workers and supervisors left; the town fell into disrepair and began to disappear. To the Lees, it may have seemed like there was some hope of returning to the more tranquil times of the past. But this was not to be. In 1929 the Georgia Legislature passed a bill that, in effect, encouraged the federal government to acquire the Hebard Lumber Company property in the Okefenokee and create some sort of reserve or park. Squatters and homesteaders, who had no title to the land, would be in the way. Perhaps sale of land by Hebard would be slowed if occupied farmsteads were present. If these were not the motives, then it may simply have happened that a time had arrived when, regardless of the reason, someone living on land without having title was no longer going to be tolerated.

In late March or early April of 1932 the sheriff of Charlton County arrived on Billys Island, along with an attorney and a pair of deputies. Mrs. Mattie Saunders Lee was the head of the Lee family, her husband, Jackson Lee, having died two years earlier. Mrs. Lee was told that the

family would have to leave the island. Whether or not she understood the reasons cannot be determined, but it would have been impossible for her to grasp them completely. The island had been her only home. To her, lawmen and lawyers were probably not perceived as people who always meant well. After the pair left, Mrs. Lee sat and wept. Nothing of her conversation with the sheriff and his companion is known, but it seems that veiled threats may have been a component. Mrs. Lee's grandson, Eugene Velie, then nine, relates that his grandmother felt that if they didn't leave they might be burnt out.

In the middle of April a big fire came from the west, sweeping across the island and destroying the houses made for workers during the logging efforts of the previous decade. The Lee home was saved because of the surrounding fields and the backfires that had been set to protect it.

After the fire, on May 7, Mrs. Lee became a grandmother again, her daughter Rose Velie giving birth to a child that was called Ruth. Shortly thereafter, the officials who had visited previously arrived again, this time by boat. When they left, Mrs. Lee was more upset than before.

Then the sheriff came again with the attorney and deputies. This time they were in a flatbed truck. Mrs. Lee raised little objection. She knew that there was little she could do. The Lees were given no opportunity to leave the island gracefully or to gather any of their belongings. Departure with dignity was denied to them. The house and all of its contents, except for some bedding and clothes that the officials had tossed in the bed of the truck, were set afire and burned. Much of the physical evidence of the Lee family's seventy-year-or-so history on the island went up in smoke before their eyes. On the rough and rutted trip to Lem Griffis Camp, most of the bedclothes and associated items fell out of the truck or were torn out by vegetation, leaving the Lee family with little to wear or to cover themselves with at night.

The Lee family had been dismantled, its ancestral home destroyed, its links with the land severed and traumatized. At a meeting on a back street in Homerville, the attorney gave Mrs. Lee three hundred dollars and told her to leave Georgia and never return. The reasons for this are not clear, but Mattie Saunders Lee and her family left and made their way to Wisconsin. She would die there, never to see Billys Island or her husband's grave again.

Of course they were squatters. Of course their tenancy was illegal. But these are concepts of ownership that often ignore the value of human life and happiness. Was it unlawful to oust the Lees from Billys Island? Probably not. Was it wrong to wrench them away from their roots and home so ignominiously? Certainly!

We are not promulgating here another noble savage fiction. All of us really know that, by our nature as humans, we share with the Lees a desire for a peaceful and happy life, unspoiled by the ills of artificiality that plague modern western culture. Such a yearning is as innate as the desire for food and water. We all want what the Lees had on Billys Island, but our cognizance of how to achieve it is dimmed and fractured by the seductiveness of modern technology and twisted by the dazzling mind-altering power of postmodern media. With the expelling of the Lees, an element of basic humanness was destroyed in the Okefenokee. The ailments of this frenetic and fearful age may be hostile to our life as real people. Can we ever be as human as the Lees?

tations of today are no more natural than a parking lot and nearly always have less biological diversity than an urban subdivision. When the Okefenokee becomes surrounded by this type of artificial habitat, as it almost is already, its eventual doom is certain.

Early in 1773, as the Swamp pools yellowed with the blooms of bladderworts, the young Philadelphia naturalist William Bartram passed southward to the east of the Swamp. This event marks the beginning of the biological investigation of southeastern Georgia. Although Bartram's descriptions of the natural history of the Southeast are some of the earliest and most valuable we have, he contributed little to our knowledge of the Okefenokee. Bartram's accounts of what the Okefenokee was like are fanciful, apparently being garnered from campfire chats with local Indians. Bartram peopled the Swamp with fierce natives who jealously guarded their beautiful women. According to these tales, few who entered ever returned.

Many who received snatches of information about the Swamp from Bartram or others viewed it as a place of horror. In *The Deserted Village* Oliver Goldsmith alluded to the region with his reference to "Altama" (Altamaha), characterizing it as a place "where birds forget to sing," "Where the dark scorpion gathers death around," and "Where crouching tigers wait their hapless prey." Although the Okefenokee has been and is much more of a paradise than it is a hell, these images and ideas linger to the present day. But to the biologists who followed Bartram, the Okefenokee was not only of great interest; it was a veritable Eden of natural delights.

The superbly talented but enigmatic natural scientist Roland Harper first entered the Swamp in 1902. In publications in the years that followed he called for the preservation of the Swamp, claiming that "There is nothing else exactly like it in the world." But during this era, mechanization, profit, and progress were foremost in the eyes of the public. Harper's pleas went unheeded. But other biologists responded, and it eventually became clear that Roland Harper began the chain of events that led to the preservation of the Swamp.

Barrels and cart used in the harvesting of pine sap. Cowhouse Island.

Harper lives on in the Swamp today, for he was the early prophet of longleaf pine, believing it to be the most important tree in North America. Current efforts to restore longleaf pine in the Swamp are partially his legacy.

Without doubt, the group that became most excited about Roland Harper's account of the Swamp was a group at Cornell University. This group included Harper's younger brother Francis, also talented but perhaps more firmly hinged than his brother. Cornell biologists led by Albert Hazen Wright initially visited the Swamp in 1909. Francis Harper first came along in 1912. Research into the biology of the Okefenokee by this group and their academic descendants continued for over thirty years. Their publications turned the Swamp into a biological Mecca. But they did not explore alone. As numerous statements in their works evidence, they obtained significant amounts of help from the native residents of the Swamp, whose knowledge, in the words of Albert Hazen Wright, was "surprisingly accurate."

Obediah Barber's house on the northern edge of the Okefenokee Swamp. This early swamper was known as the "king" of the swamp, and his home is now a living museum. It can be entered via Swamp Road south of Waycross, Georgia.

Francis Harper probably became more familiar with the biology of the Swamp than any other biologist. From 1912 to 1951 he compiled information on the Okefenokee in thirty-eight notebooks. Although he may have initially been attracted by the biology of the area, it is evident that he soon became captivated by the people of the Okefenokee and their lives. He was impressed by the knowledge of those who had lived with the Swamp throughout their lives. The Lees of Billys Island, in another time, would have been coauthors of many of his papers. As time passed he became as interested in gathering anecdotes and folklore as he was in obtaining information on all of the Swamp's creatures. In many ways he "went native," becoming a swamper more so than any other person who was from the outside. Eventually, he was accepted as a member of the Swamp culture by most of the locals. Without doubt, he loved and appreciated the Lees and all of the other Okefenokee families that he came in contact with. He lived to see the culture of the Swamp transformed by modern pressures, and there is little doubt that he was saddened by the influences of the outside world on the Swamp natives.

Regardless of his fascination with the people, he never really lost sight of his duties as a biologist studying a unique and fascinating area. To this day, his account of the Swamp mammals remains the definitive study. It is not recorded how he may have suffered from mixed feelings about his role in creating a federal wildlife refuge in the Swamp. As a biologist, he knew that the unique resources of the Swamp would vanish without protection. Yet protection and federal ownership clearly spelled the end for the native lifestyle that he had come to appreciate and meant that his longtime friends were bound to suffer.

Although Roland Harper's proposals for preservation seemed to fall on deaf ears in the early part of the century, as time passed more people began to realize that the Swamp was so unique that it must be preserved as a national treasure. In 1918, the Okefenokee Society was formed in Waycross to further this goal. It consisted of prominent local citizens, notably Dr. J. F. Wilson, and biologists, mainly the Cornell group. The next year, action by this group resulted in the Georgia Legislature passing a resolution to establish a national park in the Swamp. But the death of Dr. Wilson, the prime motivator of the Society, allowed the group to lapse into inactivity.

Throughout the 1920s, biologists, Audubon Society enthusiasts, and even Dan Hebard of Hebard Lumber Company promoted the preservation of the Swamp and helped prevent damage from proposed development schemes. Luckily, potentially fatal alterations such as the dam across the St. Marys River, the cross-Swamp canal, and other similar plans were half-baked enough so that with opposition from a small group, they eventually failed.

In 1929, renewed efforts to preserve the Okefenokee began, spearheaded by the Waycross Chamber of Commerce. Various bills were discussed and passed in both the U.S. Congress and the Georgia Legislature. Eventually, a plethora of proposals and ideas emerged. It became difficult to find one workable solution or to gather all supporters around a single idea. In 1932, the efforts seemed to congeal into a proposal to create a wildlife refuge. However, the idea again faltered when the Biological Survey (ancestor to the U.S. Fish and

Fishermen in Big Water.

Wildlife Service) claimed that they needed a refuge for waterfowl and contended that the Okefenokee was not of great importance to migratory ducks.

The next few years saw a flurry of activity by both conservationists and groups who wanted to use the Swamp for other purposes. The Georgia Society of Naturalists became active in promoting preservation. Proposals developed to build a canal across the Swamp and to construct an Atlantic-Gulf canal through the Swamp, eventually connecting the St. Marys River to the St. Marks River southwest of Tallahassee. When this idea faltered, two different plans were submitted for building scenic highways across the Swamp. The last of these fizzled out when Governor Talmadge seized state highway moneys as a result of a conflict with the federal government.

Mrs. Jean Harper, the wife of Francis Harper, had worked for the Franklin Delano Roosevelt family as a tutor for their children, after

Shade Tree Pickers and Story Tellers performing at the Chesser house on Chesser Island.

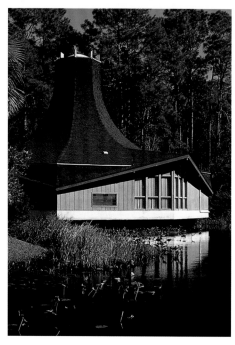

The visitor center at the Okefenokee Swamp Park south of Waycross, Georgia. The private enterprise park serves as a museum and as a classroom for the study of flora, fauna, and lore of the Okefenokee Swamp. Visitors can also take boat tours into the northeastern portion of the swamp, water level conditions permitting. Cowhouse Island.

she graduated from Vassar. In 1933, she wrote to President Roosevelt, objecting to the canal and pleading for the preservation of the Swamp. The president replied, indicating his sympathy with her views. Later he wrote to officials in the Biological Survey asking them to support preservation. By 1935, through the work of many, Congress had authorized the purchase of the Swamp, and in 1936, the Biological Survey acquired an option to buy the Hebard lands. On November 30, 1936, the Biological Survey assumed responsibility for the lands they had purchased from the Hebard Lumber Company for $1.50 an acre. On March 30, 1937, the Okefenokee Wildlife Refuge was created by executive order.

Mere ownership of much of the Okefenokee Swamp did not ensure preservation of its natural values. More proposals to build canals and roads had to be stopped. Lumber companies still wanted some of the timber. Luckily, their offers were refused. But Refuge personnel and supporters of the Swamp throughout the nation found that a constant vigil was necessary to protect the area.

Gradually, the fame of the Swamp began to grow. In the 1940s, Vereen Bell's serialized novel in the *Saturday Evening Post* made the Swamp famous, as did the movie *Swamp Water,* made from the novel. In 1946, Okefenokee Swamp Park reopened on Cowhouse Island southeast of Waycross. An earlier attempt at developing this area as a tourist attraction had failed. In 1948, Walt Kelly published the first *Pogo* comic strip. From this date into the 1970s, Pogo kept the Swamp in the public eye, especially when, in the heat of environmental reawakening, he uttered the famous words, "We have met the enemy, and he is us."

A significant event took place in the swamp with the construction of the sill on the southwestern edge. This structure, started in the mid 1950s and finished in 1962, is a dam of sorts, although seldom called that. It runs for about four and three-quarters miles from the southeastern portion of Pine Island along the east edge of Middle Island to the southwestern end of The Pocket. The sill has two major angles which project to the east and thus has its convex side toward the Swamp, toward the force of the flow.

In Professor Mitchum's Class

As much as I want to, I find it almost impossible to understand the feelings, yearnings, and day-to-day lives of those of an earlier Okefenokee. As I write this I stare at a picture, now over one hundred years old, of a group of children standing in front of the Northern Methodist Church in Folkston. This was Professor H. W. Mitchum's class, taught in the church because no school building was erected in Folkston until 1914. All who gaze back at me from the photo have surely departed this mortal coil by now. No interviews can be conducted. I cannot eavesdrop on their chattings. Poring over the picture with a magnifying glass, I hope to read the personalities, aspirations, fears, and life forces of the thirty children and one adult who are frozen there. Some strike me as intelligent and alert. Others appear hostile, bewildered, or dull. A few evidence hints of mystery or mischief. In many ways they are like any group of schoolchildren today. But they knew neither cocaine nor Cadillacs. Surfing, whether on waves of water or electromagnetism, was not a part of their lives. The planet's ills and horrors did not fly into their minds through the magic of the media. If they became sick, their own constitutions, along with parental love and care, made them well. Penicillin, sulfa, and the other wonders were not yet discovered. Their goals and ambitions did not include professional sports, Wall Street, or visiting the moon. If they were evil, it was hard to flee to where their corruption was unknown. Like all of us, they were products of inheritance and conditions, but conditions very different from those that most of us can grasp.

I know that I cannot really understand these children any more than they could understand me if they were thrust forward into the last days of the twentieth century. Even so, I get the feeling that simplicity, satisfaction with the uncomplicated, and the lack of taint by rampant technology made them somewhat more human than I, who sit at my computer while the air-conditioning blows and the trucks whine ominously on the interstate a few blocks away. I do not really know what kind of people these were, but I know that, in many ways, I envy them. The urge to jump into the picture and take my place beside them is very strong. But I cannot. The barons and power brokers of today say that we cannot go back to the old ways, that we should not, that it is backsliding. It is only Luddites, the unrealistic, and foolish dreamers that long for the old times. The prophets of progress scream from their pulpits that simple lives are extinct. From their well-thumbed bibles they quote Dow Jones. Surely the children of Dr. Mitchum's class were not really happy. What kind of happiness would it have been without a satellite phone, Nintendo, and breakfast cereal in neon colors? More of everything is clearly the key to happiness.

I peer again at the thirty-one faces, hoping to grasp something that I missed before. Was worry about gun-carrying classmates a part of their day? Did Professor Mitchum ruin the joys of their afternoons and evenings with burdensome homework so they could become proper cogs in the corporate machinery? How many were from homes in which one parent had to attempt to do the job of two? Did some feel burning envy for others who wore a more expensive brand of shoe? My attempts to understand them are doomed. Their world was so different from the present one that it could have been on a different planet. I cannot go back to their world, no matter how much I may want to. The best I can do is go back to the Swamp. Among the cypresses, out on the prairies, on the silent islands, I can try to heal the wounds inflicted by the slings and arrows of life in today's world. Away from traffic rage and madding schedule I can perhaps shed the burden of artificialities under which I grind my teeth and which threaten to bury me. Perhaps here among the lily pads I can come as close as possible to being a member of Professor Mitchum's class, for the green lakelets of the Swamp have changed little in a century. But as my eyes lift to the sky, I see it slashed by the swelling weals of vapor trails. My hopes fade. In my world even the sky is scarred and mutilated.

Perhaps the motives for the creation of the sill were good. It was thought that fire had burned out the peat that dammed the Swamp near the outflow to the Suwannee. In order to compensate for this, it was supposed that a sill should be installed to mimic the effects of the masses of peat. Another rationale was that if water levels remained relatively high, the great fires would no longer rage. Some wanted the sill so it would keep the water deep for tourboats. Others thought, "More water, more fish." One can easily empathize with natives of the region who envisioned their homes and lives disappearing in the next conflagration. In the 1950s the importance of fire to the preservation of natural systems was only recognized by a few, and an antifire mindset was common among the public and land managers.

The changes wrought by the sill were many. The damages are still accumulating. Reducing the fluctuations in a naturally fluctuating freshwater system is a traumatic change. Reproduction among plants that live in water but have seeds requiring dry land for germination has been curtailed. Deep portions of the western interior of the Swamp could become a swampy lake and may become a more open lake as the species which demand fluctuating water gradually disappear. On the other hand, plant species that cannot stand fluctuation are now invading some areas. Access to some of the islands is more difficult for colonizers that now have no low-water times during which to cross. If the sill remains, some of the results may not be seen for a century or so. Certainly it is not possible to assess all of the results yet.

But the sill did not stop all water fluctuations, and its effects seem to be almost insignificant in the northerly and easterly portions of the Swamp. Regardless of the data on the effects of the sill, it is an unnatural component of the Swamp and thus has effected some unnatural changes, the magnitude of which can be endlessly debated. Within the next few years the process of removal of most components of the sill will begin, at least if present plans are followed. Officials at the Refuge are very cognizant of their responsibility to maintain the Swamp in a natural state, if the "natural state" can be determined.

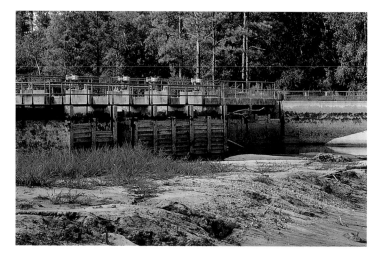

The sill at low water. The dam was created to raise the water table in the southwestern portion of the swamp, which is the Suwannee River exit.

Boat basin at the Suwannee Canal Recreation Area on the east side of the swamp. Entrance is through Folkston, Georgia.

From the middle of the twentieth century on, the Swamp has become more and more popular, causing an increase in public demands for recreational opportunities. In response to this demand, the Refuge initiated a formalized system of canoe trails in the early 1970s. The Indians made trails for their watercraft, the early settlers made boat trails, and the loggers and canalizers made many trails

through the waters. However, the formal canoe trails are a little different. They allow even the most naive visitor to have what many consider to be an essential Swamp wilderness experience.

In order to use these trails, under most circumstances, one must have a reservation. Canoe trails may be reserved in advance by phone no earlier than two months in advance of the intended date of the trip. Six trails designated and marked with specific colors have been established. For the trips that take more than one day, camping is permitted only at designated overnight stops. Many of these consist of partially roofed wooden platforms built over the water. A few are clearings on islands. The longest canoe trip takes five days and covers forty-five miles. At times obstructions block the trails and have to be negotiated. Floating masses of peat may have to be conquered. During low-water periods some of the trails are very difficult to negotiate. However, in general, the canoe trips are easy and relaxed.

The most recent major threat to the future of the Swamp reared its head in the 1990s. E. I. du Pont de Nemours and Company began making plans to mine for titanium in the region of the Swamp. Titanium-bearing minerals occur under the southwest portion of Trail Ridge in a band about one mile wide and eighteen miles long, running along the Branford–Clay County line. DuPont has purchased or leases around thirty-eight thousand acres in the area. Titanium dioxide is used in plastics, paint, and paper. Mines similar to the one proposed for the Okefenokee region have been operated by DuPont on Trail Ridge in northeast Florida for over fifty years. But there, they are not close to a wetland of international importance.

Mining the area would involve bringing in colossal dredges that would dig out dozens of fifty-acre pits as deep as fifty feet in the sandy soils of Trail Ridge. Because of the proximity of the project to the Swamp and because it is felt by some geologists that water from Trail Ridge eventually enters the Swamp, refuge personnel, biologists, environmentalists and the local public had many concerns about the proposed mining. After the project was examined carefully it became apparent that the possible damages were numerous, including alteration of ground and surface water flow, destruction of wetlands, air pollution, visual pollution, loss of wildlife habitat and many others. Municipalities became concerned about their water supplies. A nationwide survey found that 78 percent of Americans were opposed to the project.

DuPont said that they believed that their mining could be conducted in "a safe and environmentally sound manner." But there are two problems with this. It assumes that mere mining in itself is not harmful. Thus it is like saying we can do surgery without any cutting. Second, it ignores the history of the Exxon Valdez, Chernobyl and many other cases in which guarantees of safety were given but failed in the end.

Eventually, public concern caused DuPont to enter into a mediation process, the result of which is an agreement to withdraw the proposal to mine if $90 million can be raised, most of which will go to DuPont so the company can recoup its $20 million investment and get some of the money that it would have made from the mine anyway. So it looks like the threat is over, at least for now.

Interior Secretary Babbitt did not like the agreement because he felt it was burdensome to taxpayers and that the amount DuPont would obtain was inflated. However, a spokesman for one environmental group said, "This is a good deal. This is the right approach."

Let's see if we have this straight. A company, without proper investigation of the possible ramifications, makes plans to do something that might harm public resources. People get upset about it and say, "In order to protect our resources, we will pay you for your stupidity and lack of foresight. Not only that, but we will give you a little extra to make up for some of the profit you would have made if you had been allowed to ruin public resources." A great plan! A wonderful concept! Now any company that wants to do something damaging in the area can agree not to do it and expect to be paid for not doing it by the public. A marvelous precedent! Why rely on law, federal regulatory agencies, or corporate responsibility. Let's just use the bribe method. Surely noone would ever tell DuPont, "You made an unwise investment. Now you have to pay for it." It is a cheerless day indeed when even environmental organizations laud methods in which corporations are, in effect, given payoffs to not destroy. Has profit become a sacred cow, even to John Muir?

An Okefenokee Timeline

	
200,000,000 B.P.	The southeastern portion of the North American landmass severs its contact with the African landmass, beginning its drift to its present position.
200,000 B.P.	Trail Ridge begins to form as a beach ridge at the edge of the Atlantic Ocean.
18,000 B.P.	A slight possibility that ancient Solutreans from southeastern Europe visited the area of the Swamp, some perhaps living in the vicinity for a time.
7000–5000	Formation of the Swamp.
2500 B.C.	First evidence of early Americans inhabiting the Swamp.
A.D. 500	People of the Weeden Island Culture colonize the Swamp area.
1773	Early naturalist William Bartram visits the Swamp.
1796	Treaty between the U.S. government and the kings and chiefs of the Creek Nation signed on the banks of the St. Marys, just east of the Swamp.
1836	Militia under Captain William B. North kills fourteen Indians from ambush near what is now Griffis Fish Camp.
1844	"Big Fire."
1851	Stephen Collins Foster, who never saw the river, publishes "Old Folks at Home," more commonly known as "Way Down upon the Suwannee River," making the area internationally known.
1853	Dan Lee and his bride settle on Billys Island.
1858	W. T. Chesser settles on Chesser Island.
1891	Suwannee Canal Company begins digging canals and channels.
1895	Suwannee Canal project abandoned.
1902	First botanical reconnaissance of the Swamp by Roland Harper and P. L. Ricker.
1908	Hebard Cypress Company begins operations in the Swamp.
1908	Major drought.
1909	Major fire.
1912	Francis Harper, the Okefenokee Biologist, first visits the Swamp.
1916	Governor Dorsey says that there is enough timber in the Okefenokee to last a hundred years if cutters worked night and day.
1921	Last evidence of red wolves in the Swamp.
1927	Hebardville timber mill ceases operation because all easily obtainable timber is gone.
1927	Mammals of the Okefenokee Swamp Region of Georgia published by Francis Harper.
1932	Intense fire in southwestern part of Swamp.
1932	Major drought.
1932	Lee family forced to leave Billys Island.
1932	Albert Hazen Wright publishes Life Histories of the Frogs of Okefinokee Swamp, Georgia, which remains the only detailed work on the frogs of any major world wetland.
1933	Major fire.
1937	Okefenokee Refuge created by Executive Order 7593, but over ninety percent of primeval forest already gone.

1941 — Vereen Bell publishes the novel *Swamp Water*, drawing national attention to the Swamp. Results in two movies.

1942 — Tony and Margaret Carter sight some of the last ivory-billed woodpeckers to be seen in the Swamp.

1945 — Refuge patrolmen Bryant Crews and Joseph Martin shot and killed by Swamp native Oliver Thrift.

1946 — Okefenokee Swamp Park re-opens.

1948 — First Pogo comic strip appears, beginning a long history of strips by Walt Kelly, which popularized the Swamp in America.

1954 — Major drought.

1955 — Major fire.

1959 — The Chessers leave Chesser Island.

1959 — Freddy Cannon records the song "Okefenokee."

1962 — Sill on southwestern edge completed. Water level becomes less variable.

1963 — Armadillos first seen in the Okefenokee, presaging an increasing rate of invasion by exotic species.

1972 — Francis Harper dies.

1972 — Wilderness canoe trail system development begins.

1974 — Most of the Refuge area designated as Okefenokee National Wilderness.

1987 — The Swamp named as a wetland of international importance by the Ramsar Convention, a worldwide group promoting wetland protection and waterfowl conservation.

1989 — Okefenokee Wildlife League formed to promote education about and preservation of the Swamp.

1991 — E. I. du Pont de Nemours and Company begins obtaining land and mineral rights with the intention of mining for titanium in the Okefenokee region.

1996 — Public outcry about the possible damages from titanium mining becomes conspicuous.

1997 — Okefenokee Refuge reaches age sixty.

1997 — DuPont agrees to put plans for titanium mining on hold in order to enter into a dialogue with interested stakeholders.

1998 — Proposal approved to alter sill and perhaps return water regime to a more natural state.

1999 — DuPont agrees to drop its proposal for a titanium strip mine near the Swamp. . . . if $90 million can be raised.

2001 — The Swamp, along with the rest of the increasingly fragile natural world, enters the new millennium.

"If only it could have been saved in the shape in which I first knew it." This statement by Francis Harper brings grief to many of us who have seen myriads of natural places be degraded to the extent that there is no hope of recovery to anything like the original state. Such catastrophes are occurring more rapidly and are more numerous today than when the Swamp was preserved. They have affected wetlands more so than other types of habitats. Dismal Swamp is a mere remnant of what once occurred on the Virginia–North Carolina border. It is hard to locate even vestiges of the Great Kankakee Marsh of northeastern Illinois and northwestern Indiana. The Cheyenne Bottoms of Kansas face new threats and alterations each year. Powerful outboard motorboats and overzealous spraying of herbicides have degraded swampy Reelfoot Lake, the only major earthquake lake in the United States. The Everglades water flow is controlled like a faucet, and monotonous cattail stands now rule places where the sawgrass once waved. It is apparent that we learn little from past experiences when it comes to conservation. But to dwell on the positive, at least we have the Swamp, and it still harbors many of its original values.

What does the future hold for the Swamp and what should be done to ensure its health and value to our society? To most of us who love the Okefenokee, it is of primary importance for its natural values, as a place where nature can be experienced and enjoyed. It therefore seems that promoting and perpetuating the Swamp as a natural place should be primary. At present, there are a number of things that need to be done to achieve this goal. I trust that my temerity in making suggestions will be forgiven by those who may disagree with some of them.

First, the Okefenokee cannot exist for long in isolation. It must be connected by natural or nearly natural lands to other relatively unaltered areas of habitat on the continent. This must be accomplished by developing a system of corridors and connecting areas. Pinhook Swamp, Moccasin Swamp and other sites to the south have been mentioned by others as being important corridors connecting the Swamp with Osceola National Forest. Trail Ridge should be pre-served and recovered to a more natural state to provide a dry corridor to the south. This feature was probably a dispersal pathway for animals and plants throughout its history. Small portions of Trail Ridge in northern Florida have already been preserved. How about connections to the east, north, northwest and west? Buffering borders along both the St. Marys and the Suwannee are needed to connect the Okefenokee to Atlantic and Gulf Coast systems. A natural zone bordering the Suwannee would be particularly important in connecting southeastern Georgia systems to what may remain of the Gulf Hammock area of Florida. To the north and northeast, major modifications in land use will be necessary to create connecting corridors. An immediate, vigorous, and well-supported program is necessary to reestablish open longleaf pine stands in areas now dominated by slash and loblolly pine plantations. The help of timber companies and other large landowners must be solicited. Realistically, Fort Stewart, near Savannah, represents the nearest large block of public land to the north that still retains some natural features to which corridors could be created. But connections to the Altamaha, the Ocmulgee, the Ohoopee dunes area, and the Satilla-Alapaha region should be explored.

Second, there are many changes that could be easily effected on the Refuge and within the Swamp itself that would improve conditions, facilitate public use and appreciation, and ensure the long-term survival of the system. Among these I mention only a few as examples.

Removal of the sill seems to be in the planning stages so restoration of a more natural water regime may occur. Some of the old tramways and railroad beds that seem to interfere with water movement could also be removed.

The spoil banks along the edge of the Suwannee Canal must be removed, along with the unnatural and view-obstructing vegetation they support. There seems to be little reason to introduce naive visitors to the Swamp via a long shrub- and tree-lined, tunnel-like canal. The splendid natural waterscapes in the area should be open to access and open to view.

A vigorous and well-supported program for the removal and elimination of exotic species from the Swamp should be promptly initiated. It may be possible to greatly reduce the numbers of armadillos in the area, allowing for the survival and perhaps recovery of organisms associated with the forest floor and with litter. Exotic plant removal programs must also be initiated. Deer, although native, are probably present in unnatural abundance and may be detrimentally affecting the flora, as they are in most habitats throughout the Southeast. Extreme care must be taken to prevent exotic fish species from invading the Swamp. The tragedies of the Everglades and Lake Victoria do not need to be repeated here.

In a way, Okefenokee Refuge is caught in an identity crisis. Although it is legally a wildlife refuge, it is used more like a national park. But it is staffed like a refuge. The problem here lies in the fact that wildlife refuges seldom have enough personnel to adequately interpret the natural scene to the public. A staff of trained interpretive biologists is really a necessity if the Okefenokee is going to be understood by and thus supported by many of its visitors.

There are many investigations needed into the biology of the Swamp if it is to be understood. Among the vertebrate groups, only for the fishes does a modern faunistic survey exist. Intensive surveys are needed for almost all insect groups, for aquatic invertebrates, for forest floor arthropods, and for plankton and benthos. Studies are needed to assess the affects of armadillo and wild pig presence. Permanent plots for vegetation monitoring need to be set up throughout the Swamp.

Although 200 hp bass boats and jet skis do not exist in the Swamp, the whine of motorboats and the effects of their propwash do affect the major arteries of the Swamp. If there is to be a communion with nature achieved in an Okefenokee experience, perhaps it is time to quiet things down a little and roil the waters a little less vigorously. In today's world, the concept of getting places quickly is so firmly embedded in our wounded psyches that even many of my conservation-oriented friends would hate to have to make the trip from Stephen Foster State Park to Billys Island in an oar boat, as I

did in the early years of my visits to the Swamp. But what is going into the Swamp all about? If a motorboat is necessary, maybe one ought to go elsewhere. Electric motors might be OK.

My two final suggestions will be deemed outlandish by most, but I make them without tongue in cheek and with the ultimate welfare of the Swamp in mind. I believe we should attempt to use DNA in the preserved skins of ivory-billed woodpeckers, passenger pigeons, and Carolina parakeets to clone these species as soon as possible. Pileated woodpeckers and perhaps mourning doves could be used as surrogates to eventually ready the cloned young of the first two species for life on their own. The absence of a native parrot-like bird in the region will make initiation of a flock of wild Carolina parakeets more difficult, but with innovation it can be done. We destroyed these species before their time for natural extinction had come. It is time to call them back from heaven so they can resume their vital jobs in the ecosystems of the region.

Finally, the spelling of Okefenokee should be changed back to the historically more correct Okefinokee. I will not belabor this point. Francis Harper and others long ago spoke about this issue with more eloquence than I ever could.

I write the last few sentences of this chapter as I sit at the edge of the road to The Pocket, some miles north of Edith. This is the place where Al Skorepa and I found the spotted turtle in 1966. Between here and Edith, I passed by a number of large clear-cuts. They may represent profit and efficiency. They may be the results of ownership controlling what it owns. But regardless of all of this, clear-cutting seems to be a vile way to treat this earth that we have been given. The beautiful sphagnous stream from whence the spotted turtle emerged that day, affected by surrounding alterations, is now muddy and scarred. As I stand in the mucky stream I hear an unearthly clamor. I look to the south from whence it emanates. It is the hordes of the Jacksonville metropolis, astride pale horses, riding toward the Swamp with scythes ready for reaping. I blink and shake my head. Maybe I am conjuring this up. Perhaps it is a figment of my worry

about human population increase and its effects on the Okefenokee. Or maybe just an undigested bit of beef, or a crumb of cheese.

I turn back and head toward Fargo. I see that Fargo now has two restaurants. Although at a few times in the past two were present, this new one is bright and shiny and modern. Although a nice restaurant, its presence seems to be a bad omen. It scares me. I think to myself, "At least Fargo could stay the same." There is little hope for Waycross and Folkston. To me, compared with how they were when I first came here in the 1950s, they now belch and whine with people, progress, roads, motels, and those innumerable little unnatural hybrids of gas stations and grocery stores that plague the American landscape. But the blame lies at the feet of all of us. We have fallen for the prevarication of progress, for the fable of development, for that great untruth told by too many chambers of commerce, the idea that without growth we cannot survive. The opposite is really the truth. Only a cancer grows forever.

I have been coming to these places for over four decades. But I know no one here in Fargo, or in any of the Okefenokee towns. I am not an outgoing person. I am unwilling to insinuate myself into the local scene. Even so, from what I suppose has been mainly a distance, I have grown to like the people of this region. I am not even sure why. Maybe I assume, undoubtedly wrongly, that they are all still the Lees, Mizells, Thrifts, and Chessers of an earlier day and therefore must be good folks. Maybe it is my love of the Swamp that is rubbing off and causing me to like the locals. Maybe, like Francis Harper, I have, in a way, "gone native."

I head east from Fargo, toward Moniac. This is a lonely road, or has always seemed so to me. A couple of miles past Eddy Road I begin to cross Moccasin Swamp. A tune wafts up out of the waters. Here I am, forty years after my first crossing of this mire, one more time "Way down yonder in Okefenokee." Maybe in Moniac I can find some of the cats still "doin' the pokie." If so, maybe I'll do it with them for a while.

A trail on Floyds Island in the middle of the swamp. This beautiful island was named for General Charles Floyd, who conducted a campaign against the Seminoles. Hearing the soldiers approaching, the Native Americans fled, leaving campfires still burning amid signs of the ancient civilizations that had preceded them. A troop of Boy Scouts maintains the old hunting cabin built by the Hebards, whose Hebard Cypress Company logged the swamp in the 1920s.

A Conversation with Chris Trowell

Much of what has been aggregated, organized and researched in recent years about the history of the Okefenokee is the result of the labors of one man. Some years ago, I was fortunate to run across this person, Chris Trowell, when the Georgia Botanical Society had its annual meeting in his hometown of Douglas, Georgia. It is this chance meeting that resulted in my poor attempts to put the Okefenokee into words in these pages, because Chris, who really should have been the person to write the narrative for this book, recommended me for the job.

For a number of reasons, I want to record here some pieces of a chat I had with Chris. First, I want the reader to hear a few things about the history of the Swamp from the person who knows the history best. Second, I want to acknowledge the debt that we all owe Chris for his diligent research and for the clarification that he has brought to much of the Swamp's history. Finally, I want to use Chris as a symbol of those who struggle, often alone, in intellectual pursuits that enrich us all, but who seldom receive the credit they deserve. We cannot repay Chris for all of the information he has unearthed nor for what it has meant and will mean to us, but I here acknowledge the debt. In addition to his many years of delving into the history of the Swamp, Chris spent his professional life as a professor at South Georgia College, from which he retired in 1995.

Question: What do you think the Swamp is going to look like a hundred years from now?

Chris: I think the Swamp will be there and that it will be remarkably similar to what it is right now. I don't think that the character of the Swamp will change. When you go back and look at descriptions of the Swamp from the late 1800s and early 1900s you find that things have changed in detail but that the natural communities of the Swamp have remained the same.

Question: When I look back at the accounts of people being removed from the Swamp, such as the case of the Lees being forced to leave Billys Island, I feel pretty sad about people who had lived there being removed. But do you think that if the people hadn't been removed, if it hadn't been made into a refuge, that it would have survived?

Chris: I think it would be similar to the case in Great Dismal Swamp, in which everything that could have been developed would have been. The southern part of Dismal Swamp is now basically a pasture. A small part of the Okefenokee may have survived because it would have been difficult to make money off of it. Once you can make the big buck, that's when the transformation begins.

Question: What about the wildlife? Has it declined or increased, in your experience?

Chris: There are more alligators now, no doubt about it. But it seems to me that there are far fewer birds, especially ibises. The great rookeries are gone. But it is hard for me to judge this, because years ago I couldn't recognize all of the living things and it is hard to get a feel for something if you can't recognize it.

Question: Will there have to be strict limits on human use of the Swamp in the near future? Is that something that is coming? Will a cap have to be put on visitors?

Chris: No, I think that there will be more use of the Swamp in the near future. They may put a cap on visitors sometime in the future, but right now the momentum is moving toward more public involvement in order to get more public support. The Okefenokee is a little different than many other wildlife refuges, especially the wilderness part. When it was originally revealed, when the refuge was proposed, that outboard motors were going to be permitted, the environmental groups absolutely went through the roof, and approval of the refuge was stopped in Congress until they finally

got around that wording. I think that much of the use will continue to be restricted to the boat trails, which is good. But I have some real reservations about use of the boat trail idea to the extent that the refuge personnel may not know what is going on in the rest of the Swamp, perhaps because it is considered wilderness and they think that they do not have to or perhaps shouldn't go into it.

Question: Is the future of the Swamp good, excellent, fair, poor, or how do you see the future?

Chris: I think part of that answer has to be qualified by what happens with the DuPont project and what DuPont decides to do with that mine. If it's a long-term relatively low impact kind of thing I don't see a lot of risk there. Also, we don't know what will happen with removal of the sill. Again, what do we mean by "the future of the Swamp"? Sometime, probably within the next twenty-five years, we are going to get another major fire, particularly if we take out the sill. For two or three years after the fire it will look awful, but after that will come right back. Then, I would suspect, a risk may come because there will be pressure to do something about the Swamp so fires that take place there won't close down I-95 or I-75. There are so many things we don't know about the Swamp that it is hard to predict its future exactly. We don't really know the reasons for the origins of the prairies. We don't know for sure that the lakes are the result of burns. But, all in all, I think that the future of the Swamp is good.

Chris's answer to this last question raises my hopes about the Swamp. I need this optimistic view, for I am by nature a pessimist. If Chris Trowell, who understands the Swamp's history better than anyone, believes that the future looks good, I believe that there is hope.

These are not the only questions I asked Chris, and the answers printed here contain only a small amount of the information I obtained from Chris during the interview. Knowledge brings with it great joy, and every time I chat with Chris my knowledge about the Swamp grows immensely. Not only is there much joy in knowledge, but chatting with friends on any topic gladdens the heart, although it is a pursuit that is dying in the rushed and frenetic age of technology. On this occasion, my chat with Chris was enhanced by the presence of another extremely knowledgeable person, Frankie Snow, one of southern Georgia's premier naturalists. I hope to be able to participate in many such conversations in the future.

> Billys Island boat dock. Throughout the swamp are islands that the Native Americans inhabited. In the 1920s a company town with a hotel and theater supported the logging community that clear-cut the Okefenokee. Railroad trestles were built just above the high-water mark, and steam locomotives were used to take timber out of the swamp to the mills in Waycross.

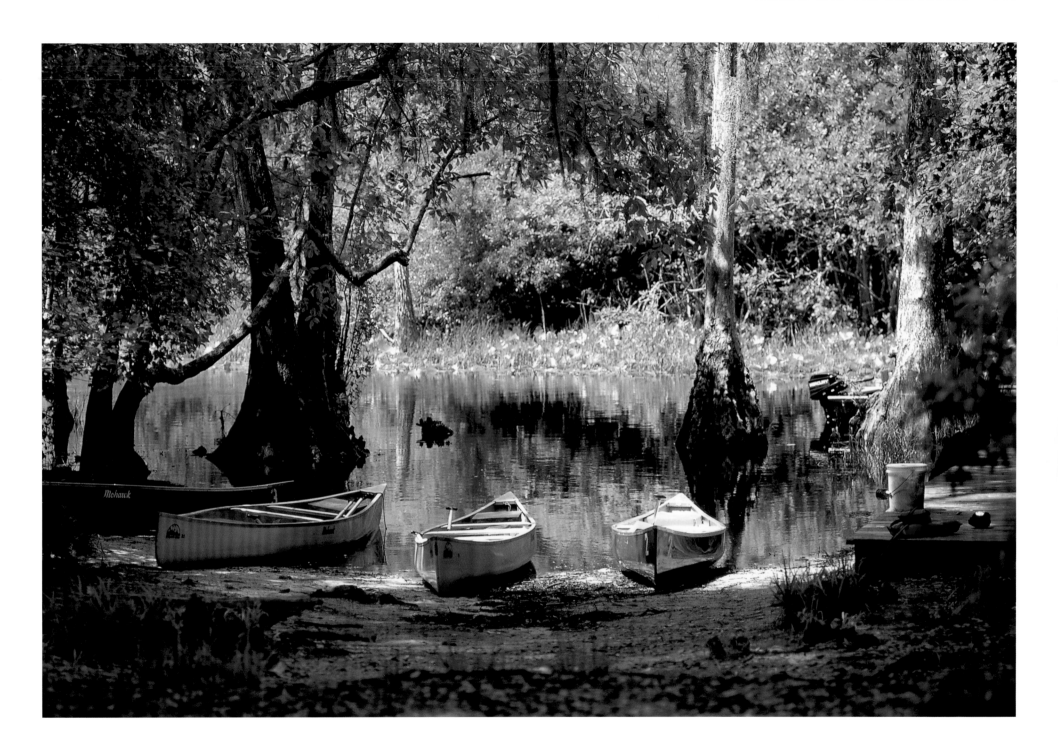

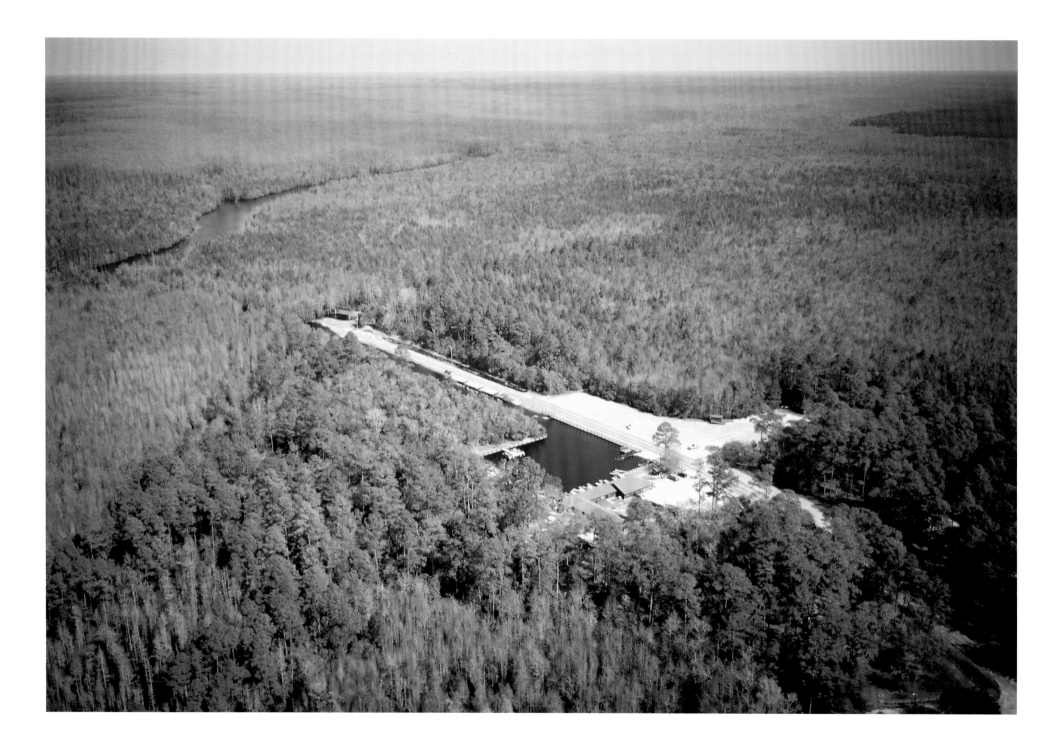

The Chesser homestead, now a living museum that depicts an early swamper's way of life. Chesser Island is 1 1/2 miles long and 1/2 mile wide.

< An aerial view of Stephen Foster State Park on Jones Pocket. The park may be reached from the west side of the Okefenokee Swamp through Fargo, Georgia.

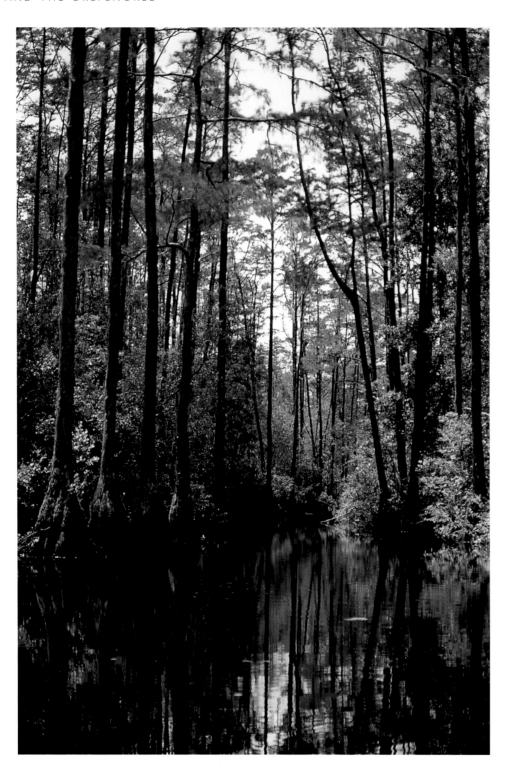

Deep up in Big Water in the summer.

> An aerial view of Grand Prairie in average water. It is 5 miles long and 3 1/2 miles wide.

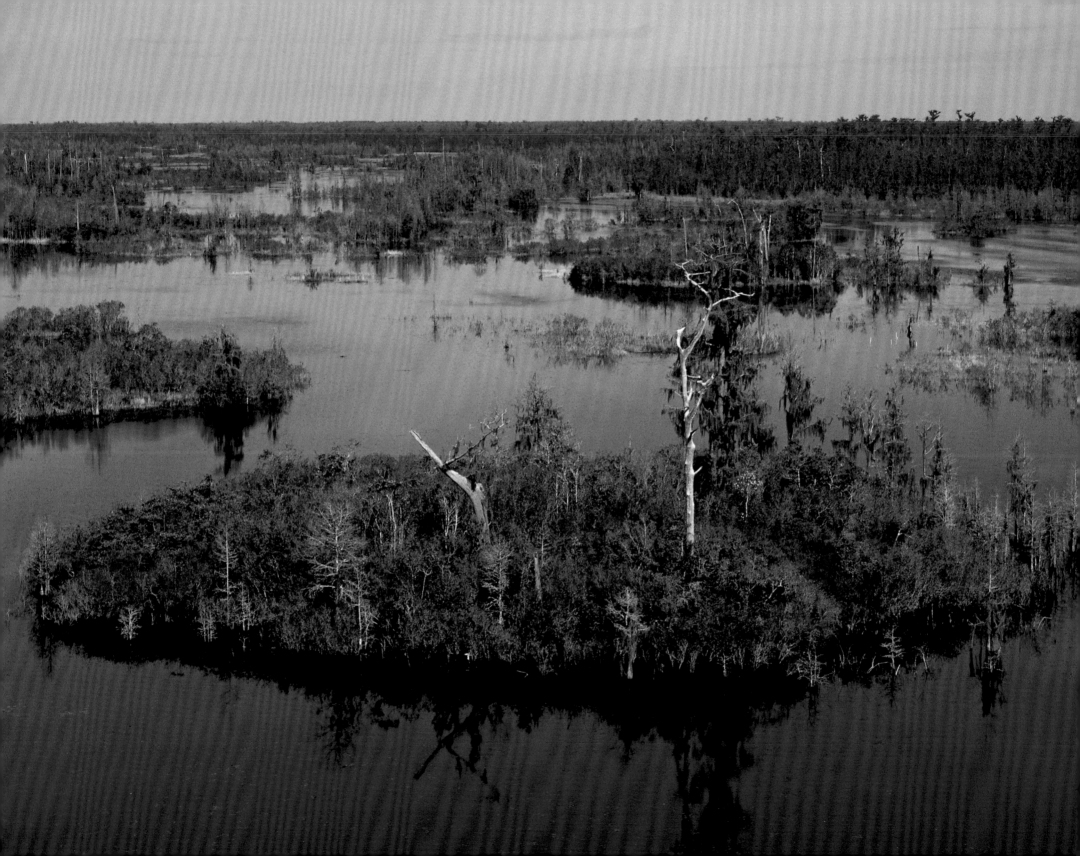

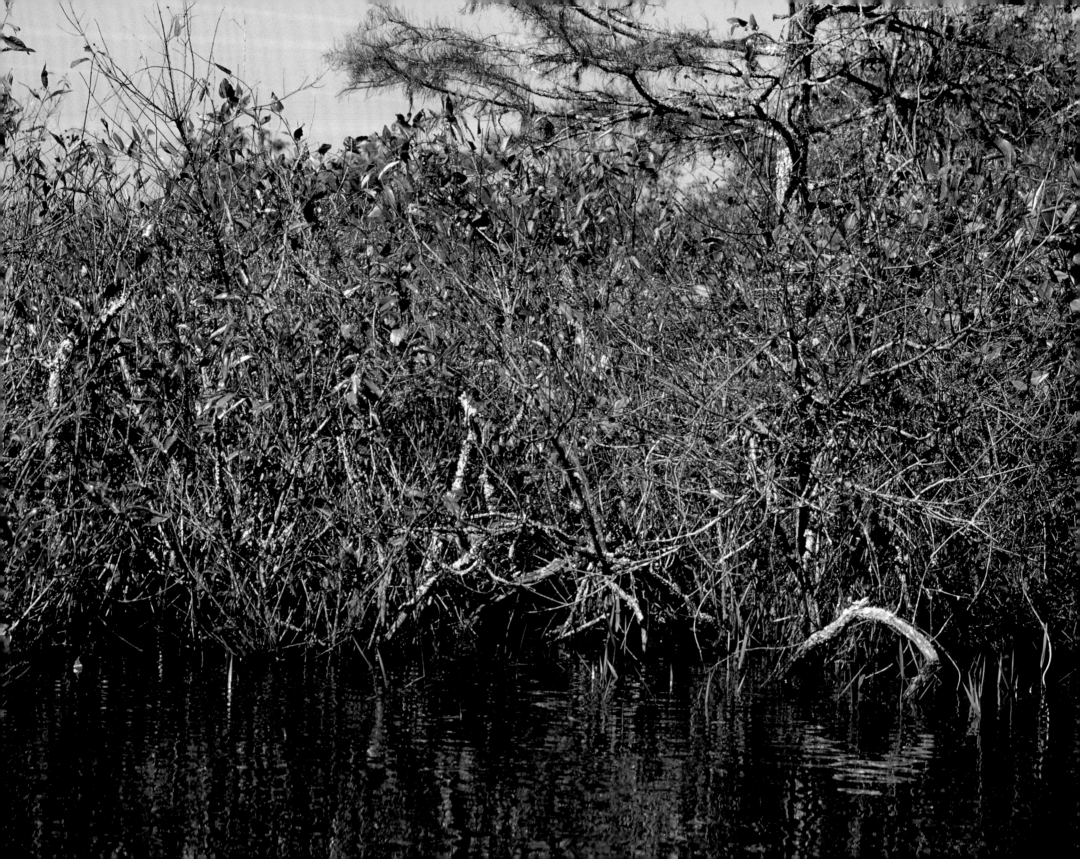

< In a remote area of the swamp north of Craven's Hammock, the underbrush is thick with coral greenbrier.

The Suwannee River Narrows, on the way to the sill, provides a study of different ecological zones based on the levels of the water tables.

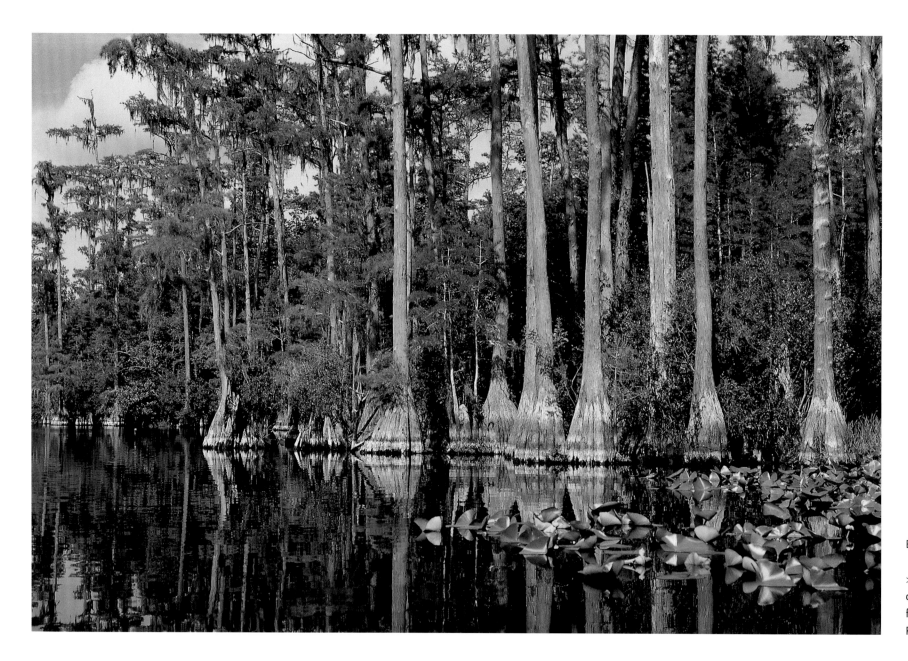

Billys Lake at very low water.

> Buzzard's Roost Lake on the canoe trail to Gannett Lake from the Suwannee Canal Recreation Area.

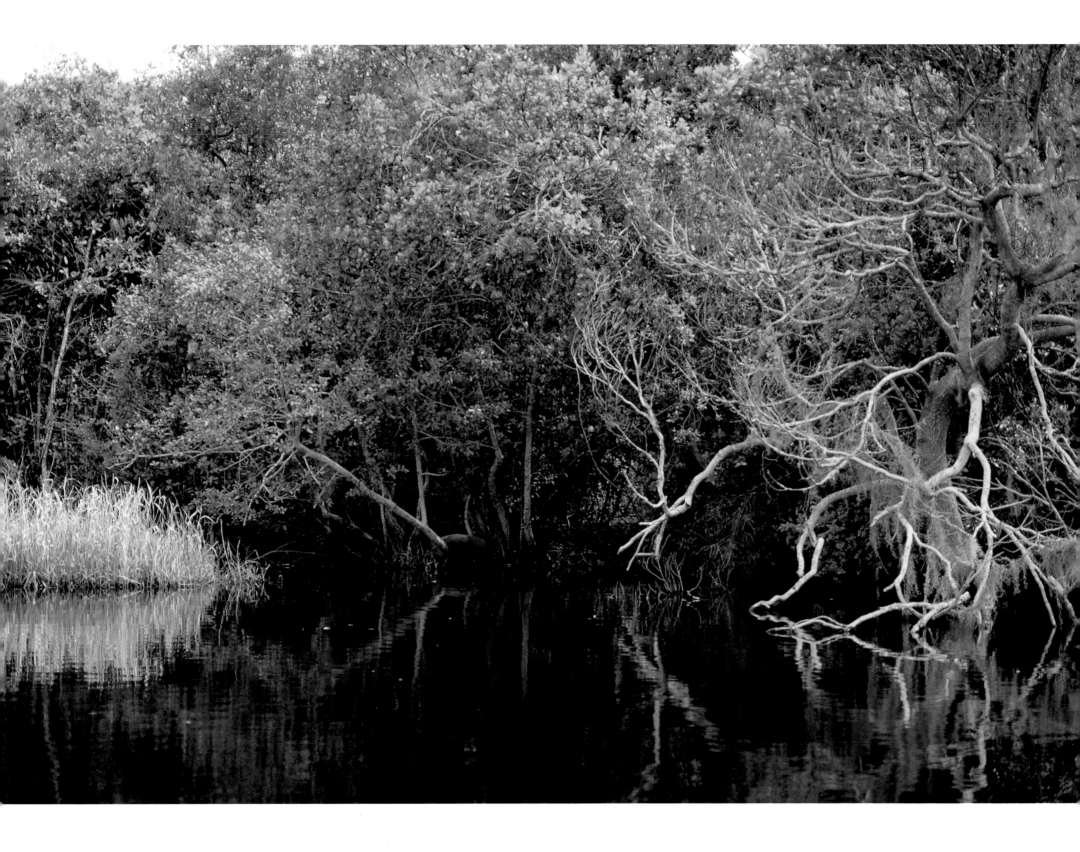

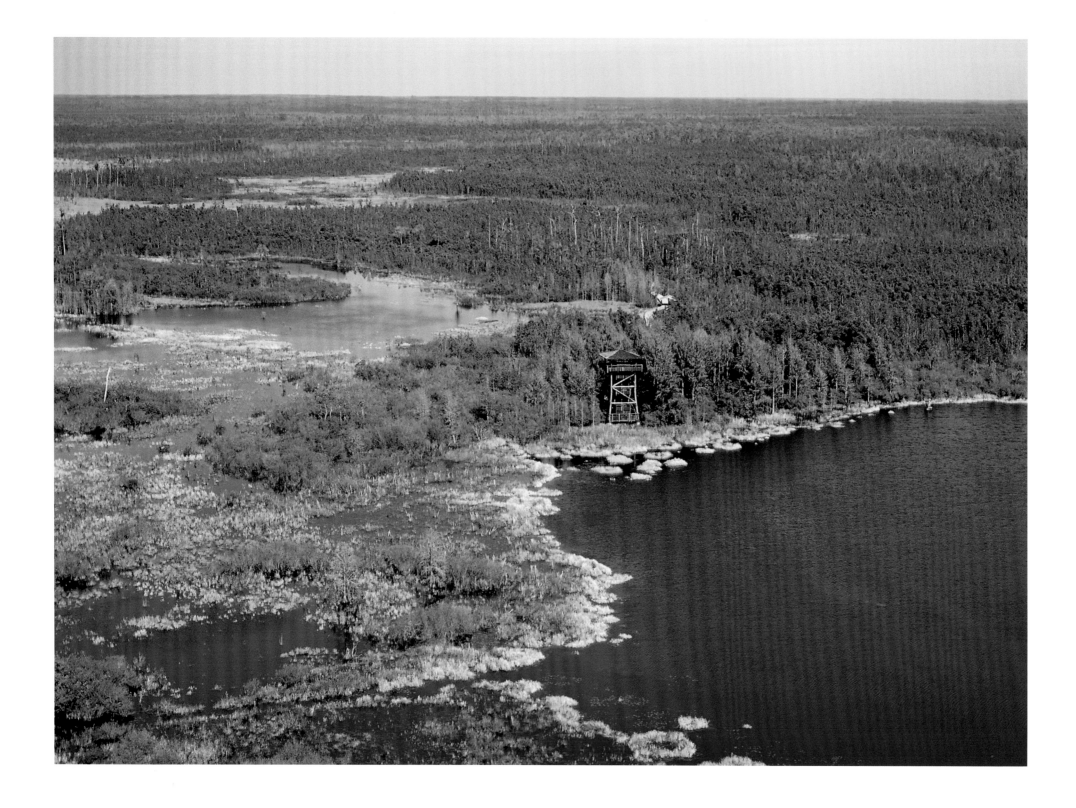

< An aerial view of Seagrove Lake. It is possible to see Chesser Prairie and the Chesser Island boardwalk with its observation tower.

Joan Niemeyer. A drive from the park's visitor center leads to the nature boardwalk on Chesser Island. At the end is the observation tower.

A young turtle sunning itself.
Billys Island.

> Middle Fork of the
Suwannee River, in the nar-
rows south of Minnie's Lake.

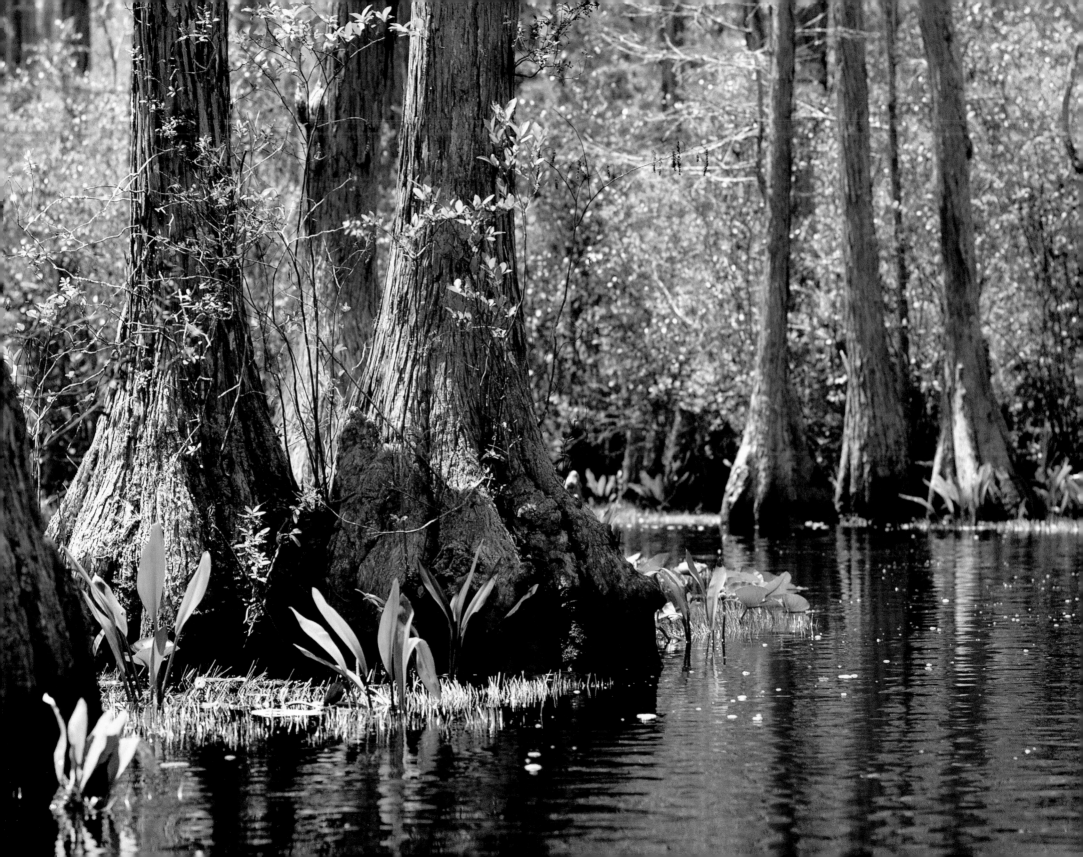

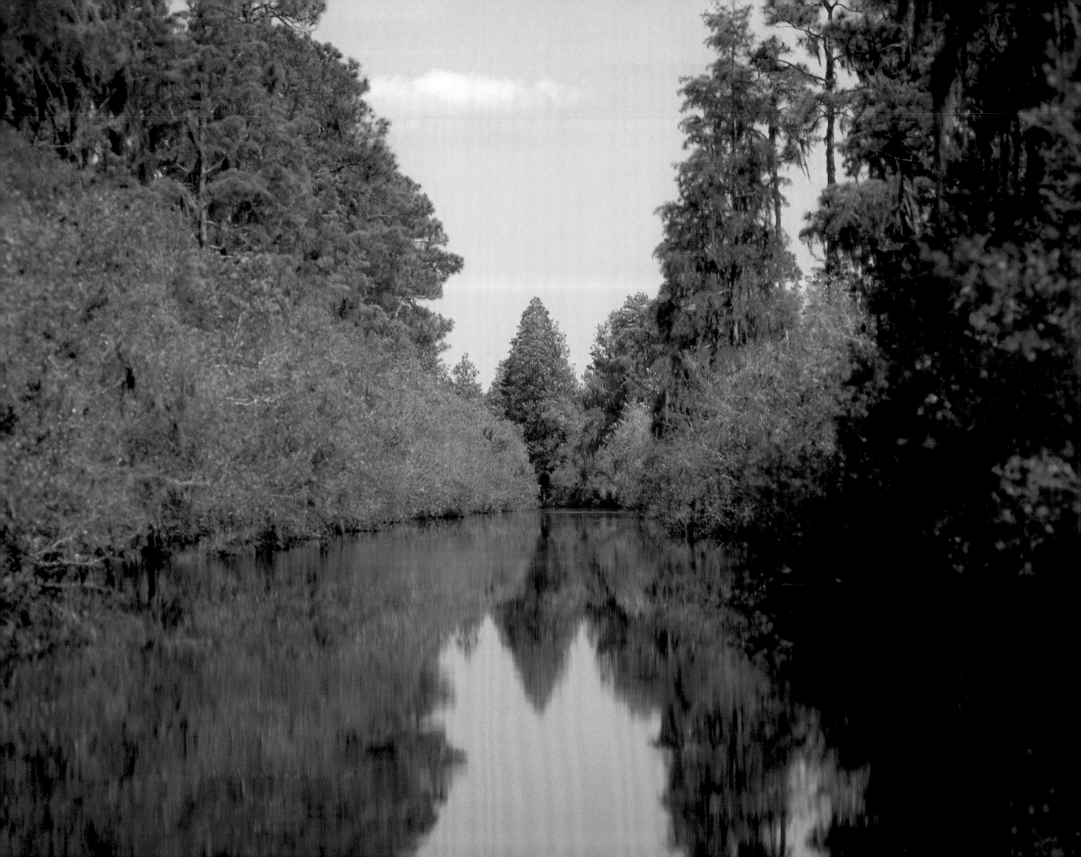

< The Suwannee Canal was started in 1891 to drain the swamp and to create a commercial water link between the St. Marys and the Suwannee rivers, establishing connections from the Atlantic to the Gulf of Mexico. The project failed in 1895 and was abandoned after the death of Captain Harry Jackson. Ultimately fourteen miles of the main canal were dug, almost reaching Billys Island to the west; eight miles of branches were also excavated. The effort was called Jackson's folly.

Visitors who want to reach Craven's Hammock by canoe can obtain a use permit from the Okefenokee National Wildlife Refuge headquarters near Folkston, Georgia.

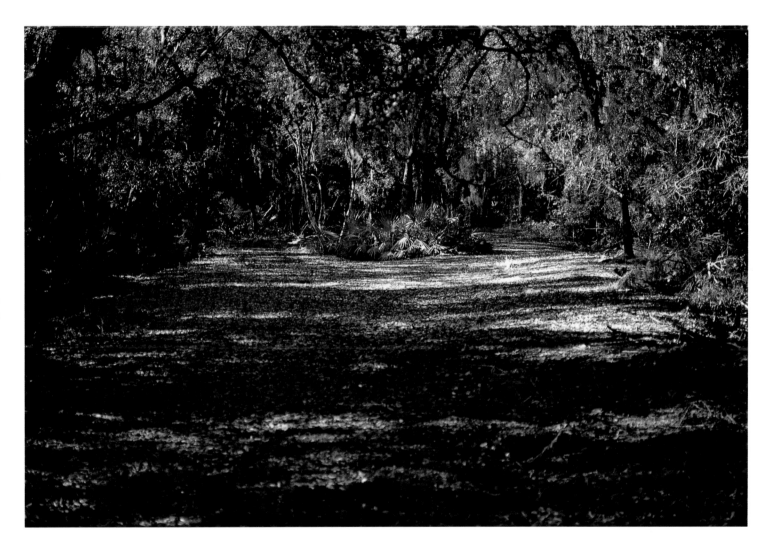

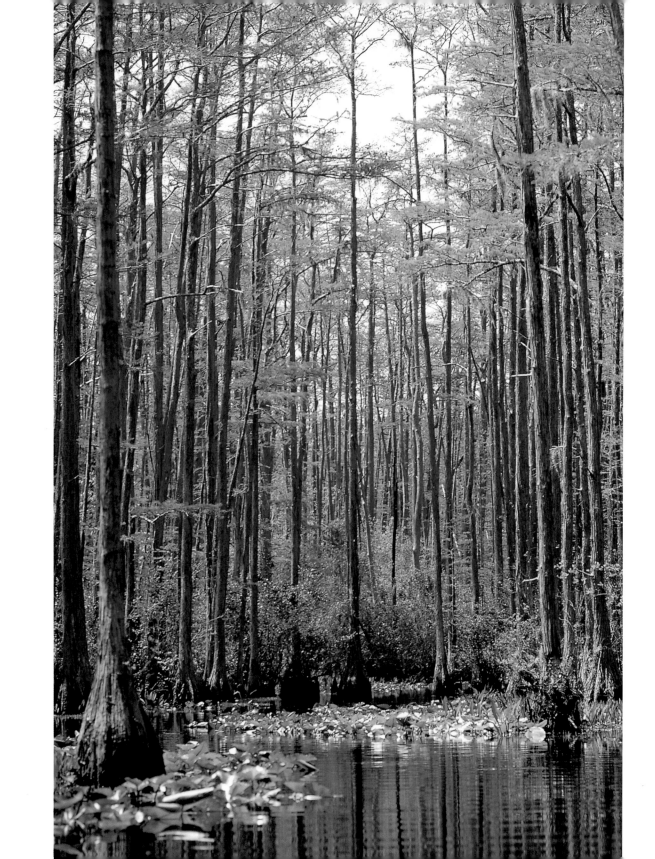

5 THE ESSENCE OF THE SWAMP

Many lines, phrases, and chapters have been penned in attempts to communicate something about soul, or essence. I wish that I knew exactly what I mean by the heading of this chapter. But I cannot tell you in words. Everything I intend to convey comes out trite and wooden. Even so, I leave the heading as it is, having come up with nothing that expresses my intentions better.

All of the natural places of the earth have their own unique qualities. Often these features are to some extent portrayable in words, as are the radiances in the travertine terraces of Yellowstone, the shimmering of the sawgrass in the Everglades, the pinkness of the flamingo hordes at Lake Natron, or the mistiness of the rhododendron thickets on the slopes of Kinabalu. But there is much about any part of the natural world that cannot be described, even though an essence may be felt and perhaps known with great intensity. It is in the ineffable that the soul of the Okefenokee lies. An attempt, no doubt feeble, to communicate these transcendent features is a major purpose of this book. The images that sprinkle these pages, captured so wondrously by Lucian, are themselves miraculous. But Lucian knows, more than most, how much of the real essence of the Swamp is always just out of grasp. The Swamp is marvelous beyond all we succeed in communicating here. Even so, its singularity is clear to all who have visited, at least to all who possess souls that are somewhat kindred to that of this watery place.

But affection and attachment to this place come not only from visits. There are many who love the Okefenokee who have never seen it. Pogo and his creator, Walt Kelly, have made the Swamp known to readers throughout the world. Movies made in the middle part of this century helped spread the fame of the Swamp, even though many of the impressions they conveyed were erroneous. Images and accounts of the Okefenokee pass by in many forms in modern media. It is comforting, even encouraging, to know that many who will never visit here have some feeling, even love, for this place. It increases the numbers of those who will rise to protect the Swamp when help is needed, as it is now and always will be.

The Swamp is remarkable as a natural place, as one of the largest mosaics of wetland habitats in the southeastern part of this continent, as a portion of the planet unlike any other. In previous pages I have attempted to portray some aspects of its natural history. Knowledge of the living inhabitants is always important in getting a feel for a place and is certainly a vital step toward understanding the Okefenokee. Yet, in some ways, it does not matter what the biological facts of the Okefenokee are. It is more important to assess the feelings evoked by the Swamp, how we believe the Swamp to be. The truest answers may lie in reaching for the unfathomable, for that which is forever mysterious. Those who search to know the Swamp by traditional paths to knowledge will be forever ignorant. The Okefenokee is more than just the sum of its biological and physical components. It is even more than just this place in southeastern North America. It is archetypical, representing all of the mires, bogs, muskegs, swamps and wet places of the world. It is "The Swamp."

In seeking to understand the Swamp, we will fail if our intent is merely to enumerate, measure, toil, capture, or modify. If we come

< The Middle Fork of the Suwannee River in early spring.

with grand purpose, with scientific hubris, or set out upon the waters with a goal firmly in mind, we will come back with little of value. If we are so fixed on the birds that the subtle hues of the red blanket lichen elude us, we have let the real Swamp slip from our grasp.

To attempt to understand the Swamp completely one would have to live with it, within it, and be a part of it every hour of every day. No one can ever really know the Swamp. To understand the Swamp, even superficially, one has to experience it in all of its phases, moods, and tempos. There are many seasons in the Swamp, far more than those of the calendar. The March yellowing of isolated ponds by the bladderworts promises that winter is past. The moving flocks of warblers in early April mark an ephemeral season, the transient passing of these vibrant beings. The first blooming of the golden clubs begins a season of invigoration, a throbbing in the life of the Swamp. The earliest warm rains bring forth an exuberance of frogs and insects. In the steaminess of a July afternoon, the metabolism of the Swamp seems to lie torpid, almost aestivating. There is a period of languor in late summer when all of the flowers are yellow and the tupelo leaves have become spotted and old. In the fall, when the cypresses have changed color and the branchlets begin to fall, there is a time of melancholy that eludes further definition. Later, the wind has a different voice as it brushes the bare cypresses under leaden January skies.

What is the future of the Okefenokee? Will it gradually fill, become forest, and disappear from the ken of mankind? Will the Swamp, like so many other vanished natural treasures, become the victim of those who inhabit the halls of power, the parvenus of government and industry who would make our world a place of cost-benefit ratios, technological artifice, media hype, cultural arrogance, and mindless slogans? Will global warming wreak ecological havoc here as it may with many native habitats? Will our values change again and cause us to call in the bulldozers, draglines, and dredges a final time? Perhaps the burgeoning hordes of humanity to come will simply overrun the Swamp? No matter what its future, like all com-

ponents of the thin rind of life that clings to this planet, it must eventually become something else. However, if change is left to natural processes, it is almost certain that the Okefenokee will far outlast the present culture.

What is the place of the Okefenokee in our mind and thought? What is its importance to our lives and happiness? These questions are answerable only in smallest part. The answers do not lie in these pages. They must be found in the Swamp itself. Let your canoe drift silently, and watch. Turn off your motor and ease in among the trees. Watch the droplets roll from the leaves of the neverwet. Look for the greenness of the lizard in the grayness of the moss. Crinkle your lip and mimic the grin of the alligator on the log. Point your finger high until a dragonfly comes and rests. Watch the play of light on the water that hints at where a bowfin has passed. On some days, if you wait, and are lucky, the swallow-tailed kites will come, skiing the sky.

To become at all acquainted with the Swamp, one must bring senses to bear that are seldom used. The swamp has a thousand smells. In contrast to the view of common folklore, swamps smell good. Spend a day sniffing in the various habitats. Let the odors of the duckweed masses permeate your nostrils. Catch a whirligig and sample its apple-like mellow odor. Reach down and pull up a handful of the deepest bottom muck and savor an aroma like that of the primeval, an olfactory hint of the world's beginnings.

Listen, always listen. Those of us whose days must be lived in the artificial world often have lost a feel for the music of the wild. Our ears have become illiterate and must be educated before they can decipher the missives of the Swamp. There is wisdom in the sounds of wild places. In our times, this knowledge is more vital than ever before. When the tree crickets begin to call at dusk, a part of their message is for us. Myriad innuendos exist in the barred owl's raucous lyric. There are comprehensions here beyond comprehension because they come from the primal places of nature and speak to the ancient within us.

Listen for the lessons that the Swamp can teach.

Hearken to the trumpeting of the cranes.

Lost Chords

In midafternoon I start out from the dock at Stephen Foster State Park. It has been several years since I rowed, and I strain to get the rhythm, struggle to go in the direction I intend. Two or three hours later I am somewhere north of Minnies Lake. Off to the right is a very bright patch, nearly hidden, shimmering and glowing among the trees. I row toward it, hoping to catch an unusually showy mass of a swamp plant in flower. As I reach the area where the brightness should have lain, it is still in front of me, almost as far as it was. I row on, knowing that I had probably misjudged, having been fooled by apparent distances many times before. Rapidly moving clouds suddenly darken the Swamp. With the dimness the bright patch disappears, and I am surrounded by dull green ovals floating on the water. I let the oars rest and the boat lolls among the lilies.

I know I am lost. I am not panicky, just puzzled. The bright patch lured me to a place from whence I cannot easily or without error return. Then it was gone. It should be easy to follow the trail of slightly disturbed vegetation, the path with a slightly thinner pollen blanket, back to the main channel. I try this and fail. There is no clear path, no unambiguous message in the bent grasses and tipping stems. As I pass an angular stump, I realize that I passed it on the other side a few minutes ago. I have become the classical novice in the Swamp. I am rowing in circles.

The wind comes up a little. Now and then a strong gust drops small branches into the water. I feel that uneasy sensation one tends to get before a storm, the response of human physiology to a pressure change. There is nothing around me that can harm me. The natural world is familiar and has been so to me for many years. I have been alone in many wild places and often have plied these waters without company. Even so, rationale is not all that fashions the world. I row slowly and carefully now. I continually look back to make sure I am rowing consistently in one direction. After I have traveled what I know to be much more than the distance from the channel to the point of my first confusion, I stop. I clearly will not find the channel this way. I stop to rest. I feel a rapid pulse in the sweaty palms that grasp the oar handles.

The wind velocity accelerates. It now whistles and scrapes its way through the cypresses and tupelos. Above, it gathers masses of

Spikerushes (*Eleocharis engelmanni*) from the boardwalk over the Chesser Prairie.

darkness. I listen with faint and forlorn hope that the wind will bring a familiar sound. But it murmurs and whimpers in meaningless phrases. Then, from among all the sighings and moanings, a melody begins to emerge. I look around to see from whence the tones emanate, but I seem to be alone. There is no one, nothing. From up ahead of me, somewhere among the bays, I hear Wagnerian strains. It must be a fisherman with a portable radio. But the music is not that usually picked by fishermen, nor do most like accompaniment while fishing. With some labor I make my way in the direction of the music. Phrases waft toward me more strongly. It is from Die Walküre. I can almost see mounted, golden-haired maidens riding down the winds of the churning sky above. As I push through the bushes toward the sound, it fades into near inaudibility and then is gone. I sit, befuddled. Then, farther ahead, a different melody rises, almost indiscernible. I freeze to utmost quietude and can barely pick out pipe organ notes, perhaps from Bach. I paddle toward it. It is Toccata and Fugue in D Minor. For a moment it becomes so loud and familiar that I can see E. Power Biggs rocking on the bench as he plays. The stretching branches of a gnarled Ogeechee tupelo scrape and claw at me as I pass. The music is drowned. On the other side the only noises are a distant cawing and a keening too high to hear, seemingly coming from everywhere, but perhaps having its origin in me. Then, suddenly and powerfully, from not too far ahead, I hear "Rhapsody in Blue" quite clearly. It crosses my mind that someone has managed to drag a Steinway into the Swamp, but I know that it cannot be. Gershwin continues playing as I row vigorously toward the sound. It becomes louder and clearer. Pushing though a fence-like mass of hurrah bushes, I abruptly emerge into the channel. I am no longer lost, but the music is gone. For a moment, I am more saddened by the loss of the melody than gladdened by finding the channel. I stop and glance around to make sure that this is a real pathway, not just some apparition or illusion created by the same power, fashioned by whatever is capable of making melodies and perhaps channels where none really exist. But this water and passage are real. In inspecting my surroundings I become aware of the lateness of the day and the slant of the sun, low among the cypresses. I begin rowing purposefully back toward Stephen Foster. My oars churn the water with a gentle gurgle. Then, behind me, low and reverberant, I hear what could possibly have been a bull alligator beginning his evening roaring. Some would claim it was a distant pig frog. But I know better. It was not loud but was very audible. It was clearly that wonderful bass antiphony from "The Book of Love." It was the Monotones. I heard it as clearly as ever I heard anything . . . mellifluent . . . resonant . . . strong . . . even comforting. . . . "Oh who, yaaayyuuuhhhh, who wrote the Book of Love?"

> In the summer, pondcypress west of the Suwannee River Narrows creates a cathedral of uncommon beauty.

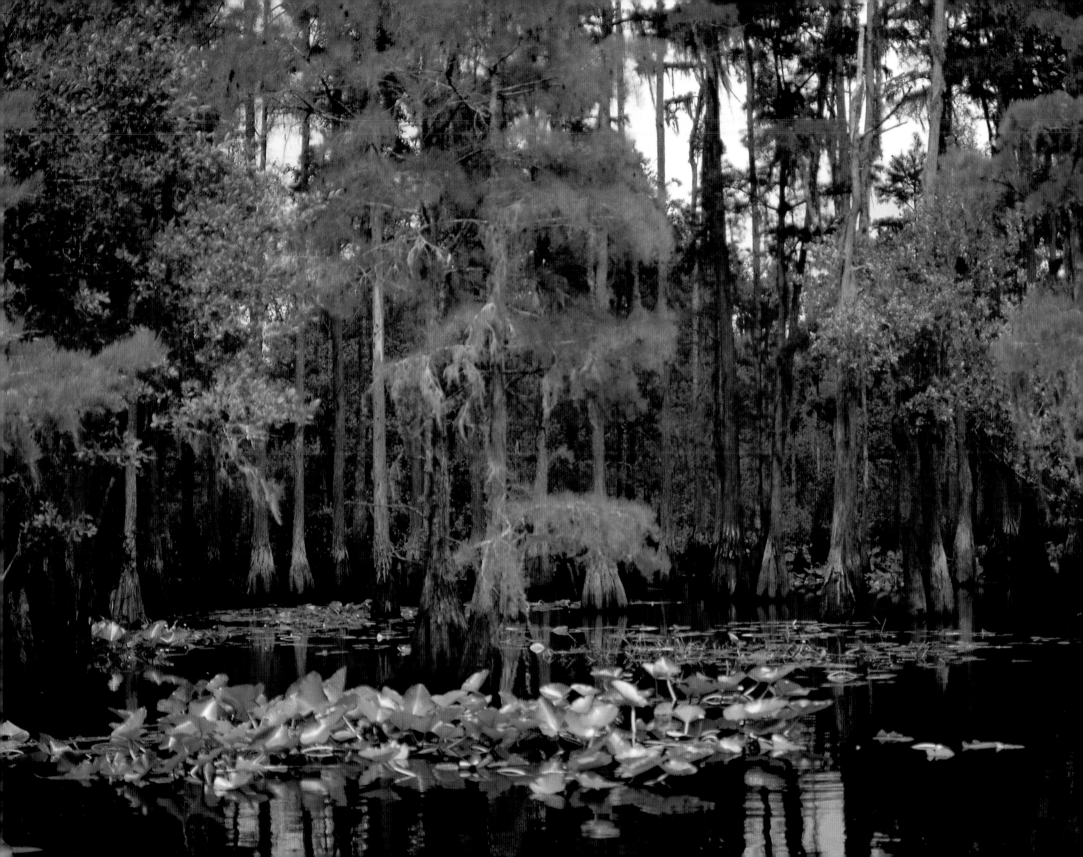

SOURCES FOR ADDITIONAL INFORMATION

The references listed here are by no means intended to comprise an exhaustive bibliography on the Okefenokee Swamp. They are simply selections from the literature that cover a broad spectrum of topics that will allow an interested person to delve further into the biology, functions, and history of the Swamp. Some are quite technical and will be of little interest to the general reader.

GENERAL AND MULTITOPIC WORKS

Harper, F., and D. E. Presley. 1981. *Okefinokee Album*. Athens: University of Georgia Press.

Cohen, A. D., D. J. Casagrande, M. J. Andrejko, and G. R. Best. 1984. *The Okefenokee Swamp: Its natural history, geology, and geochemistry.* Los Alamos, NM: Wetland Surveys. (This large publication contains many scientific papers. These papers do not appear individually elsewhere in this list.)

Russell, F. 1973. *The Okefenokee Swamp.* New York: Time-Life Books.

ECOLOGY *(including fire, geology, hydrology, pollution and related subjects)*

Bano, N., M. A. Moran, and R. E. Hodson. 1998. Photochemical formation of labile organic matter from two components of dissolved organic carbon in a freshwater wetland. *Aquatic Microbial Ecology* 16:95–102.

Benner, R., R. E. Hodson, and M. A. Moran. 1985. Effects of pH and plant source on lignocellulose biodegradation rates in two wetland ecosystems, the Okefenokee Swamp and a Georgia saltmarsh. *Limnology and Oceanography* 30:489–99.

Blood, E. R. 1980. Surface water hydrology and biogeochemistry of the Okefenokee Swamp watershed. Ph.D. diss., University of Georgia.

Bosserman, R. W. 1983. Elemental composition of *Utricularia*-periphyton ecosystems from Okefenokee swamp. *Ecology* 64:1637–45.

———. 1985. Distribution of heavy metals in aquatic macrophytes from Okefenokee Swamp. *Symposia Biologica Hungarica* 29:31–40.

Cohen, A. D. 1974. Petrography and paleoecology of Holocene peats from the Okefenokee swamp-marsh complex of Georgia. *J. Sediment. Petrol.* 44:716–26.

Cypert, E. 1961. The effects of fires in the Okefenokee Swamp in 1954 and 1955. *Am. Midl. Nat.* 66:485–503.

———. 1973. Plant succession on burned areas in Okefenokee Swamp following the fires of 1954 and 1955. *Proc. Tall Timbers Fire Ecol. Conf.* 12:199–217.

Davis, J. D. 1987. The origin of arcuate sand ridges in the Okefenokee Swamp. Okefenokee Ecosystem Investigations, Tech. Rep. #21. Dept. of Zoology and Inst. of Ecology, University of Georgia.

DeLucia, E. H., and W. H. Schlesinger. 1995. Photosynthetic rates and nutrient-use efficiency among evergreen and deciduous shrubs in Okefenokee swamp. *International Journal of Plant Sciences* 156:19–28.

Duever, M. J., and L. A. Riopelle. 1983. Successional sequences and rates on tree islands in the Okefenokee Swamp. *Am. Midl. Nat.* 110:186–93.

Fair, P. T., and A. D. Cohen. 1990. Paleoecological history of west-central Okefenokee swamp Georgia, USA based on palynologic and petrographic analysis. *Palynology* 14:27–40.

Flebbe, P. A. 1983. Aquatic carbon cycle in Okefenokee Swamp habitats: Environmental analysis. In *Analysis of ecological systems: State-of-the-art in ecological modeling,* ed. W. K. Lauenroth, G. V. Skogerboe, and M. Flug. 751–60. New York: ISEM and Elsevier.

Glasser, J. E. 1985. Successional trends on tree islands in the Okefenokee Swamp as determined by interspecific association analysis. *Am. Midl. Nat.* 113:287–93.

Glasser, J. E., and M. C. Barber. 1983. Formulating hydroperiod effects for a multispecies stand simulation model for the Okefenokee Swamp. In *Analysis of ecological systems: State-of-the-art in ecological modeling,* ed. W. K. Lauenroth, G. V. Skogerboe, and M. Flug. 733–39. New York: ISEM and Elsevier.

Hamilton, D. B. 1982. Plant succession and the influence of disturbance in the Okefenokee Swamp. Ph.D. diss., University of Georgia.

Jagoe, C. H., B. Arnold-Hill, G. M. Yanochko, P. V. Winger, and I. L. Brisbin Jr. 1998. Mercury in alligators (*Alligator mississippiensis*) in the southeastern United States. *Science of the Total Environment* 213:255–62.

Loftin, C. S. 1997. The hydrology of Okefenokee Swamp. In *Proceedings of the 1997 Georgia Water Resources Conference, March 20–22*, ed. K. J. Hatcher. 266–69. Athens: University of Georgia.

———. 1998. Assessing patterns and processes of landscape change in Okefenokee Swamp, GA. Ph.D. diss., University of Florida.

Johansen, R. W., and R. A. Phernetton. 1982. Smoke management on the Okefenokee National Wildlife Refuge. *Southern Journal of Applied Forestry* 6:200–205.

Moser, W. K., and C. K. Yu. 1998. The stand structure and management history of longleaf pine (*Pinus palustris* Mill.) forests in Okefenokee NWR: Relationship to understory species mix. *Proceedings of the Society of American Foresters National Convention.* Bethesda.

Murray, R. E., and R. E. Hodson. 1984. Microbial biomass and utilization of dissolved organic matter in the Okefenokee Swamp ecosystem. *Applied Environmental Microbiology* 47:685–92.

Parrish, F. K., and E. J. Rykiel Jr. 1979. Okefenokee Swamp origin: Review and reconsideration. *Journal of the Elisha Mitchell Scientific Society* 95:17–31.

Patten, B. C., T. P. Burns, and M. Higashi. 1989. Network trophic dynamics: The food web of an Okefenokee Swamp aquatic bed marsh. In *Freshwater wetlands and wildlife: Proceedings of a symposium*, ed. R. R. Sharitz and J. W. Gibbons, 401–24. DOE Symposium Series No. 61. Department of Energy, Office of Scientific and Technical Information. Charleston, SC.

Pirkle, W. A. 1972. Trail Ridge, relic shoreline feature of Florida and Georgia. Ph.D. diss., University of North Carolina.

Rich, F. J. 1979. The origin and development of tree islands in the Okefenokee Swamp, as determined by peat petrography and pollen stratigraphy. Ph.D. diss., Pennsylvania State University.

Roelle, J. E., and D. B. Hamilton. 1990. Suwannee River sill and fire management alternatives at the Okefenokee National Wildlife Refuge. U.S. Fish and Wildlife Service, National Ecology Research Center, Fort Collins, Colorado.

Schipper, L. A., and K. R. Reddy. 1994. Methane production and emissions from four reclaimed and pristine wetlands of southeastern United States. *Journal of the Soil Science Society of America Journal* 58:1270–75.

Schlesinger, W. H. 1976. Biogeochemical limits on two levels of plant community organization in the cypress forest of Okefenokee Swamp. Ph.D. diss., Cornell University.

———. 1978a. Community structure, dynamics and nutrient cycling in the Okefenokee cypress swamp-forest. *Ecol. Monogr.* 48:43–65.

———. 1978b. On the relative dominance of shrubs in Okefenokee Swamp. *Am. Nat.* 112:949–54.

Schoenberg, S. A., R. Benner, A. Armstrong, P. Sobecky, and R. E. Hodson. 1990. Effects of acid stress on aerobic decomposition of algal and aquatic macrophyte detritus: Direct comparison in a radiocarbon assay. *Applied & Environmental Microbiology* 56:237–44.

Trowell, C. T. 1987. Some notes on the history of fire and drought in the Okefenokee Swamp: a preliminary report. Working Paper No. 3, South Georgia College, Douglas, GA.

U.S. Fish and Wildlife Service. 1964. Supporting Papers I/D. 1. Restoration of altered wetlands. Pages 336–46 in L. Hoffman, comp. Project MAR. The conservation and management of temperate marshes, bogs, and other wetlands. Vol. 1. Proc. MAR Conf. organized by IUCN, ICBP, and IWRB at Les Saintes-Maries-de-la-Mer, 12–16 November 1962. IUCN Publ. (New Ser.) 3 (relatively early information on positive effects of fire in the Swamp).

Yin, Z. Y., and G. A. Brook. 1991. The impact of the Suwannee River Sill on the surface hydrology of Okefenokee Swamp, USA. *Journal of Hydrology* 136:193–217.

Yu, K. B. 1986. The hydrology of the Okefenokee Swamp watershed with emphasis on groundwater flow. Ph.D. diss., University of Georgia.

PLANTS

Gerritsen, J., and H. S. Greening. 1989. Marsh seed banks of the Okefenokee Swamp: Effects of hydrologic regime and nutrients. *Ecology* 70:750–63.

Greening, H. S., and J. Gerritsen. 1987. Changes in macrophyte community structure following drought in the Okefenokee Swamp, Georgia, U.S.A. *Aquatic Botany* 28:113–28.

Scherer, R. P. 1988, Freshwater diatom assemblages and ecology-paleoecology of the Okefenokee swamp-marsh complex, southern Georgia, USA. *Diatom Research* 3:129–57.

Schoenberg, S. A., and J. D. Oliver. 1988. Temporal dynamics and spatial variation of algae in relation to hydrology and sediment characteristics in the Okefenokee Swamp, Georgia. *Hydrobiologia* 162:123–33.

Smedley, J. 1968. Summary report on the geology and mineral resources of Okefenokee National Wildlife Refuge, Georgia. *U.S. Geological Survey Bulletin 1260-N*, Washington, DC.

Williges, K. A., and C. S. Loftin. 1995. Noteworthy plant species from the Okefenokee Swamp, Georgia. *Sida* 16:775–80.

Wright, A. H., and A. A. Wright. 1932. The habitats and composition of the vegetation of the Okefinokee Swamp, Georgia. *Ecological Monographs* 2:110–282.

ANIMALS

Bennett, A. J., and L. A. Bennet. 1990. Productivity of Florida sandhill cranes in the Okefenokee Swamp, Georgia, USA. *Journal of Field Ornithology* 61:224–31.

Freeman, B. J. 1989. Okefenokee swamp fishes: abundance and production dynamics in an aquatic macrophyte prairie. In *Freshwater wetlands and wildlife: Proceedings of a symposium*, ed. R. R. Sharitz and J. W. Gibbons, 529–40. DOE Symposium Series No. 61. Department of Energy, Office of Scientific and Technical Information. Charleston, SC.

Harper, F. 1927. The mammals of the Okefinokee Swamp region of Georgia. *Proceedings of the Boston Society of Natural History* 38:191–396.

Hunt, R. H. 1990. Aggressive behavior of adult alligators (*Alligator mississippiensis*) toward sub-adults in Okefenokee Swamp. In *Crocodiles. Proc.* 9th Working Meeting of the Crocodile Specialist Group, IUCN, The World Conservation Union, Gland, Switzerland 2:360–72.

Hunt, R. H., and J. J. Ogden. 1991. Selected aspects of the nesting ecology of American alligators in the Okefenokee swamp. *Journal of Herpetology* 25:448–53.

Laerm, J., and B. J. Freeman. 1986. *Fishes of the Okefenokee Swamp*. Athens: University of Georgia Press.

Loftin, R. W. 1994. Ivory-billed woodpeckers reported in Okefenokee Swamp in 1941–42. *Oriole* 56:74–76.

Meyers, J. M., and E. P. Odum. 1991. Breeding bird populations of the Okefenokee swamp in Georgia, USA: Baseline for assessing future avifaunal changes. *Journal of Field Ornithology* 62:53–68.

Oliver, J. D. 1991. Consumption rates, evacuation rates, and diets of pygmy killfish, *Leptolucania ommata*, and mosquitofish, *Gambusia affinis* (Osteichthyes, Atheriniformes) in the Okefenokee Swamp. *Brimleyana* 17:89–103.

Trowell, C. T. 1998. The search for the Ivory-billed Woodpecker in the Okefenokee Swamp. Part 1. *OWL News* 6:1–13.

Volkova, T., R. W. Matthews, and M. C. Barber. 1999. Spider prey of two mud dauber wasps (Hymenoptera:Sphecidae) nesting in Georgia's Okefenokee Swamp. *Journal of Entomological Science* 34:322–27.

Wright, A. H. 1932. *Life-histories of frogs of the Okefinokee Swamp, Georgia.* New York: The Macmillan Company.

Wright, A. H., and W. D. Funkhouser. 1915. A biological reconnaissance of Okefinokee Swamp: The reptiles. *Proceedings of the Academy of Natural Sciences of Philadelphia* 1915:107–92.

Wright, A. H., and F. Harper. 1913. A biological reconnaissance of Okefinokee Swamp: The birds. *The Auk* 30:477–505.

HISTORY

Coulter, E. M. 1964. The Okefenokee swamp, its history and legends. Parts 1 and 2. *Georgia Historical Quarterly* 48:166–89, 291–312.

Gibson, M., and L. B. Mays. 1989. *Memories of Charlton.* Folkston, GA: Okefenokee Press.

Hopkins, J. M. 1947. Forty-five years with the Okefenokee Swamp 1900–1945. *Ga. Soc. Nat. Bull.* 4.

Mays, L. B. 1975. *Settlers on the Okefenokee: Seven biographical sketches.* Folkston, GA: Okefenokee Press.

McQueen, A. S., and H. Mizell. 1926. *History of Okefenokee Swamp.* Clinton, SC: Jacobs & Co.

Trowell, C. T. 1984. The Suwannee Canal Company in the Okefenokee Swamp. Occasional Papers from South Georgia, No. 5. Douglas, GA: South Georgia College.

———. 1988a. Exploring the Okefenokee: The Richard L. Hunter survey of the Okefenokee Swamp, 1856–57. Research Paper No. 1.

———. 1988b. Exploring the Okefenokee: Roland M. Harper in the Okefenokee Swamp, 1902 & 1919. Research Paper No. 2.

———. 1989. Okefenokee: The Biography of a Swamp. Douglas, GA: South Georgia College.

———. 1998a. Okefenokee: Profiles of the past. Okefenokee Wildlife League Special Publication No. 1.

———. 1998b. Life on the Okefenokee frontier. Okefenokee Wildlife League Special Publication No. 3.

———. 1998c. Okefenokee: The Hebard Lumber Company. Okefenokee Wildlife League Special Publication No. 4.

———. 1998d. Seeking a sanctuary: Chronicle of the efforts to preserve the Okefenokee. Okefenokee Wildlife League Special Publication No. 6.

———. 1999. Civilian Conservation Corps Company 1433 and the development of Okefenokee National Wildlife Refuge. *OWL News* 7:1–5.

Trowell, C. T., and R. L. Izlar. 1984. Jackson's folly: The Suwannee Canal Company in the Okefenokee swamp. *Journal of Forest History* 28:187–95.

Trowell, C.T., and L. Fussell. 1998. Exploring the Okefenokee: Railroads of the Okefenokee realm. Occasional Paper from South Georgia No. 8. Douglas, GA: South Georgia College.

Velie, E. 1992. Billys Island: Okefenokee's mystery island. Waycross, GA: Brantly Printing Company.

Wright, A. H. 1945. Our Georgia-Florida frontier: The Okefenokee Swamp, its history and cartography. Part 1. Ithaca, NY: Cornell University.

OTHER TOPICS

Kelly, Mrs. W., and B. Crouch Jr. 1985. *Outrageously Pogo.* New York: Simon and Schuster.